THE GERM

THE GERM

*The Literary Magazine
of the
Pre - Raphaelites*

Preface
by
Andrea Rose

Ashmolean Museum
OXFORD
1992

Reprinted from the 1901 edition by courtesy of the Ashmolean Library. Preface by Andrea Rose, formerly Deputy Keeper of Art, Birmingham Museums and Art Gallery.

D. G. Rossetti conceived the idea of a literary journal shortly after the first exhibition by members of the Pre-Raphaelite Brotherhood in 1849. Four issues appeared in 1850 and were reprinted in facsimile in 1901 with an explanatory introduction by W. M. Rossetti, Dante Gabriel's younger brother, who wrote: "I am quite aware that some of the articles in 'The Germ' are far from good, and some others, though good on essentials, are to a certain extent juvenile; but juvenility is anything but uninteresting when it is that of such men as Coventry Patmore and Dante Rossetti...."

'The Germ' contains short stories, essays and literary reviews, but most particularly poetry, such as Rossetti's *The Blessed Damozel*; Christina Rossetti's *Dreamland*; Bell Scott's *Morning Sleep* and Patmore's *The Seasons*, thus emphasising the claim that "an attempt will be made, both intrinsically and by review, to claim for Poetry that place to which its present development in the literature of this country so emphatically entitles it".

ISBN Casebound 1 85444 023 3
 Paperbound 1 85444 024 1

This edition originally published jointly by the Ashmolean Museum,
Oxford and Birmingham City Museums and Art Gallery in 1979,
printed by A. Wheaton Ltd., Exeter, England.
Reprinted 1984 by Paradigm Print, Gateshead,
and 1992 by The Bath Press

PREFACE

Although *The Germ* has been reprinted several times since its first publication between January–April 1850, little apology is made here for its further appearance in this edition. Neither the first reprint, published in 1898 with an introduction by James Ashcroft Noble in Portland, Maine, nor the first facsimile edition of 1901, with an introduction by William Michael Rossetti, is readily available today; of the three other reprints, one is a photo-facsimile of the original magazine (without, therefore, the important preface by William Michael Rossetti), one is a photo-facsimile of the 1901 reprint and is not on sale in this country, and one is a hybrid of the two, which only confuses what is an already complex publishing venture. As one of the few primary documents of the Pre-Raphaelite movement however, and as one of the earliest examples of a group manifesto on the nature and aims of art, *The Germ* clearly belongs on the shelf alongside the growing body of critical work published on the subject of Pre-Raphaelitism since 1948, the centenary year of the birth of the movement.

1948 was the year in which the B.B.C. began to broadcast its series of eighty-three programmes designed "to examine the assumptions of the Victorian Age, and to appraise its ideals and to re-assess its controversies with a view to shedding some light on matters which puzzle us today".[1] The upsurge of interest in all things Victorian which followed in the wake of this series (which included speakers and subjects as diverse as Harold Laski on Fabian Socialism and Humphry House on Pre-Raphaelite Poetry) was pursued more specifically in the field of art history by a series of large retrospective exhibitions devoted to the works of the major artists associated with the Pre-Raphaelite movement: William Morris (William Morris Society, 1962), Ford Madox Brown (Liverpool, 1964), John Everett Millais (Liverpool, 1967), William Holman Hunt (Liverpool, 1969), Arthur Hughes (Cardiff, 1971), Dante Gabriel Rossetti (R.A. and Birmingham, 1973), Frederick Sandys (Brighton, 1974), and Edward Burne-Jones (Arts Council, 1975). An exhibition of the work of Elizabeth Siddal

[1] *The Ideas and Beliefs of the Victorians* (B.B.C., London, 1949) p. 10.

is being put together even now in Sheffield. These exhibitions have afforded an opportunity to look again at the accomplishments of the most influential artistic movement in England during the nineteenth century, and what they have emphasised overall about the movement is its diversity—making all the more elusive the definition of what it is that makes a work 'Pre-Raphaelite'. As the exhibitions have shown the accomplishments of the Pre-Raphaelite painters, so *The Germ* exposes their original intentions. For although the term 'Pre-Raphaelite' is linked in the public mind with the aesthetic development of the movement, with its images of chain-mail reverie and languishing maidens, the original impulse of the movement was essentially a belief in the morality of art. Lingering notions about the radicalism of the Brotherhood, its bohemianism and its isolation from contemporary social thought are not supported by its earliest statements of intent in *The Germ*. In a way, the history of Pre-Raphaelitism is a history of the gradual disillusionment that the Pre-Raphaelites felt with their capacity to effect a change in society. Between their stated intentions and their achievements one reads a pattern of adjustment from a socially committed art to a more detached and introspective form of expression. One of the reasons that *The Germ* is instructive about the Pre-Raphaelite movement is that it presages the different directions that it eventually took and publishes from the outset the difficulties by which it was beset: its literariness, its bifurcated aesthetics and the basic incompatibility of its components.

Although the aesthetics of *The Germ* are confused, the genesis of the magazine is fairly clear. It was the invention of Dante Gabriel Rossetti, as William Michael recalls in his memoir of his brother:

> If Dante Rossetti cannot rightly be credited (in derogation of Hunt and Millais) with inventing the Praeraphaelite movement and Brotherhood, a very significant enterprize, he certainly *can* be credited with inventing *The Germ*. He was eager to distinguish himself in literature, no less than in painting, and wanted to have some safe vehicle both for ushering his writings before the public, and for diffusing the Praeraphaelite principles in art. I feel pretty sure that at first every one of his colleagues regarded the enterprize as rash, costly, foredoomed to failure, and an interruption to

other more pressing and less precarious work. But Rossetti was not to be denied. The magazine was enacted in his mind; it was to be, and was to enlist the energies of all the P.R.B's, and of some other persons as well.[2]

With William Michael appointed editor, it might seem that *The Germ* was more of a Rossetti affair than a P.R.B. venture, and the literary habits of the Rossetti household do feature strongly in the make-up of the magazine. A family magazine called *Hotchpotch,* or *Weekly Efforts* had been in existence in the Rossetti home before 1843 (Rossetti believed he had first written *The Blessed Damozel* for this magazine, though this is almost certainly inaccurate[3]), and by 1843, when Rossetti was only fifteen, he had published his prose-ballad *Sir Hugh The Heron,* albeit on the private press of his grandfather. The practice of writing sonnets to *bouts-rimés* was shared by the two brothers with Christina until 1849, and William Michael has acknowledged that most of his own contributions in verse to *The Germ* were but *bouts-rimés* performances. There is also some evidence from William Michael's entry in *The P.R.B. Journal* to suggest that *The Germ* was not intended initially to be a strictly Pre-Raphaelite affair:

> Monday, July 13th, 1849. . . . In the evening Gabriel and I went to Woolner's with the view of seeing North (whom, however, we did not find at home) about a project for a monthly sixpenny magazine for which four or five of us would write and one make an etching, each subscribing a guinea, and thus becoming a proprietor.

As there were seven members of the Brotherhood, and North was not one of these, there was clearly little question of Pre-Raphaelite exclusivity in the early stages of planning for the magazine. The title of the magazine also underwent several revisions. Initially to be called *Monthly Thoughts in Literature, Poetry, and Art,* the title was abbreviated to *Thoughts Towards Nature* by September 1849. *The P.R.B. Journal* was mooted as a title but rejected by William Michael on the grounds of its narrowness, and Dante

[2]*Dante Gabriel Rossetti. His Family Letters with a Memoir by William Michael Rossetti* (London, 1895) Vol. 1, p. 149.

[3]See *The Blessed Damozel by Dante Gabriel Rossetti with an Introduction by William Michael Rossetti* (London, 1898) p. vi where W.M. negates the possibility of his brother's authorship of this poem in 1843.

Gabriel's suggestion of *Thoughts Towards Nature* was not viewed with much predilection either. On the 19th December, 1849, at a meeting which William Michael documents in his Preface to the 1901 edition, Cave Thomas' suggestion of *The Germ* was carried by six votes to four.

The aims of the magazine, however, are more clearly enunciated in the sub-title, *Thoughts towards Nature in Poetry, Literature and Art* than in the chosen title. The sub-title, William Michael explains in his Preface, was designed to indicate "that an artist, whether painter or writer, ought to be bent upon defining and expressing his own personal thoughts, and that these ought to be based upon a direct study of Nature, and harmonized with her manifestations". These aims were further advertised on the front and back wrappers of the magazine; in William Michael's specially written sonnet and in the note on the back of the first two issues, which reads, "The endeavour held in view throughout the writings on Art will be to encourage and enforce an entire adherence to the simplicity of nature; and also to direct attention, as an auxiliary medium, to the comparatively few works which Art has yet produced in this spirit." With such emphasis on the simplicity of expression, which harks back fifty years to Wordsworth's defence of an unadorned language of emotion, it is particularly surprising to find a poem such as John Tupper's *Sketch from Nature* printed in the January issue of the magazine. Tupper's conscious ballad-mongering, his decorative descriptions of nature, and his use of archaisms (corbies and merles in Sydenham Wood in 1849?) are simply a gloss on the poet's vision, and this sort of 'word-painting' flies straight in the face of the opening lines of William Michael's sonnet, which demand that

> Whoso merely hath a little thought
> will plainly think the thought that is in him.

A more obvious uneasiness between the aims of the contributors and their manifestation is illustrated in the choice of a black and heavy Gothic type for the cover, more appropriate to the literature of a Puseyite parish magazine than to that of a group of writers hoping to express essential truths in essential forms. This is all the more incongruous considering that the Pre-Raphaelites were, by and large, a

group of visual artists. This lack of correspondence between external form and inner content was to widen as the movement grew older, and some of the later criticism which suggested that the Pre-Raphaelites were the fathers of Aestheticism draws its argument from just this sort of discrepancy, where form and content are allowed to exist independently of each other.

The Puseyite flavour of the cover raises one of the most vexed questions concerning the Pre-Raphaelites—namely, their ambiguous use of religion and their stand on the morality of art. Robert Buchanan, in his criticism of Rossetti and "The Fleshly School of Poetry", called *The Germ* "an unwholesome periodical"[4] This is undeserved. The majority of its debates on art fall directly in line with the ideas of such mid-Victorian aestheticians as Pugin, Ruskin, Carlyle and even Matthew Arnold. And although the debates in *The Germ* register a protest against the existing conditions of art, they do not advocate the resignation of art from human concerns, nor do they ask for any special licence for artists from society. The moral aesthetics of the Brotherhood were founded upon the belief that the artist had a duty to communicate, and that the substance of his message would have social, and therefore moral, significance. These are neither revolutionary, nor "unwholesome" ideas in the sense of licencing an abdication from social responsibility. In *The Purpose and Tendency of Early Italian Art* (Feb.) F. G. Stephens defines, in a way that clearly illustrates his concern with the moral sphere of art, why the primitive Italian painters are worthy of emulation:

> The most successful school of painters has produced upon us the intention of their earnestness at this distance of time . . . let us follow in their path . . . in the confidence of equal power and equal destiny, and then rely that we shall obtain the same success and equal or greater power such as is given to the age in which we live. This is the only course which is worthy of the influence which might be expected by means of the Arts upon the character of the people.

As well as defining the moral impetus behind the historicism of the Pre-Raphaelites this passage also exposes their

[4]See Robert Buchanan, "The Fleshly School of Poetry," *Contemporary Review,* XXVIII (1871) and *The Fleshly School of Poetry and Other Phenomena of the Day* (London, 1872).

nascent didacticism. Far from counselling a withdrawal from society, such a philosophy recognizes the need to approach society on its own terms:

> Why teach us to revere the saints of old, and not our own family-worshippers? . . . Why to love a *Ladie in bower,* and not a wife's fireside? Why paint or poetically depict the horrible race of Ogres and Giants, and not show Giant Despair dressed in that modern habit he walks the streets in? Why teach men what were great and good deeds in the old time, neglecting to show them any good for themselves? ...Art, to become a more powerful engine of civilization, assuming a practically humanizing tendency (the admitted function of Art), should be made more directly conversant with the things, incidents, and influences which surround and constitute the living world of those whom Art proposes to improve.

The Subject in Art No. II by John Tupper (March)

The proposal that art should 'improve' has a ring of colonialism to it, (echoed, coincidentally, in the contemporary political activism abroad) which sounds all too ominously the pious tone muffling many of the Pre-Raphaelite attempts to portray contemporary life: *The Awakening Conscience* by Holman Hunt, *Found* by D. G. Rossetti and *Past and Present* by Augustus Egg are all cases in point. If these works are compared with paintings such as *Nana* or *Olympia* by Manet or with Degas' monotype series of brothel scenes of the 1870's, one can see that the Pre-Raphaelites were unable to discard an overlay of conventional moral sentiment in the way that their French equivalents were able to do, and in consequence the French works still appear fresh and contemporary, where the Pre-Raphaelite paintings are interesting but dated.

Pious hopes for art are carried to their furthest extreme in John Orchard's *Dialogue on Art,* published in the April number of *The Germ.* Orchard was not a member of the P.R.B. but the purism of his argument suggests that his affinities stretched tautly between the Pre-Raphaelites and the Nazarenes, that earlier monastic Brotherhood of German artists anxious to purify their national art through a reversion to the styles of the fifteenth century. The chief protagonist of the *Dialogue,* Christian, argues that the

decorative and sensual values of art are only impurities, and should therefore be discarded:

> Beautiful things, to be beautiful in the highest degree, like the rainbow, must have a spiritual as well as a physical voice. Lovely as it is, it is not the arch of colours that glows in the heavens of our hearts; what does, is the inner and invisible sense for which it was set up of old by God, and of which its many-hued form is only the outward and visible sign.

In defence of the physical aspect of life, Kosmon and Kalon, the Man of the World and the Aesthete respectively, attempt to show the hermeticism of Christian's views:

> Kosmon, your thoughts seduce you; or rather, your nature prefers the full and rich to the exact and simple; you do not go deep enough — do not penetrate beneath the image's gilt overlay, and see that it covers only worm-devoured wood.

It is interesting to look at a Pre-Raphaelite painting of this date executed in the spirit of Orchard's purism, Millais' *Christ in the House of his Parents* (Tate Gallery), and to recognize the obvious sincerity behind this approach, as well as the equally obvious gaucheness. Contemporary critics were shocked by the painting, but its iconography is in fact, quite conventional. The newness of the work lies in Millais' attempt to strip the scene of all the associative and cognitive values which have accrued to the concept of the carpenter's house through centuries of Christian culture. Compared with the really radical and original questioning of divinity by men such as Ernest Renan in *La Vie de Jésus,* published in 1863, both Millais' and Orchard's works are conceived in the spirit of the Early Church Fathers, which betray not their rebellion but their fundamental orthodoxy.

Perhaps the most surprising thing about Orchard's contribution to *The Germ* is that it should have been so admired by Dante Rossetti, the author of its introductory note, and the author of the views which most diametrically oppose those of Orchard. Rossetti's prose-tale, *Hand and Soul,* has been considered an Archimedean point in the direction which moved from Rossetti and the Pre-Raphaelites through the Aesthetic movement and on towards the decadence of the nineties. William Michael, on the other hand, considered it to be "the core of the Praeraphaelite creed". *Hand and Soul*

tells the story of a fictitious painter, Chiaro dell'Erma, living in thirteenth century Tuscany. Chiaro is convinced of his innate artistic genius, but fails to produce the masterpiece of which he believes himself capable. He achieves worldly fame but it leaves him unsatisfied, so he decides to devote his art to the depiction of abstract, moral truths. One moral allegory that he paints in this vein illustrates Peace standing in the porch of the Church of San Rocco, but one day, when a bloody fight takes place on the steps of the very church where his painting hangs, Chiaro recognizes that both his art and his faith are dislocated. In despair over his inadequacy, he has a vision of the image of his own soul, in the body of a young and beautiful woman. She tells him why worldly fame and moral abstraction have failed him, and exhorts him to look deeply into himself for inspiration:

> Chiaro, servant of God, take now thine Art unto thee, and paint me thus as I am, to know me; weak as I am, and in the weeds of this time; only with eyes which seek out labour, and with a faith not learned, yet jealous of prayer. Do this, so shall thy soul stand before thee always, and perplex thee no more.

This exhortation affirms that the Godhead exists deep within the experience of the artist and not high on the altars of conventional religion. This is a real departure from the view of morality expressed by Tupper, Stephens and Orchard, although in each case, including that of Rossetti, one can feel the argument digging beneath the encrustations of formal dogma in an attempt to touch the wellspring of religious experience. For Chiaro, living in the context of a naturally sacramental and religious world, the soul of the artist would naturally express, in its moment of most intense creativity, the most real religious experience. For the nineteenth century artist, however, living in a world where spirit and matter were irrevocably parted, the most fundamental experiences of his existence, although maybe expressed in the heightened language of religious intensity, could not naturally celebrate and reflect the sacrament of life. Released from the service of orthodox dogma, and given licence to refer only to his own genuine experiences, he could not but stand as a herald for the detachment of art from received moral standards — with what results one sees in the decadence of the nineties. For Rossetti, the case

is not so clear-cut. His imaginative experiences are shot through with the mystic symbols of Dante's medieval world , a world in which he was so steeped and with which his identification is so interlaced, that his poetic voice is at its most genuine and most personal when it employs the religious language of *La Divina Comedia.*

One can hear the accents of that voice in the language of *Hand and Soul.* In his Preface to *The Germ,* William Michael maintains that his brother made only one revision of any significance in preparing the manuscript for its second edition, which was privately printed in 1869: this involved the changing of the name of the church from "San Rocco" to "San Petronio". There were however several other significant revisions made. After 1869, the references to the "crucifixes and *addolorate*" of the early Italian painters were expunged, as were the explicitly Catholic intonation of phrases such as the "ecstasy of prayer" in which Chiaro beholds the vision of Italian art, and the description of the Mystical Lady's smile as "like the dove of the Trinity." Revised too is the description of Chiaro's room, which, in the first edition of the story as it appears in *The Germ,* emphasises the Catholic inspiration of Chiaro's work:

> During the offices, as he sat at work, he could hear the music of the organ and the long murmur that the chanting left; and if his window were open, sometimes, at those parts of the mass where there is silence throughout the church, his ear caught faintly the single voice of the priest. Beside the matters of his art and a very few books, almost the only object to be noticed in Chiaro's room was a small consecrated image of St Mary Virgin wrought out in silver, before which stood always, in summer-time, a glass containing a lily and a rose.

The few devotional furnishings of the room described above are similar to those which Rossetti drew in his pen study for *The First Anniversary of the Death of Beatrice* of 1849 (Birmingham Art Gallery) and they betray the emblematic tradition at work behind both Chiaro's and Rossetti's picture-making. For the second edition of *Hand and Soul,* this evidence is omitted. Chiaro's room becomes simply the place where the artist would "remain at work through the whole day . . . weak with yearning as one who gazes upon a path of stars". Possibly these revisions were

made with the same intent to guard against "imputations of popery"[5] that had prompted Rossetti to alter the title of one of his earliest Pre-Raphaelite canvases, from *Ecce Ancilla Domini* (1848–50) to *The Annunciation* in 1853. They show nonetheless that Rossetti's first creative impulses were inextricably linked with the images communicating a Catholic understanding of life, images which in their turn had been the building blocks from which the medieval artist had constructed and fabricated his visions of life on earth and in heaven. Thus, the incipient aestheticism of Rossetti's Chiaro, "who feels faint in sunset and at the sight of stately persons" is complicated by the personal reading of Catholic imagery which Rossetti gives to the very language of his prose, and it is this complication which gives weight to Rossetti's own resistance at being called the father of Aestheticism. As he commented to Hall Caine in 1880, "As for all the prattle about Pre-Raphaelitism I should confess to you I am weary of it and long have been. Why should we go on talking about the visionary vanities of half-a-dozen boys? We've all grown out of them, I hope, by now".[6]

Yet, despite Rossetti's disclaimer, the sensual philosophy of *Hand and Soul* was undoubtedly instrumental in directing the theme of the aesthetic withdrawal from the hesitating and weak voice of Tennyson in the early part of the nineteenth century towards its more committed advocates, Walter Pater and Oscar Wilde, in the 1880's and 1890's. Tennyson felt morally bound to reject the ivory tower of art and to locate the proper sphere for moral action within the active and social field of life, despite the tremendous appeal the contemplative life of art held for him, as is witnessed in works such as *The Idylls of the King* and *The Palace of Art*. Mrs Allonby, however, in Wilde's comedy, *A Woman of No Importance*, comes much closer than Tennyson's *Sir Galahad* to the quality of intense sensationalism of Chiaro's vision when she turns to Lady Stutfield and declares that "Life is simply a *mauvais quart d'heure* made up of exquisite moments." Without Chiaro's affirmation that fidelity to one's own inner experiences is to be pursued

[5] *Praeraphaelite Diaries and Letters* edited by William Michael Rossetti (London, 1900) p. 309.

[6] Quoted by Hall Caine in *My Story* (New York, 1909) p. 115.

even when it delves where formal morality will not go, Mrs Allonby's comments may not have been uttered.

The attempts to define the nature of sincerity in art which form the backbone of *The Germ* are debated, as we have seen, from varying aesthetic standpoints. There are, however, few rules laid down in the manifesto about how this sincerity should be made objective in art, apart from the pragmatic advice given by Ford Madox Brown in his treatise *On The Mechanism of a Historical Picture* (Feb.). The technical innovations of the Pre-Raphaelite painters, such as painting directly onto a canvas with a wet white ground, are not adumbrated here, although Brown does point out how a degree of sincerity can be achieved by not using paid models as sitters, for, he says, "it will always be found that they are stiff and feelingless, and as such tend to curb the vivacity of a first conception, so much so that the artist may believe an action impossible through the want of comprehension of the model, which to himself or a friend makes easy." The practice of painting from friends and intimates was adhered to by the Pre-Raphaelite painters long after other technical rules were relaxed: it satisfied, in a way that other technical practices did not, both camps of the Pre-Raphaelite movement. It allowed for the mimetic adherence to natural, objective phenomena prescribed by Millais and Holman Hunt as well as for the exploration of inner, subjective experience by Rossetti. The women that Rossetti chose to portray all embody in their physical persons some vital, poetic conception that corresponds to his own imaginative experience, and so they become intimate, personal symbols of his experience in a manner not dissimilar from the way in which medieval imagery mirrored his creative thoughts. Elizabeth Siddal, the most important of his models, and subsequently his wife, appears in the final number of *The Germ,* for the head of Viola in the etching of *Olivia and Viola* by Walter Deverell.

The protest against existing formulas registered in the contributions to *The Germ* is met to some degree in the very act of publishing such a magazine. Commercially a failure, it never sold more than two hundred copies of any one edition, and folded after a run of four months. Yet one of the most important features of the nineteenth century literary scene was the periodical. It was the great disseminator of

ideas and information—indeed, by 1829, Christopher North commented glowingly in *Blackwood's Magazine* that "our current periodical literature teems with thought and feeling . . . the whole surface of society is thus irrigated by a thousand streams." The majority of these magazines however, such as Leigh Hunt's *Examiner, The London and Westminster Review* and *Blackwood's* itself, were aimed at an amateur readership of catholic tastes. Articles of social and political concern were printed contiguously with reviews on literature and the arts and as such were expressive of the rightness of the inter-relationship between art and society. Although a few specialist reviews of literature and the arts were in existence, such as *The Literary Gazette,* founded in 1817 and *The Art Journal,* established by 1849, they were not doctrinaire about the acceptance of articles of a specific viewpoint. The notice on the back wrapper of numbers three and four of *The Germ* however make it clear that the editors will print only work that concurs with their own narrow definition of art, and that the journal is "not open to the conflicting opinions of all who handle the brush and palette." No effort at popularisation is made in order to increase the sales of the magazine, and the contents are uncompromisingly and self-consciously about art. This demarcation of art from all other pursuits of contemporary life naturally fanned the growing suspicion by the general public that art was an activity conducted outside the pale of normal social intercourse, produced by and for a small, peripheral community, and therefore ultimately dispensable from the routine of social existence. Although the publications of specialist magazines grew apace in the second half of the nineteenth century, in response to an increasingly factious social structure, the publication of *The Germ* spearheaded a movement for the detachment of art from the body politic, and ushered in what Graham Hough has called "the modern intellectual schizophrenia, where to be seriously (repeat seriously) interested in literature and the arts is to belong to an eccentric and isolated minority."[7]

Thus the question of who the magazine was for raises a serious problem, for it is obvious that if the Pre-Raphaelites were interested in communicating a message to society at

[7] "Books in General" by Graham Hough, *New Statesman and Nation,* XXXVI (August, 1948) p. 117.

large they chose a vehicle peculiarly uncongenial to that task. The ambiguities about the responsibilities the artist to society which are raised in so many of the contributions to *The Germ,* are highlighted by this very question, to which the answer can only be one of uncertainty. It is interesting to note here however on the positive side that the ideas that *The Germ* was putting forward about the premium of sincerity in art were being discussed contemporaneously in French intellectual circles, by critics such as Saint-Beuve, Champfleury, Flaubert and Louis-Emile Duranty. In fact, Duranty's short-lived periodical, *La Réalisme,* which was published in six issues between July 1856–April 1857, closely echoes the concerns of the Pre-Raphaelite Brotherhood. The Pre-Raphaelites have often been criticized for their insularity and for their prejudice against the radical aesthetic doctrines being formulated by the French Realists at the time, but although their working aesthetic was different from that adopted by the avant-garde French schools, their sympathies and their artistic motivations ran clearly in parallel lines with progressive European thought. One could read the following statement and be in some doubt as to whether its author was D.G. Rossetti, Holman Hunt, William Michael Rossetti of Ford Madox Brown:

> I seek above all to render my impressions sincerely in the simplest language. What I see in my head descends into my pen, and becomes what I have seen. The method is simple, within anybody's reach. But how much time is necessary to get rid of memories, imitations, the milieu in which one lives, and to rediscover one's own nature.

The author is in fact Champfleury, writing in his preface to *Contes Domestiques* of 1852.

Despite its concurrence with contemporary thought in Europe, and despite the fact that it was a forcing-bed for important literature (such as D. G. Rossetti's *The Blessed Damozel, Hand and Soul,* and William Michael's laudatory review of Clough's *The Bothie of Toper-na-fuosich*), *The Germ* withered in the spring of 1850. The interest in reprinting it however blossomed soon after the publication of D. G. Rossetti's *Poems* in 1870, but at that date interested publishers were rejected on the grounds that one or other of the contributors dissented. The first reprint was pro-

duced by Thomas Bird Mosher in 1898. This was not a facsimile edition, but a completely reset version of the original magazine, printed together with an article by James Ashcroft Noble entitled "A Pre-Raphaelite Magazine", an article which had already appeared twice before: in *Fraser's Magazine* in 1882, and in *The Sonnet in England and Other Essays* by James Ashcroft Noble in 1896.

The most important reprint, and upon which this present edition is based, is that of 1901, printed by Elliot Stock with a Preface by William Michael Rossetti. Although the Stock edition goes under the title of a facsimile, that is not strictly accurate, as the text was entirely reset using a typeface so close to that of the original (although fractionally smaller) that many an unsuspecting purchaser might not distinguish between the two. There are however significant differences between the original of 1850 and the Stock reprint, the most obvious of which is a printer's error over the disposition of the wrappers. The text of the Stock reprint is reset, but the wrappers and the etched frontispieces are photo-facsimiles of the original. In collating the wrappers with the text, the wrappers for the February and March numbers were transposed, so that the March issue carries the February advertisement, while the February issue carries the advertisement of the March issue. Since the title of the magazine was altered after the February issue, from *The Germ: Thoughts towards Nature in Poetry, Literature and Art* to *Art and Poetry: Being Thoughts towards Nature,* this makes a nonsense of the advertisement on the back wrapper. For the March issue in the Stock reprint advertises itself as *The Germ,* which was by then defunct, and the February issue advertises itself as *Art and Poetry,* which had not as yet come into being. In addition, the January issue of *The Germ* did not identify its contributors at all, as was the practice with many serious reviews such as the *Edinburgh* and the *Quarterly,* but for the second issue, the contributors were named on the inside of the front wrapper, and the identity of the contributors to the first issue were given a separate list on the inside of the back wrapper although some of these were pseudonyms. This latter appears in the Stock edition in the March issue. In this

present edition these transpositions have been corrected, and a separate table of contents is given.

The 1850 edition of *The Germ* was in fact remarkably free of typographical errors, which in part was corrected by Stock, and in part amplified by his own errors. A list of textual variants between the 1850 and 1901 editions has been prepared by William E. Fredeman, and these are given in the appendix to this introduction.[8] Besides these textual variants, there are a few minor typographical errors in the Stock reprint, affecting compositor departures from the line-for-line resetting, the positioning on the page of signature and page numbers, the alignment of rules, indented sections and individual letters, and spacing and leading. These deviations appear in this edition, which has been prepared from photographs of the Stock reprint, and include the important typographical error by which the title of Walter Deverell's poem, *The Sight Beyond* appears as *The Light Beyond* (p. 79). Other differences between the editions concern the bindings. The original magazine was printed on a very thinly calendered paper, while the wrappers were of a reasonably wellsized paper, which does not discolour readily. The Stock reprint uses a slightly thicker paper for the text, and an inferior quality paper for the wrappers, which have all too easily discoloured in extant copies. The Stock reprint was issued as five separate parts: the four numbers of the magazine together with the Preface by William Michael Rossetti, which was printed on a thick, deckle-edged paper and wrapped in a blue-grey wrapper, overprinted in red. It was sold in either a boxed edition or in a black slip envelope. In both the original and the Stock edition, the frontispiece etchings were tipped-in. One other point to note is that the final number in this present edition is dated May, rather than April. This was a mistake originating in the 1850 edition, some copies of which survive with printed pasteovers reading April. Stock must have made his photo-facsimile of the wrappers from an original that existed without a pasteover.

Besides the 1901 reprint, three other reprints of *The Germ* have been published: a photo-facsimile of the 1850 edition, published by Frank Cass in 1967 as part of a reprint series of The English Little Magazines; a photo-facsimile of the 1901

reprint, published by the American Magazine Service in 1968; and a reprint published by the University of Miami in 1971, and edited by Robert Stahr Hosmon. Professor Fredeman's review of this last reprint says all that need be said on the matter, besides providing an invaluable source on the history of the publishing of the magazine.[8]

The fact that *The Germ* has been reprinted a number of times confirms William Michael's contention that "juvenility is anything but uninteresting when it is that of men such as Coventry Patmore and Dante Rossetti." More than the juvenility of its writers however it is the juvenility of its ethic, of which we ourselves are heirs, that still concerns and interests us. The ideal of personal honesty which the Pre-Raphaelites promoted opened a floodgate to amateurism, allowing it to make pretences as "art" on the grounds of its sincerity alone. We are victims, if not accomplices, in this pretension today in no small measure. As it was formulated by the Pre-Raphaelites, however, the belief in the validity of the individual voice, and its accent of direct expression, was made in response to the dehumanizing aspect of the division of labour under an emerging industrialism. While it may be true that the Pre-Raphaelites were at the root of the decadence that permeated the last decades of the century, it must also be said that this decadence witnessed a disintegration of the conventional moral, religious and social orders, and consequently helped to bring about the collapse of outmoded restrictions and the establishment of a new social order. For this reason such decadence as the Pre-Raphaelites may be said to have promoted was also the sign of a new vitality in the areas of personal independence and individual culture, and it is to *The Germ* that one must return to watch the beginnings of this growth.

Andrea Rose, 1979
Deputy Keeper of Art,
Birmingham Museum and Art Gallery

[8]Reprinted from William E. Fredeman's review of "The Germ: A Pre-Raphaelite Magazine, edited and with an introduction by Robert Stahr Hosmon" (University of Miami Press, 1971) in *Victorian Poetry*, Vol. 10, No. 1, Spring, 1972 (West Virginia University). pp. 87–94. I am greatly indebted to Professor Fredeman for permission to reprint this appendix and for the invaluable information concerning the publishing history of the magazine contained in this review, from page xviii on.

APPENDIX

Textual Variants between *The Germ* (1850) and the Elliot Stock Facsimile Edition (1901), compiled by William E. Fredeman.

The Germ (1850)	**Elliot Stock Edition** (1901)
Number 1	
p.16, 1.31 idea	ideas
p.27, 1.8 unjustly,	unjustly.
p.34, 1.18 relinquish them,	relinquish them
p.38, 1.36 what-did-he-call-it' ''–it'' '–
p.40, 1.6 (ocean:	(ocean;
Number 2	
p.49, 1.4. Lamentations, i.12	Lamentations i.12
p.64, 1.15 path,	path
p.77, 1.25 your's	yours
p.79, 1.1 The Sight Beyond	The Light Beyond
p.80, 1.17 her's	hers
p.83, 1.20 mild;	mild:
p.83, 1.21 ceased:	ceased;
p.87, 1.13 supersposed	superposed
Number 3	
p.109, 1.30 enterprize	enterprise
p.121, 1.33 *transendency*	*transcendency*
p.128, 1.13 thought;	thought:
p.136, 1.42 Morals	Models
p.139, 1.1 *declining,*	*declining*
p.140, 1.18 but,	but
Number 4	
p.159, 11.11–12 man/hood?	man/hood.
p.182, 1.28 silence:	silence;

TABLE OF CONTENTS

The identity of the various contributors to *The Germ* was not disclosed in the original 1850 publication of the magazine. In the preface to the 1901 facsimile edition, William Michael Rossetti mentions the authors by name, and the indices to this edition lists some of the authors by their correct name, others under pseudonyms. For ease of reference, the full list of authors is printed below, with the pseudonyms given in brackets.

The sonnet on the front wrapper of all four numbers is by William Michael Rossetti.

No. 4

The four issues of *The Germ* are reproduced in facsimile from the 1901 edition, preceded by W.M. Rossetti's introduction. The four issues are paginated continuously from page 1 to page 192. The only anomaly is at the end of number 3 (following page 144) where the contents of number 1 (with an errata note) are repeated on the inside cover.

Preface

By W. M. Rossetti

"The Germ"

The Subscribers to this Periodical are respectfully informed that in future it will appear under the title of "Art and Poetry" instead of the original arbitrary one, which occasioned much misapprehension — This alteration will not be productive of any ill consequence, as the title has never occurred in the work itself, and Label will be supplied for placing on the old Wrappers, so as to make them conformable to the new —

It should also be noticed that the Numbers will henceforward be published on the last day of the Month for which they are dated —

Town Subscribers will oblige by filling up & returning the accompanying form, which will ensure the Numbers being duly forwarded as directed. —

Country Subscribers may obtain their Copies by kindly forwarding their orders to any Booksellers in their respective Neighbourhoods. —

Published Monthly.—Price One Shilling.

"Art and Poetry,"

Being Thoughts towards Nature.

Conducted principally by Artists.

OF the little worthy the name of writing that has ever been written upon the principles of Art, (of course excepting that on the mere mechanism), a very small portion is by Artists themselves; and that is so scattered, that one scarcely knows where to find the ideas of an Artist except in his pictures.

With a view to obtain the thoughts of Artists, upon Nature as evolved in Art, in another language besides their *own proper* one, this Periodical has been established. Thus, then, it is not open to the conflicting opinions of all who handle the brush and palette, nor is it restricted to actual practitioners; but is intended to enunciate the principles of those who, in the true spirit of Art, enforce a rigid adherence to the simplicity of Nature either in Art or Poetry, and consequently regardless whether emanating from practical Artists, or from those who have studied nature in the Artist's School.

Hence this work will contain such original Tales (in prose or verse), Poems, Essays, and the like, as may seem conceived in the spirit, or with the intent, of exhibiting a pure and unaffected style, to which purpose analytical Reviews of current Literature—especially Poetry—will be introduced; as also illustrative Etchings, one of which latter, executed with the utmost care and completeness, will appear in each number.

PUBLISHED BY MESSRS. DICKINSON, 114, NEW BOND STREET, AND SOLD BY ALL BOOK AND PRINTSELLERS.

OPINIONS OF THE PRESS.

... Original Poems, stories to develop thought and principle, essays concerning Art & other subjects, are the materials which are to compose this unique addition to our periodical literature. ... Among the poetry, there are some rare gems of poetic conception; among the prose essays, we notice "the Subject in Art," which treats of Art itself in a noble and lofty tone, with the view which he must take of it who would, in the truest sense of the word, be an Artist; and another paper, not less interesting, on "the Purpose and Tendency of Early Italian Art." A well executed Etching in the medieval style, accompanies each number."

<div align="right">John Bull</div>

"... There are so many original and beautiful thoughts in these pages — indeed some of the poems & tales are, in themselves, so beautiful in spirit & form, that we have hopes of the writers, when they shall have got rid of those ghosts of medieval art, which now haunt their every page. The essay "On the Mechanism of a Historical Picture" is a good practical treatise, and indicates the kind of writing which is much wanted among artists."

<div align="right">Morning Chronicle.</div>

"We depart from our usual plan of noticing the periodicals under one heading, for the purpose of introducing to our readers a new aspirant for public favour, which has peculiar and uncommon claims to attention, for, in design & execution, it differs from all other periodicals. ... A periodical largely occupied with poetry wears an unpromising aspect to readers who have learned from experience what nonsensical stuff most fugitive Magazine poetry is.... But, when they have read a few extracts, which we propose to make, we think they will own that for once appearances are deceitful. That the contents of this work are the productions of no common minds, the following extracts will sufficiently prove. We have not space to take any specimens of the prose; but the essays on Art are conceived with an equal appreciation of its _meaning_ & requirements. Being such, this work has our heartiest wishes for its success; but we scarcely dare to _hope_ that it may win the popularity it deserves. The truth is, that it is too good for the time. It is not _material_ enough for the age."

<div align="right">Critic.</div>

"... It bears unquestionable evidences of true inspiration; and, in fact, is so thoroughly spiritual that it is more likely to find "the fit audience though few" than to attract the multitude. ... The prose articles are much to our taste. ... We know, however, of no periodical of the time, which is so genuinely poetical and artistic in its tone."

<div align="right">Standard of Freedom.</div>

THE GERM

1850

THE GERM

Thoughts toWards Nature in Poetry, Literature
and Art

BEING

A *FACSIMILE* REPRINT OF THE LITERARY
ORGAN OF THE PRE-RAPHAELITE
BROTHERHOOD, PUBLISHED
IN 1850

WITH AN INTRODUCTION

BY

WILLIAM MICHAEL ROSSETTI

LONDON
ELLIOT STOCK, 62, PATERNOSTER ROW, E.C.
1901

INTRODUCTION.

O F late years it has been my fate or my whim to write a good deal about the early days of the Præraphaelite movement, the members of the Præraphaelite Brotherhood, and especially my brother Dante Gabriel Rossetti, and my sister Christina Georgina Rossetti. I am now invited to write something further on the subject, with immediate reference to the Præraphaelite magazine "The Germ," republished in this volume. I know of no particular reason why I should not do this, for certain it is that few people living know, or ever knew, so much as I do about "The Germ"; and if some press-critics who regarded previous writings of mine as superfluous or ill-judged should entertain a like opinion now, in equal or increased measure, I willingly leave them to say so, while I pursue my own course none the less.

"The Germ" is here my direct theme, not the Præraphaelite Brotherhood; but it seems requisite to say in the first instance something about the Brotherhood—its members, allies, and ideas—so as to exhibit a raison d'être for the magazine. In doing this I must necessarily repeat some things which I have set forth before, and which, from the writings of others as well as myself, are well enough known to many. I can vary my form of expression, but cannot introduce much novelty into my statements of fact.

In 1848 the British School of Painting was in anything but a vital or a lively condition. One very great and incomparable genius, Turner, belonged to it. He was old and past his executive prime. There were some other highly able men—Etty and David Scott, then both very near their death; Maclise, Dyce, Cope, Mulready, Linnell, Poole, William Henry Hunt, Landseer, Leslie, Watts, Cox, J. F. Lewis, and some others. There were also some distinctly clever men, such as Ward, Frith, and Egg. Paton, Gilbert, Ford Madox Brown, Mark Anthony, had given sufficient indication of their powers, but were all in an early stage. On the whole the school had sunk very far below what it had been in the days of Hogarth, Reynolds, Gainsborough, and Blake, and its

ordinary average had come to be something for which commonplace is a laudatory term, and imbecility a not excessive one.

There were in the late summer of 1848, in the Schools of the Royal Academy or barely emergent from them, four young men to whom this condition of the art seemed offensive, contemptible, and even scandalous. Their names were William Holman-Hunt, John Everett Millais, and Dante Gabriel Rossetti, painters, and Thomas Woolner, sculptor. Their ages varied from twenty-two to nineteen—Woolner being the eldest, and Millais the youngest. Being little more than lads, these young men were naturally not very deep in either the theory or the practice of art: but they had open eyes and minds, and could discern that some things were good and others bad—that some things they liked, and others they hated. They hated the lack of ideas in art, and the lack of character; the silliness and vacuity which belong to the one, the flimsiness and make-believe which result from the other. They hated those forms of execution which are merely smooth and prettyish, and those which, pretending to mastery, are nothing better than slovenly and slapdash, or what the P.R.B.'s called "sloshy." Still more did they hate the notion that each artist should not obey his own individual impulse, act upon his own perception and study of Nature, and scrutinize and work at his objective material with assiduity before he could attempt to display and interpret it; but that, instead of all this, he should try to be "like somebody else," imitating some extant style and manner, and applying the cut-and-dry rules enunciated by A from the practice of B or C. They determined to do the exact contrary. The temper of these striplings, after some years of the current academic training, was the temper of rebels: they meant revolt, and produced revolution. It would be a mistake to suppose, because they called themselves Præraphaelites, that they seriously disliked the works produced by Raphael; but they disliked the works produced by Raphael's uninspired satellites, and were resolved to find out, by personal study and practice, what their own several faculties and adaptabilities might be, without being bound by rules and big-wiggeries founded upon the performances of Raphael or of any one. They were to have no master except their own powers of mind and hand, and their own first-hand study of Nature. Their minds were to furnish them with subjects for works of art, and with the general scheme of treatment; Nature was to be their one or their paramount storehouse of materials for objects to be represented; the study of her was to be deep, and the representation (at any rate in the earlier stages of self-discipline and work) in the highest degree exact; executive methods were to be learned partly from precept and example, but most essentially from practice and experiment. As their minds were very different in range

and direction, their products also, from the first, differed greatly ; and these soon ceased to have any link of resemblance.

The Prœraphaelite Brothers entertained a deep respect and a sincere affection for the works of some of the artists who had preceded Raphael ; and they thought that they should more or less be following the lead of those artists if they themselves were to develop their own individuality, disregarding school-rules. This was really the sum and substance of their "Prœraphaelitism." It may freely be allowed that, as they were very young, and fired by certain ideas impressive to their own spirits, they unduly ignored some other ideas and theories which have none the less a deal to say for themselves. They contemned some things and some practitioners of art not at all contemptible, and, in speech still more than in thought, they at times wilfully heaped up the scorn. You cannot have a youthful rebel with a faculty who is also a model head-boy in a school.

The P.R.B. was completed by the accession of three members to the four already mentioned. These were James Collinson, a domestic painter ; Frederic George Stephens, an Academy-student of painting ; and myself, a Government-clerk. These again, when the P.R.B. was formed towards September 1848, were all young, aged respectively about twenty-three, twenty-one, and nineteen.

This Prœraphaelite Brotherhood was the independent creation of Holman-Hunt, Millais, Rossetti, and (in perhaps a somewhat minor degree) Woolner : it cannot be said that they were prompted or abetted by any one. Ruskin, whose name has been sometimes inaccurately mixed up in the matter, and who had as yet published only the first two volumes of "Modern Painters," was wholly unknown to them personally, and in his writings was probably known only to Holman-Hunt. Ford Madox Brown had been an intimate of Rossetti since March 1848, and he sympathized, fully as much as any of these younger men, with some old-world developments of art preceding its ripeness or over-ripeness : but he had no inclination to join any organization for protest and reform, and he followed his own course—more influenced, for four or five years ensuing, by what the P.R.B.'s were doing than influencing them. Among the persons who were most intimate with the members of the Brotherhood towards the date of its formation, and onwards till the inception of "The Germ," I may mention the following. For Holman-Hunt, the sculptor John Lucas Tupper, who had been a fellow Academy-student, and was now an anatomical designer at Guy's Hospital : he and his family were equally well acquainted with Mr. Stephens. For Millais, the painter Charles Allston Collins, son of the well-known painter of domestic life and coast-scenes William Collins ;

the painter Arthur Hughes ; also his own brother, William Henry
Millais, who had musical aptitudes and became a landscape-painter.
For Rossetti, William Bell Scott (brother of David Scott), painter, poet,
and Master of the Government School of Design in Newcastle-on-Tyne ;
Major Calder Campbell, a retired Officer of the Indian army, and a
somewhat popular writer of tales, verses, etc. ; Alexander Munro the
sculptor ; Walter Howell Deverell, a young painter, son of the Secretary
to the Government Schools of Design ; James Hannay, the novelist,
satirical writer, and journalist ; and (known through Madox Brown)
William Cave Thomas, a painter who had studied in the severe classical
school of Germany, and had earned a name in the Westminster Hall
competitions for frescoes in Parliament. For Woolner, John Hancock
and Bernhard Smith, sculptors ; Coventry Patmore the poet, with his
connections the Orme family and Professor Masson ; also William
North, an eccentric young literary man, of much effervescence and
some talent, author of "Anti-Coningsby" and, other novels. For
Collinson, the prominent painter of romantic and biblical subjects John
Rogers Herbert, who was, like Collinson himself, a Roman Catholic
convert.

The Præraphaelite Brotherhood having been founded in September
1848, the members exhibited in 1849 works conceived in the new spirit.
These were received by critics and by the public with more than moderate
though certainly not unmixed favour : it had not as yet transpired that
there was a league of unquiet and ambitious young spirits, bent upon
making a fresh start of their own, and a clean sweep of some effete re-
spectabilities. It was not until after the exhibitions were near closing
in 1849 that any idea of bringing out a magazine came to be discussed.
The author of the project was Dante Gabriel Rossetti. He alone among
the P.R.B.'s had already cultivated the art of writing in verse and in
prose to some noticeable extent (" The Blessed Damozel " had been pro-
duced before May 1847), and he was better acquainted than any other
member with British and foreign literature. There need be no self-
conceit in saying that in these respects I came next to him. Holman-
Hunt, Woolner, and Stephens, were all reading men (in British litera-
ture only) within straiter bounds than Rossetti : not any one of them,
I think, had as yet done in writing anything worth mentioning. Millais
and Collinson, more especially the former, were men of the brush, not
the pen, yet both of them capable of writing with point, and even in
verse. By July 13 and 14, 1849, some steps were taken towards dis-
cussing the project of a magazine. The price, as at first proposed, was
to be sixpence ; the title, " Monthly Thoughts in Literature, Poetry,
and Art " ; each number was to have an etching. Soon afterwards

a price of one shilling was decided upon, and two etchings per number : but this latter intention was not carried out.* All the P.R.B.'s were to be proprietors of the magazine : I question however whether Collinson was ever persuaded to assume this responsibility, entailing payment of an eventual deficit. We were quite ready also to have some other proprietors. Mr. Herbert was addressed by Collinson, and at one time was regarded as pretty safe. Mr. Hancock the sculptor did not resist the pressure put upon him ; but after all he contributed nothing to " The Germ," either in work or in money. Walter Deverell assented, and paid when the time came. Thus there seem to have been eight, or else seven, de facto proprietors—not one of them having any spare cash, and not all of them much steadiness of interest in the scheme set going by Dante Rossetti.

With so many persons having a kind of co-equal right to decide what should be done with the magazine, it soon became apparent that somebody ought to be appointed Editor, and assume the control. I, during an absence from London, was fixed upon for this purpose by Woolner and my brother—with the express or tacit assent, so far as I know, of all the others. I received notice of my new dignity on September 23, 1849, being just under twenty years of age, and I forthwith applied myself to the task. It had at first been proposed to print upon the prospectus and wrappers of the magazine the words " Conducted by Artists," and also (just about this time) to entitle it "The P.R.B. Journal." I called attention to the first of these points as running counter to my assuming the editorship, and to the second as in itself inappropriate : both had in fact been already set aside. My brother had ere this been introduced to Messrs. Aylott and Jones, publishers in Paternoster Row (principally concerned, I believe, with books of evangelical religion), and had entered into terms with them, and got them to print a prospectus. "P.R.B." was at first printed on the latter, but to this Mr. Holman-Hunt objected in November, and it was omitted. The printers were to be Messrs. Tupper and Sons, a firm of lithographic and general printers in the City, the same family to which John Lucas Tupper belonged. The then title, invented by my brother, was "Thoughts towards Nature," a phrase which, though somewhat extra-peculiar, indicated accurately enough the predominant conception of the Præraphaelite Brotherhood, that an artist, whether painter or writer, ought to be bent upon defining and expressing his own personal thoughts, and

* Many of the particulars here given regarding " The Germ" appear in the so-called " P.R.B. Journal," which was published towards December 1899, in the volume named " Præraphaelite Diaries and Letters, edited by W. M. Rossetti." At the date when I wrote the present introduction, that volume had not been offered for publication.

that these ought to be based upon a direct study of Nature, and harmonized with her manifestations. It was not until December 19, when the issue of our No. 1 was closely impending, that a different title, " The Germ," was proposed. On that evening there was a rather large gathering at Dante Rossetti's studio, 72 Newman Street; the seven P.R.B.'s, Madox Brown, Cave Thomas, Deverell, Hancock, and John and George Tupper. Mr. Thomas had drawn up a list of no less than sixty-five possible titles (a facsimile of his MS. of some of them appears in the " Letters of Dante Gabriel Rossetti to William Allingham," edited by George Birkbeck Hill—Unwin, 1897). Only a few of them met with favour; and one of them, " The Germ," going to the vote along with " The Seed " and " The Scroll," was approved by a vote of six to four. The next best were, I think, " The Harbinger," " First Thoughts," " The Sower," " The Truth-Seeker," and " The Acorn." Appended to the new title we retained, as a sub-title, something of what had been previously proposed; and the serial appeared as " The Germ. Thoughts towards Nature in Poetry, Literature, and Art." At this same meeting Mr. Woolner suggested that authors' names should not be published in the magazine. I alone opposed him, and his motion was carried. I cannot at this distance of time remember with any precision what his reasons were; but I think that he, and all the other artists concerned, entertained a general feeling that to appear publicly as writers, and especially as writers opposing the ordinary current of opinions on fine art, would damage their professional position, which already involved uphill work more than enough.

" The Germ," No. 1, came out on or about January 1, 1850. The number of copies printed was 700. Something like 200 were sold, in about equal proportions by the publishers, and by ourselves among acquaintances and well-wishers. This was not encouraging, so we reduced the issue of No. 2 to 500 copies. It sold less well than No. 1. With this number was introduced the change of printing on the wrapper the names of most of the contributors : not of all, for some still preferred to remain unnamed, or to figure under a fancy designation. Had we been left to our own resources, we must now have dropped the magazine. But the printing-firm—or Mr. George I. F. Tupper as representing it—came forward, and undertook to try the chance of two numbers more. The title was altered (at Mr. Alexander Tupper's suggestion) to "Art and Poetry, being Thoughts towards Nature, conducted principally by Artists"; and Messrs. Dickinson and Co., of New Bond Street, the printsellers, consented to join their name as publishers to that of Messrs. Aylott and Jones. Mr. Robert Dickinson, the head of this firm, and more especially his brother, the able portrait-painter

Mr. Lowes Dickinson, were well known to Madox Brown, and through him to members of the P.R.B. I continued to be editor; but, as the money stake of myself and my colleagues in the publication had now ceased, I naturally accommodated myself more than before to any wish evinced by the Tupper family. No. 3, which ought to have appeared on March 1, was delayed by these uncertainties and changes till March 31. No. 4 came out on April 30. Some small amount of advertising was done, more particularly by posters carried about in front of the Royal Academy (then in Trafalgar Square), which opened at the beginning of May. All efforts proved useless. People would not buy "The Germ," and would scarcely consent to know of its existence. So the magazine breathed its last, and its obsequies were conducted in the strictest privacy. Its debts exceeded its assets, and a sum of £33 odd, due on Nos. 1 and 2, had to be cleared off by the seven (or eight) proprietors, conscientious against the grain. What may have been the loss of Messrs. Tupper on Nos. 3 and 4 I am unable to say. It is hardly worth specifying that neither the editor, nor any of the contributors whether literary or artistic, received any sort of payment. This was foreseen from the first as being " in the bond," and was no grievance to anybody.

"The Germ," as we have seen, was a most decided failure, yet it would be a mistake to suppose that it excited no amount of literary attention whatever. There were laudatory notices in " The Dispatch," " The Guardian," " Howitt's Standard of Freedom," " John Bull," " The Critic," " Bell's Weekly Messenger," " The Morning Chronicle," and I dare say some other papers. A pat on the back, with a very lukewarm hand, was bestowed by " The Art Journal." There were notices also—not eulogistic—in " The Spectator " and elsewhere. The editor of " The Critic," Mr. (afterwards Serjeant) Cox, on the faith of doings in " The Germ," invited me, or some other of the art-writers there, to undertake the fine-art department—picture-exhibitions, etc.—of his weekly review. This I did for a short time, and, on getting trans-ferred to " The Spectator," I was succeeded on " The Critic " by Mr. F. G. Stephens. I also received some letters consequent upon " The Germ," and made some acquaintances among authors; Horne, Clough, Heraud, Westland Marston, also Miss Glyn the actress. I as editor came in for this; but of course the attractiveness of " The Germ " depended upon the writings of others, chiefly Messrs. Woolner, Patmore, and Orchard, my sister, and above all my brother, and, among the artist-etchers, Mr. Holman-Hunt.

I happen to be still in possession of the notices which appeared in " The Critic," " Bell's Weekly Messenger," and " The Guardian," and of extracts (as given in our present facsimile) from those in "John Bull,"

" The Morning Chronicle," and *" The Standard of Freedom" : I here reproduce the first three for the curious reader's perusal. First comes the review which appeared in " The Critic" on February* 15, 1850, *followed by a second review on June* 1. *The former was (as shown by the initials) written by Mr. Cox, and I presume the latter also. Major Calder Campbell must have called the particular attention of Mr. Cox to " The Germ." My own first personal acquaintance with this gentle- man may have been intermediate between* 15 *February and* 1 *June.*

The Germ. Thoughts towards Nature in Poetry, Literature, and Art.
 Nos. I. and II. London : Aylott and Jones.

We depart from our usual plan of noticing the periodicals under one heading, for the purpose of introducing to our readers a new aspirant for public favour, which has peculiar and uncommon claims to attention, for in design and execution it differs from all other periodicals. *The Germ* is the somewhat affected and unpromising title given to a small monthly journal, which is devoted almost entirely to poetry and art, and is the production of a party of young persons. This statement is of itself, as we are well aware, enough to cause it to be looked upon with shyness. A periodical largely occupied with poetry wears an unpromising aspect to readers who have learned from experience what nonsensical stuff most fugitive magazine-poetry is ; nor is this natural prejudice diminished by the knowledge that it is the production of young gentlemen and ladies. But, when they have read a few extracts which we propose to make, we think they will own that for once appearances are deceitful, and that an affected title and an unpromising theme really hides a great deal of genius ; mingled however, we must also admit, with many conceits which youth is prone to, but which time and experience will assuredly tame.

That the contents of *The Germ* are the productions of no common minds the following extracts will sufficiently prove, and we may add that these are but a small portion of the contents which might prefer equal claims to applause.

" My Beautiful Lady," and " Of my Lady in Death," are two poems in a quaint metre, full of true poetry, marred by not a few affectations—the genuine metal, but wanting to be purified from its dross. Nevertheless, it is pleasant to find the precious ore anywhere in these unpoetical times.

To our taste the following is replete with poetry. What a *picture* it is ! A poet's tongue has told what an artist's eye has seen. It is the first of a series to be entitled " Songs of One Household." [Here comes Dante Ros- setti's poem, " My Sister's Sleep," followed by Patmore's " Seasons," and Christina Rossetti's " Testimony."] We have not space to take any speci- mens of the prose, but the essays on art are conceived with an equal ap- preciation of its *meaning* and requirements. Being such, *The Germ* has our heartiest wishes for its success ; but we scarcely dare to *hope* that it may win the popularity it deserves. The truth is that it is too good for the time. It is not *material* enough for the age.

Art and Poetry : being Thoughts towards Nature. Conducted principally
 by Artists. Nos. 3 and 4. London : Dickinson and Co.

Some time since we had occasion to direct the attention of our readers to a periodical then just issued under the modest title of *The Germ.* The surprise and pleasure with which we read it was, as we are informed, very generally shared by our readers upon perusing the poems we extracted from it ; and it was manifest to every person of the slightest taste that the con- tributors were possessed of genius of a very high order, and that *The Germ* was not wantonly so entitled, for it abounded with the promise of a rich harvest to be anticipated from the maturity of those whose youth could accomplish so much.

But we expressed also our fear lest the very excellence of this magazine should be fatal to its success. It was too good—that is to say, too refined and of too lofty a class, both in its art and in its poetry—to be sufficiently popular to pay even the printer's bill. The name, too, was against it, being somewhat unintelligible to the thoughtless, and conveying to the considerate a notion of something very juvenile. Those fears were not unfounded, for it was suspended for a short time ; but other journals after a while discovered and proclaimed the merit that was scattered profusely over the pages of *The Germ*, and, thus encouraged, the enterprise has been resumed, with a change of name which we must regard as an improvement. *Art and Poetry* precisely describes its character. It is wholly devoted to them, and it aims at originality in both. It is seeking out for itself new paths, in a spirit of earnestness, and with an undoubted ability which must lead to a new era. The writers may err somewhat at first, show themselves too defiant of prescriptive rules, and mistake extravagance for originality ; but this fault (inherent in youth when, conscious of its powers, it first sets up for itself) will after a while work its own cure, and with experience will come soberer action. But we cannot contemplate this young and rising school in art and literature without the most ardent anticipations of something great to grow from it, something new and worthy of our age, and we bid them God speed upon the path they have adventured.

But our more immediate purpose here is with the poetry, of which about one-half of each number is composed. It is all beautiful, much of it of extraordinary merit, and equal to anything that any of our known poets could write, save Tennyson, of whom the strains sometimes remind us, although they are not imitations in any sense of the word. [The Reviewer next proceeds to quote, with a few words of comment, Christina Rossetti's "Sweet Death," John Tupper's "Viola and Olivia," Orchard's "Whit-Sunday Morn," and (later on) Dante Rossetti's "Pax Vobis."]

Almost one half of the April number is occupied with a "Dialogue on Art," the composition of an Artist whose works are well known to the public. It was written during a period of ill health, which forbad the use of the brush, and, taking his pen, he has given to the world his thoughts upon art in a paper which the *Edinburgh Review* in its best days might have been proud to possess.

Sure we are that not one of our readers will regret the length at which we have noticed this work.

The short and unpretending critique which I add from "Bell's Weekly Messenger" was written, I believe, either by or at the instance of Mr. Bellamy, a gentleman who acted as secretary to the National Club. His son addressed me as editor of "The Germ," in terms of great ardour, and through the son I on one occasion saw the father as well.

Art and Poetry. Nos. I., II., and III. London, Dickinson and Co.

The present numbers are the commencement of a very useful publication, conducted principally by artists, the design of which is to "express thoughts towards Nature." We see much to commend in its pages, which are also nicely illustrated in the mediæval style of art and in outline. The paper upon Shakespeare's tragedy of "Macbeth," in the third number, abounds with striking passages, and will be found to be well worthy of consideration.

I now proceed to "The Guardian." The notice came out on August 20, 1850, some months after "The Germ" had expired. I do not now know who wrote it, and (so far as memory serves me) I never did know. The writer truly said that Millais "contributes nothing" to the magazine. This however was not Millais's fault, for he made an

*etching for a prose story by my brother (named " An Autopsychology,"
or now " St. Agnes of Intercession "); and this etching, along with the
story, had been expected to appear in a No. 5 of " The Germ " which
never came out. The " very curious but very striking picture " by
Rossetti was the " Annunciation," now in the National British Gallery.*

> *Art and Poetry.* Being Thoughts towards Nature. Conducted principally
> by Artists. Dickinson and Co., and Aylott and Jones.

We are very sorry to find that, after a short life of four monthly numbers,
this magazine is not likely to be continued. Independently of the great
ability displayed by some of its contributors, we have been anxious to see the
rising school of young and clever artists find a voice, and tell us what they
are aiming at, and how they propose to reach their aim. This magazine was
to a great extent connected with the Pre-Raffaelle Brethren, whose paintings
have attracted this year a more than ordinary quantity of attention, and an
amount of praise and blame perhaps equally extravagant. As might have
been expected, the school has been identified with its cleverest manipulator,
Mr. Millais, and his merits or defects have been made the measure of the
admiration or contempt bestowed by the public upon those whom it chooses to
class with him. This is not matter of complaint, but it is a mistake. As far
as these papers enable us to judge, Mr. Millais is by no means the leading
mind among his fraternity ; and, judged by the principles of some clever and
beautiful papers upon art in the magazine before us, his pictures would be
described by them as wanting in some of the very highest artistic qualities,
although possessing many which entitle them to attention and respect. The
chief contributors to this magazine (to which Mr. Millais contributes nothing)
are other artists, as yet not greatly known, but with feeling and purpose about
them such as must make them remarkable in time. Some of the best papers
are by two brothers named Rossetti, one of whom, Mr. D. G. Rossetti, has a
very curious but very striking picture now exhibiting in the Portland
Gallery. Mr. Deverell, who has also a very clever picture in the same
gallery, contributes some beautiful poetry. It is perhaps chiefly in the
poetry that the abilities of these writers are displayed ; for, with somewhat
absurd and much that is affected, there is yet in the poetical pieces of these
four numbers a beauty and grace of language and sentiment, and not seldom
a vigour of conception, altogether above the common run. Want of purpose
may be easily charged against them as a fault, and with some justice, but it is
a very common defect of youthful poetry, which is sure to disappear with time
if there be anything real and manly in the poet. The best pieces are too long
to be extracted entire, and are not to be judged of fairly except as wholes.
There is a very fine poem called " Repining " of which this is particularly true.
[Next comes a quotation of Christina Rossetti's " Dream Land," and of a
portion of Dante Rossetti's " Blessed Damozel."] The last number contains
a remarkable dialogue on Art, written by a young man, John Orchard, who
has since died. It is well worth study. Kalon, Kosmon, Sophon, and
Christian, whose names, of course, represent the opinions they defend, discuss
a number of subjects connected with the arts. Each character is well sup-
ported, and the wisdom and candour of the whole piece is very striking,
especially when we consider the youth and inexperience of the writer. Art
lost a true and high-minded votary in Mr. Orchard. [A rather long extract
from the "Dialogue" follows here.]

It is a pity that the publication is to stop. English artists have hitherto
worked each one by himself, with too little of common purpose, too little of
mutual support, too little of distinct and steadily pursued intellectual object.
We do not believe that they are one whit more jealous than the followers of
other professions. But they are less forced to be together, and the little
jealousies which deform the natures of us all have in their case, for this
reason, freer scope, and tend more to isolation. Here, at last, we have a
school, ignorant it may be, conceited possibly, as yet with but vague and un-
realised objects, but working together with a common purpose, according to

certain admitted principles, and looking to one another for help and sympathy. This is new in England, and we are very anxious it should have a fair trial. Its aim, moreover, however imperfectly attained as yet, is high and pure. No one can walk along our streets and not see how debased and sensual our tastes have become. The saying of Burke (so unworthy of a great man), that vice loses half its evil by losing all its grossness, is practically acted upon, and voluptuous and seductive figures, recommended only by a soft effeminacy, swarm our shop-windows and defile our drawing-rooms. It is impossible to over-state the extent to which they minister to, and increase the foul sins of, a corrupt and luxurious age. A school of artists who attempt to bring back the popular taste to the severe draperies and pure forms of early art are at least deserving of encouragement. Success in their attempt would be a national blessing.

Shrivelling in the Spring of 1850, " The Germ " showed no further sign of sprouting for many years, though I suppose it may have been known to the promoters of " The Oxford and Cambridge Magazine," produced in 1856, and may have furnished some incitement towards that enterprise—again an unsuccessful one commercially. Gradually some people began to take a little interest in the knowledge that such a publication had existed, and to inquire after stray copies here and there. This may perhaps have commenced before 1870, or at any rate shortly afterwards, as in that year the "Poems" of Dante Rossetti were brought out, exciting a great amount of attention and admiration, and curiosity attached to anything that he might have published before. One heard of such prices as ten shillings for a set of " The Germ," then £2, £10, £30, etc., and in 1899 a copy handsomely bound by Cobden-Saunderson was sold in America for about £104. Will that high-water mark ever be exceeded ? For the sake of common-sense, let us hope not.

I will now go through the articles in " The Germ " one by one. Wherever any of them may seem to invite a few words of explanation I offer such to the reader ; and I give the names of authors, when not named in the magazine itself. Those articles which do not call for any particular comment receive none here.

On the wrapper of each number is to be found a sonnet, printed in a rather aggressively Gothic type, beginning, " When whoso merely hath a little thought." This sonnet is my performance ; it had been suggested that one or other of the proprietors of the magazine should write a sonnet to express the spirit in which the publication was undertaken. I wrote the one here in question, which met with general acceptance ; and I do not remember that any one else competed. This sonnet may not be a good one, but I do not see why it should be considered unintelligible. Mr. Bell Scott, in his " Autobiographical Notes," expressed the opinion that to master the production would almost need a Browning Society's united intellects. And he then gave

his interpretation, differing not essentially from my own. What I meant is this: A writer ought to think out his subject honestly and personally, not imitatively, and ought to express it with directness and precision; if he does this, we should respect his performance as truthful, even though it may not be important. This indicated, for writers, much the same principle which the P.R.B. professed for painters,—individual genuineness in the thought, reproductive genuineness in the presentment.

By Thomas Woolner: "My Beautiful Lady," and "Of My Lady in Death." These compositions were, I think, nearly the first attempts which Mr. Woolner made in verse; any earlier endeavours must have been few and slight. The author's long poem "My Beautiful Lady," published in 1863, started from these beginnings. Coventry Patmore, on hearing the poems in September 1849, was considerably impressed by them: "the only defect he found" (as notified in a letter from Dante Rossetti) "being that they were a trifle too much in earnest in the passionate parts, and too sculpturesque generally. He means by this that each stanza stands too much alone, and has its own ideas too much to itself."

By Ford Madox Brown: "The Love of Beauty: Sonnet."

By John L. Tupper: "The Subject in Art." Two papers, which do not complete the important thesis here undertaken. Mr. Tupper was, for an artist, a man of unusually scientific mind; yet he was not, I think, distinguished by that power of orderly and progressive exposition which befits an argumentation. These papers exhibit a good deal of thought, and state several truths which, even if partial truths, are not the less deserving of attention; but the dissertation does not produce a very clear impression, inasmuch as there is too great a readiness to plunge in medias res, *checked by too great a tendency to harking back, and re-stating some conclusion in modified terms and with insecure corollaries. Two points which Mr. Tupper chiefly insists upon are: (1) that the subject in a work of art affects the beholder in the same sort of way as the same subject, occurring as a fact or aspect of Nature, affects him; and thus whatever in Nature excites the mental and moral emotion of man is a right subject for fine art; and (2), that subjects of our own day should not be discarded in favour of those of a past time. These principles, along with others bearing in the same direction, underlie the propositions lately advanced by Count Leo Tolstoy in his most interesting and valuable (though I think one-sided) book entitled "What is Art?"—and the like may be said of the principles announced in the "Hand and Soul" of Dante Rossetti, and in the "Dialogue on Art" by John Orchard, through the mouths of two of the speakers, Christian*

and Sophon. I have once or twice seen these papers by Mr. Tupper commented upon to the effect that he wholly ignores the question of art-merit in a work of art, the question whether it is good or bad in form, colour, etc. But this is a mistake, for in fact he allows that this is a relevant consideration, but declines to bring it within his own lines of discussion. There is also a curious passage which has been remarked upon as next door to absurd; that where, in treating of various forms of still life as inferior subjects for art, he says that "the dead pheasant in a picture will always be as 'food,' while the same at the poulterer's will be but a dead pheasant." I do not perceive that this is really absurd. At the poulterer's (and Mr. Tupper has proceeded to say as much in his article) all the items are in fact food, and therefore the spectator attends to the differences between them; one being a pheasant, one a fowl, one a rabbit, etc. But, in a varied collection of pictures, most of the works represent some subject quite unconnected with food; and, if you see among them one, such as a dead pheasant, representing an article of food, that is the point which primarily occurs to your mind as distinguishing this particular picture from the others. The views expressed by Mr. Tupper in these two papers should be regarded as his own, and not by any means necessarily those upheld by the Præ-raphaelite Brotherhood. The members of this body must however have agreed with several of his utterances, and sympathized with others, apart from strict agreement.

By Patmore: "The Seasons." This choice little poem was volunteered to "The Germ" in September, after the author had read our prospectus, which impressed him favourably. He withheld his name, much to our disappointment, having resolved to do so in all instances where something of his might be published pending the issue of a new volume.

By Christina Rossetti: "Dream Land." Though my sister was only just nineteen when this remarkable lyric was printed, she had already made some slight appearance in published type (not to speak of the privately printed "Verses" of 1847), as two small poems of hers had been inserted in "The Athenæum" in October 1848. "Dream Land" was written in April 1849, before "The Germ" was thought of; and it may be as well to say that all my sister's contributions to this magazine were produced without any reference to publication in that or in any particular form.

By Dante G. Rossetti: "My Sister's Sleep." This purports to be No. 1 of "Songs of One Household." I do not much think that Dante Rossetti ever wrote any other poem which would have been proper to such a series. "My Sister's Sleep" was composed very soon after he

emerged from a merely juvenile stage of work. I believe that it dates before " The Blessed Damozel," and therefore before May 1847. *It is not founded upon any actual event affecting the Rossetti family, nor any family of our acquaintance. As I have said in my Memoir of my brother* (1895), *the poem was shown, perhaps early in* 1848, *by Major Calder Campbell to the editress of the " Belle Assemblée," who heartily admired it, but, for one reason or another, did not publish it. This composition is somewhat noticeable on more grounds than one ; not least as being in a metre which was not much in use until it became famous in Tennyson's " In Memoriam," published in* 1850, *and of course totally unknown to Rossetti when he wrote " My Sister's Sleep." In later years my brother viewed this early work with some distaste, and he only reluctantly reprinted it in his " Poems,"* 1870. *He then wholly omitted the four stanzas* 7, 8, 12, 13, *beginning : " Silence was speaking," " I said, full knowledge," " She stood a moment," " Almost unwittingly" ; and he made some other verbal alterations.* It will be observed that this poem was written long before the Præ- raphaelite movement began. None the less it shows in an eminent degree one of the influences which guided that movement : the intimate intertexture of a spiritual sense with a material form ; small actualities made vocal of lofty meanings.*

By Dante G. Rossetti : "Hand and Soul." This tale was, I think, written with an express view to its appearing in No. 1 *of our magazine, and Rossetti began making for it an etching, which, though not ready for No.* 1, *was intended to appear in some number later than the second. He drew it in March* 1850 ; *but, being disgusted with the performance, he scratched the plate over, and tore up the prints. The design showed Chiaro dell' Erma in the act of painting his embodied Soul. Though the form of this tale is that of romantic metaphor, its substance is a very serious manifesto of art-dogma. It amounts to saying, The only satisfactory works of art are those which exhibit the very soul of the artist. To work for fame or self-display is a failure, and to work for direct moral proselytizing is a failure ; but to paint that which your own perceptions and emotions urge you to paint promises to be a success for yourself, and hence a benefit to the mass of beholders. This was the core of the " Præraphaelite" creed ; with the adjunct (which hardly came within the scope of Rossetti's tale, and yet may be partly traced there) that the artist cannot attain to adequate self-expression*

* I may call attention to Stanza 16, " She stooped an instant." The word is "stooped" in "The Germ," and in the "Poems" of 1870. This is un- doubtedly correct ; but in my brother's re-issue of the "Poems," 1881, the word got mis-printed "stopped"; and I find the same mis-print in subsequent editions.

*save through a stern study and realization of natural appearances.
And it may be said that to this core of the Præraphaelite creed Rossetti
always adhered throughout his life, greatly different though his later
works are from his earlier ones in the externals of artistic style. Most
of "Hand and Soul" was written on December 21, 1849, day and night,
chiefly in some five hours beginning after midnight. Three currents of
thought may be traced in this story : (1) A certain amount of knowledge
regarding the beginnings of Italian art, mingled with some ignorance,
voluntary or involuntary, of what was possible to be done in the middle
of the thirteenth century ; (2) a highly ideal, yet individual, general
treatment of the narrative ; and (3) a curious aptitude at detailing
figments as if they were facts. All about Chiaro dell' Erma himself,
Dresden and Dr. Aemmster, D'Agincourt, pictures at the Pitti Gallery,
the author's visit to Florence in 1847, etc., are pure inventions or "mys-
tifications"; but so realistically put that they have in various instances
been relied upon and cited as truths. I gave some details as to this in
my Memoir of Dante Rossetti. The style of writing in " Hand and
Soul" is of a very exceptional kind. My brother had at that time a
great affection for the " Stories after Nature," written by Charles Wells
(author of "Joseph and his Brethren"), and these he kept in view to some
extent as a model, though the direct resemblance is faint indeed. In the
conversation of foreign art-students, forming the epilogue, he may have
been not wholly oblivious of the scene in Browning's " Pippa Passes"
(a prime favourite of his), where some "foreign students of painting
and sculpture" are preparing a disagreeable surprise for the French
sculptor Jules. There is, however, no sort of imitation ; and Rossetti's
dialogue is the more markedly natural of the two. In re-reading
" Hand and Soul," I am struck by two passages which came true of
Rossetti himself in after-life : (1) "Sometimes after nightfall he
would walk abroad in the most solitary places he could find—hardly
feeling the ground under him because of the thoughts of the day which
held him in fever." (2) "Often he would remain at work through
the whole of a day, not resting once so long as the light lasted." When
Rossetti, in 1869, was collecting his poems, and getting them privately
printed with a view to after-publication, he thought of including
" Hand and Soul" in the same volume, but did not eventually do so.
The privately-printed copy forms a small pamphlet, which has some-
times been sold at high prices—I believe £10 and upwards. At this
time I pointed out to him that the church in Pisa which he named San
Rocco could not possibly have borne that name—San Rocco being a
historical character who lived at a later date : the Church was then
re-named " San Petronio," and this I believe is the only change of the*

least importance introduced into the reprint. In December 1870 *the tale was published in " The Fortnightly Review." The Rev. Alfred Gurney (deceased not long ago) was a great admirer of Dante Rossetti's works. He published in* 1883 *a brochure named " A Dream of Fair Women, a Study of some Pictures by Dante Gabriel Rossetti" ; he also published an essay on " Hand and Soul," giving a more directly religious interpretation to the story than its author had at all intended. It is entitled " A Painter's Day-dream."*

By W. M. Rossetti : " Review of Clough's Bothie of Toperna-fuosich." The only remark which I need make on this somewhat ponderous article is that I, as Editor of " The Germ," was more or less expected to do the sort of work for which other " proprietors " had little inclination—such especially as the regular reviewing of new poems.

By W. M. Rossetti : " Her First Season : Sonnet." As I have said elsewhere, my brother and I were at one time greatly addicted to writing sonnets together to bouts-rimés : *the date may have been chiefly* 1848, *and the practice had, I think, quite ceased for some little while before " The Germ" commenced in* 1850. *This sonnet was one of my* bouts-rimés *performances. I ought to have been more chary than I was of introducing into our seriously-intended magazine such hap-hazard things as* bouts-rimés *poems : one reason for so doing was that we were often at a loss for something to fill a spare page.*

By John L. Tupper : " A Sketch from Nature." The locality indicated in these very spirited descriptive lines is given as " Sydenham Wood." When I was compiling the posthumous volume of John Tupper's " Poems" which came out in 1897, *I should, so far as merit is concerned, have wished to include this little piece : it was omitted solely on the ground of its being already published.*

By Christina Rossetti : " An End." Written in March 1849.

By Collinson : " The Child Jesus, a Record Typical of the Five Sorrowful Mysteries." Collinson, as I have already said, was hardly a writing man, and I question whether he had produced a line of verse prior to undertaking this by no means trivial task. The poem, like the etching which he did for it, is deficient in native strength, nor is there much invention in the symbolical incidents which make it up : but its general level, and several of its lines and passages, always appeared to me, and still appear, highly laudable, and far better than could have been reckoned for. Here and there a telling line was supplied by Dante Rossetti. Millais, when shortly afterwards in Oxford, found that the poem had made some sensation there. It is singular that Collinson should, throughout his composition, speak of Nazareth as being on the sea-shore—which is the reverse of the fact. The Præ-

raphaelites, with all their love of exact truth to nature, were a little arbitrary in applying the principle; and Collinson seems to have regarded it as quite superfluous to look into a map, and see whether Nazareth was near the sea or not. Or possibly he trusted to Dante Rossetti's poem "Ave," in which likewise Nazareth is a marine town. My brother advisedly stuck to this in 1869, when I pointed out the error to him: he replied, "I fear the sea must remain at Nazareth: you know an old painter would have made no bones if he wanted it for his background." I cannot say whether Collinson, if put to it, would have pleaded the like arbitrary and almost burlesque excuse: at any rate he made the blunder, and in a much more detailed shape than in Rossetti's lyric. "The Child Jesus" is, I think, the only poem of any importance that he ever wrote.

By Christina Rossetti: "A Pause of Thought." On the wrapper of "The Germ" the writer's name is given as "Ellen Alleyn": this was my brother's concoction, as Christina did not care to figure under her own name. "A Pause of Thought" was written in February 1848, when she was but little turned of seventeen. Taken as a personal utterance (which I presume it to be, though I never inquired as to that, and though it was at first named "Lines in Memory of Schiller's Der Pilgrim"), it is remarkable; for it seems to show that, even at that early age, she aspired ardently after poetic fame, with a keen sense of "hope deferred."

By F. G. Stephens (called "John Seward" on the wrapper): "The Purpose and Tendency of Early Italian Art." This article speaks for itself as being a direct outcome of the Prœraphaelite movement: its aim is to enforce personal independent endeavour, based upon close study of nature, and to illustrate the like qualities shown in the earlier school of art. It is more hortatory than argumentative, and is in fact too short to develop its thesis—it indicates some main points for reflection.

By W. Bell Scott: "Morning Sleep." This poem delighted us extremely when Mr. Scott sent it in reply to a request for contributions. I still think it a noticeably fine thing, and one of his most equable pieces of execution. It was republished in his volume of "Poems," 1875—with some verbal changes, and shortened, I think damaged.

By Patmore: "Stars and Moon."

By Ford Madox Brown: "On the Mechanism of a Historical Picture": Part 1, the Design. It is by this time a well-recognized fact that Brown was one of the men in England, or indeed in Europe, most capable of painting a historical picture, and it is matter of regret that "The Germ" came to an end before he had an opportunity of continuing

and completing this serviceable compendium of precepts. He had studied art in continental schools; but I do not think he imported into his article much of what he had been taught,—rather what he had thought out for himself, and had begun putting into practice.

By W. M. Rossetti: " Fancies at Leisure." The first three of these were written to bouts-rimés. *As to No.* 1, " *Noon Rest,*" *I have a tolerably clear recollection that the rhymes were prescribed to me by Millais, on one of the days in 1849 when I was sitting to him for the head of Lorenzo in his first Prœraphaelite picture from Keats's " Isabella."* No. 4, " *Sheer Waste,*" *was not a* bouts-rimés *performance. It was chiefly the outcome of an early afternoon spent lazily in Regent's Park.*

By Walter H. Deverell: " The Light Beyond." These sonnets are not of very finished execution, but they have a dignified sustained tone and some good lines. Had Deverell lived a little longer, he might probably have proved that he had some genuine vocation as a poet, no less than a decided pictorial faculty. He died young in February 1854.

By Dante G. Rossetti: " The Blessed Damozel." As to this celebrated poem much might be said; but I shall not say it here, partly because I wrote an Introduction to a reprint (published by Messrs. Duckworth and Co. in 1898) of the " Germ" version of the poem, which is the earlist version extant, and in that Introduction I gave a number of particulars forestalling what I could now set down. I will however take this opportunity of correcting a blunder into which I fell in the Introduction above mentioned. I called attention to " calm" and " warm," which make a " cockney rhyme" in stanza 9 of this " Germ" version; and I said that, in the later version printed in " The Oxford and Cambridge Magazine " in 1856, a change in the line was made, substituting " swam" for " calm," and that the cockneyism, though shuffled, was not thus corrected. In " The Saturday Review," June 25, 1898, the publication of Messrs. Duckworth was criticized; and the writer very properly pointed out that I had made a crass mistake. " Mr. Rossetti," he said, " must be a very hasty reader of texts. What is printed [in ' The Oxford and Cambridge Magazine '] is ' swarm,' not ' swam,' and the rhyme with ' warm ' is perfect, stultifying the editor's criticism completely." Probably the critic considered my error as unaccountable as it was serious; and yet it could be fully accounted for, though not fully excused. I had not been " a very hasty reader of texts " in the sense indicated by " The Saturday Review." The fact is that, not possessing a copy of " The Oxford and Cambridge Magazine," I had referred to the book brought out by Mr. William Sharp in 1882,

" *Dante Gabriel Rossetti: A Record and a Study,*" *in which are given (with every appearance of care and completeness) the passages of "* **The Blessed Damozel**" *as they appeared in "* **The Germ,**" *with the alterations printed in "* **The Oxford and Cambridge Magazine.**" *From the latter, the line in question is given by Mr. Sharp as "* Waste sea of worlds *that swam"; and I, supposing him to be correct (though I allow that memory ought to have taught me the contrary), reproduced that line to the same effect. "* Always verify your references " *is a precept to which editors and commentators cannot too carefully conform. Many thanks to the writer in "* The Saturday Review " *for showing that, while I, and also Mr. Sharp, had made a mistake, my brother had made none.*

By W. M. Rossetti: " Review of the Strayed Reveller and other Poems, by A." *As we all now know, "* A." was Matthew Arnold, and *this was his first published volume; but I, at the time of writing the review, knew nothing of the identity of "* A.," *and even had I been told that he was Matthew Arnold, that would have carried the matter hardly at all further. I remember that, after I had written the whole or most of this admiring review, I found that the volume had been abused in "* Blackwood's Magazine "; *a fact of sweet savour to myself and other P.R.B.'s, as we entertained a hearty detestation of that magazine, with its blustering "* Christopher North," *and its traditions of truculency against Keats, Shelley, Leigh Hunt, Tennyson, Ruskin, and some others. I read "* A.'s" *volume with great attention, and piqued myself somewhat upon having introduced into my review some reference (detailed or cursory) to every poem in it. Possibly (but I hardly think so) the critique was afterwards shortened, so as to bereave it of this merit.*

By Madox Brown (the etching) and by W. M. Rossetti (the verses): " Cordelia." *For the belated No. 3 of "* The Germ" *we were much at a loss for an illustration. Mr. Brown offered to accommodate us by etching this design, one of a series from "* King Lear " *which he had drawn in Paris in 1844. That series, though not very sightly to the eye, is of extraordinary value for dramatic insight and energy. We gladly accepted, and he produced this etching with very little self-satis-faction, so far as the technique of execution is concerned. Dante Rossetti was to have furnished some verses for the etching; but for this he did not find time, so I was put in as a stopgap, and I am not sure that any reader of "* The Germ" *has ever thanked me for my obedience to the call of duty.*

By Patmore: " Essay on Macbeth." *In this interesting and well-considered paper Mr. Patmore assumes that he was the first person to put into writing the opinion that Macbeth, before meeting with the witches, had already definitely conceived and imparted the idea of*

obtaining the crown of Scotland by wrongful means. I have always felt some uncertainty whether Mr. Patmore was really the first ; if he was, it certainly seems strange that the train of reasoning which he furnishes in this essay—forcible, even if we do not regard it as un-answerable—should not have presented itself to the mind and pen of some earlier writer. The Essay appears to have been left incomplete in at least one respect. In speaking of " the fifth scene," the author refers to " postponement of comment " upon Macbeth's letter to his wife, and he " leaves it for the present." But the comment never comes.

By Christina Rossetti : " Repining." This rather long poem, written in December 1847 on a still broader scale, was never republished by the authoress, although all her other poems in " The Germ " were so. She did not think that its deservings were such as to call for republication. I apprehend that herein she exercised a wise discretion : none the less, when I was compiling the volume of her " New Poems," issued in 1896, I included " Repining "—for I think that some of the considerations which apply to the works of an author while living do not remain in anything like full force after death.

By Dante G. Rossetti : " The Carillon, Antwerp and Bruges." These verses, and some others further on in " The Germ," were written during the brief trip, in Paris and Belgium, which my brother made along with Holman-Hunt in the autumn of 1849. He did not re-publish " The Carillon"; but he left in MS. an abridged form of it, with the title " Antwerp and Bruges," and this I included in his "Collected Works," 1886. The only important change was the omission of stanzas 1 and 4.

By Dante G. Rossetti : " From the Cliffs, Noon." Altering some phrases in this lyric, and adding two stanzas, Rossetti republished it under the name of " The Sea-limits."

By W. M. Rossetti : " Fancies at Leisure." The first four were written to bouts-rimés : not the fifth, " The Fire Smouldering," which is, I think, as old as 1848, or even 1847.

By John L. Tupper : " Papers of the MS. Society ; No. 1, An Incident in the Siege of Troy." This grotesque outburst, though sprightly and clever, was not well-suited to the pages of " The Germ." My attention had been called to it at an earlier date, when my editorial power was unmodified, but I then staved it off, and indeed John Tupper himself did not deem it appropriate. It will be observed that "MS. Society" is said not to mean "Manuscript Society." I forget what it did mean—possibly " Medical Student Society." The whole thing is replete with semi-private sous-entendus, and banter at Free Trade, medical and anatomical matters, etc. The like general remarks apply to

No. 4, " Smoke," by the same writer. It is a rollicking semi-intelligible chaunt, a forcible thing in its way, proper in the first instance (I believe) to a sort of club of medical students, Royal Academy students, and others —highly-seasoned smokers most of them—in which John Tupper exercised a quasi-primacy, and was called (owing to his thinness, much over-stated in the poem) " The Spectro-cadaveral King." No. 5, " Rain," is again by John Tupper, and is the only item in " The Papers of the MS. Society" which seems, in tone and method, to be reasonably appropriate for " The Germ."

By Alexander Tupper : No. 2, " Swift's Dunces."

By George I. F. Tupper : No. 3, " Mental Scales." This also, in the scrappy condition which it here presents, reads rather as a joke than as a serious proposition : I believe it was meant for the latter.

By John L. Tupper : " Viola and Olivia." The verses are not of much significance. The etching by Deverell, however defective in technique, claims more attention, as the Viola was drawn from Miss Elizabeth Eleanor Siddal, whom Deverell had observed in a bonnet-shop some few months before the etching was done, and who in 1860 became the wife of Dante Rossetti. This face does not give much idea of hers, and yet it is not unlike her in a way. The face of Olivia bears some resemblance to Christina Rossetti : I think however that it was drawn, not from her, but from a sister of the artist.

By John Orchard : " A Dialogue on Art." The brief remarks prefacing this dialogue were written by Dante Rossetti. The diction of the dialogue itself was also, at Orchard's instance, revised to some minor extent by my brother, and I dare say by me. Orchard was a painter of whom perhaps no memory remains at the present day : he exhibited some few pictures, among which I can dimly remember one of " The Flight of Archbishop Becket from England." His age may, I suppose, have been twenty-seven or twenty-eight years at the date of his death. In our circle he was unknown; but, conceiving a deep admiration for Rossetti's first exhibited picture (1849), " The Girlhood of Mary Virgin," he wrote to him, enclosing a sonnet upon the picture—a very bad sonnet in all executive respects, and far from giving promise of the spirited, if unequal, poetic treatment which we find in the lines in " The Germ," " On a Whit-Sunday Morn in the Month of May." This led to a call from Orchard to Rossetti. I think there was only one call, and I, as well as my brother, saw him on that occasion. Afterwards, he sent this dialogue for " The Germ." The dialogue has always, and I think justly, been regarded as a remarkable performance. The form of expression is not impeccable, but there is a large amount of eloquence, coming in aid of definite and expansive thought. From

*what is here said it will be understood that Orchard was quite uncon-
nected with the P.R.B. He expressed opinions of his own which may
indeed have assimilated in some points to theirs, but he was not in any
degree the mouthpiece of their organization, nor prompted by any
member of the Brotherhood. In the dialogue, the speaker whose opinions
appear manifestly to represent those of Orchard himself is Christian,
who is mostly backed up by Sophon. Christian forces ideas of purism
or puritanism to an extreme, beyond anything which I can recollect as
characterizing any of the P.R.B. His upholding of the painters who
preceded Raphael as the best men for nurturing new and noble develop-
ments of art in our own day was more in their line. In my brother's
prefatory note a question is raised of publishing any other writings
which Orchard might have left behind. None such, however, were
found. Dr. W. C. Bennett (afterwards known as the author of
"Songs for Sailors," etc.), who had been intimate with Orchard, aided
my brother in his researches.*

*By F. G. Stephens (called "Laura Savage" on the wrapper):
"Modern Giants."*

*By Dante G. Rossetti: "Pax Vobis." Republished by the author,
with some alterations, under the title of "World's Worth."*

*By Dante G. Rossetti: "Sonnets for Pictures." No. 1, "A Virgin
and Child, by Hans Memmeling," was not reprinted by Rossetti, but is
included (with a few verbal alterations made by him in MS.) in his
"Collected Works." No. 2, "A Marriage of St. Katharine, by the
same." A similar observation. No. 3, "A Dance of Nymphs, by
Andrea Mantegna," was republished by Rossetti, with some verbal
alterations. No. 4, "A Venetian Pastoral, by Giorgione"—the like.
The alterations here are of considerable moment. Rossetti, in a pub-
lished letter of October 8, 1849, referred to this Giorgione picture as
follows: "A Pastoral—at least, a kind of Pastoral—by Giorgione,
which is so intensely fine that I condescended to sit down before it and
write a sonnet. You must have heard me rave about the engraving
before, and, I fancy, have seen it yourself. There is a woman, naked,
at one side, who is dipping a glass vessel into a well, and in the centre
two men and another naked woman, who seem to have paused for a
moment in playing on the musical instruments which they hold." Nos.
5 and 6, "Angelica Rescued from the Sea-Monster, by Ingres," were
also reprinted by the author, with scarcely any alteration. Patmore, on
reading these two sonnets, was much struck with their truthfulness of
quality, as being descriptive of paintings. As to some of the other
sonnets, Mr. W. M. Hardinge wrote in "Temple Bar," several years
ago, an article containing various pertinent and acute remarks.*

By *W. M. Rossetti*: "*Review of Browning's Christmas Eve and Easter Day.*" The only observation I need make upon this review—which was merely intended as introductory to a fuller estimate of the poem, to appear in an ensuing number of "*The Germ*"—is that it exemplifies that profound cultus of Robert Browning which, commenced by Dante Rossetti, had permeated the whole of the Præraphaelite Brotherhood, and formed, not less than some other ideas, a bond of union among them. It will be readily understood that, in Mr. Stephens's article, "*Modern Giants*," the person spoken of as "the greatest perhaps of modern poets" is Browning.

By *W. M. Rossetti*: "*The Evil under the Sun: Sonnet.*" This sonnet was composed in August 1849, when the great cause of the Hungarian insurrection against Austrian tyranny was, like revolutionary movements elsewhere, precipitating towards its fall. My original title for the sonnet was, "For the General Oppression of the Better by the Worse Cause, Autumn 1849." When the verses had to be published in "The Germ," a magazine which did not aim at taking any side in politics, it was thought that this title was inappropriate, and the other was substituted. At a much later date the sonnet was reprinted with yet another and more significant title, "Democracy Downtrodden."

Having now disposed of "The Germ" in general, and singly of most of the articles in it, I have very little to add. The project of reprinting the magazine was conceived by its present publisher, Mr. Stock, many years ago—perhaps about 1883. At that time several contributors assented, but others declined, and considerations of copyright made it impracticable to proceed with the project. It is only now that lapse of time has disposed of the copyright question, and Mr. Stock is free to act as he likes. I was from the first one of those (the majority) who assented to the republication, acting herein on behalf of my brother, then lately deceased, as well as of myself. I am quite aware that some of the articles in "The Germ" are far from good, and some others, though good in essentials, are to a certain extent juvenile; but juvenility is anything but uninteresting when it is that of such men as Coventry Patmore and Dante Rossetti. "The Germ" contains nothing of which, in spirit and in purport, the writers need be ashamed. If people like to read it without paying fancy prices for the original edition, they were and are, so far as I am concerned, welcome to do so. Before Mr. Stock's long-standing scheme could be legally carried into effect, an American publisher, Mr. Mosher, towards the close of 1898, brought out a handsome reprint of "The Germ" (*not in any wise a*

*facsimile), and a few of the copies were placed on sale in London.** *Mr. Mosher gave as an introduction to his volume an article by the late J. Ashcroft Noble which originally appeared in an English magazine in May 1882. This article is entitled " A Pre-Raphaelite Magazine." It is written in a spirit of generous sympathy, and is mostly correct in its facts. I may here mention another article on " The Germ," also published, towards 1868, in some magazine. It is by John Burnell Payne (originally a Clergyman of the Church of England), who died young in 1869. He wrote a triplet of articles, named " Prœraphaelite Poetry and Painting," of which Part I. is on " The Germ." He expresses himself sympathetically enough ; but his main drift is to show that the Prœraphaelite movement, after passing through some immature stages, developed into a quasi-Renaissance result. A perusal of his paper will show that Mr. Payne was one of the persons who supposed Chiaro dell' Erma, the hero of " Hand and Soul," to have been a real painter, author of an extant picture.*

Mr. Stock's reprint is of the facsimile order, and even faults of print are reproduced. I am not called upon to say with any precision what these are. On page 45 I observe " ear," which should be " car "; on page 62, Angilico, and Rossini (for Rosini). On page 155 the words, " I believe that the thought-wrapped philosopher," ought to begin a new sentence. On page 159 " Phyrnes " ought of course to be " Phrynes." The punctuation could frequently be improved.

I will conclude by appending a little list (it makes no pretension to completeness) of writings bearing upon the Prœraphaelite Brotherhood and its members. Writings of that kind are by this date rather numerous; but some readers of the present pages may not well know where to find them, and might none the less be inclined to read up the subject a little. I give these works in the order (as far as I know it) of their dates, without any attempt to indicate the degree of their importance. That is a question on which I naturally entertain opinions of my own, but I shall not intrude them upon the reader.

Ruskin : Pre-Raphaelitism, 1854, and other later writings.
F. G. Stephens : William Holman-Hunt and his Works, 1860.
William Sharp : Dante Gabriel Rossetti, 1882.
Hall Caine : Recollections of Dante Gabriel Rossetti, 1882.
Walter Hamilton : The Æsthetic Movement in England, 1882.
T. Watts-Dunton : The Truth about Rossetti, 1883, and other writings.

* I have seen in the " Irish Figaro," May 6, 1899, a very pleasant notice, signed " J. Reid," of this reprint.

W. Holman-Hunt : The Pre-Raphaelite Brotherhood, 1884 (?).

Ernest Chesneau : La Peinture Anglaise, 1884 (?).

Joseph Knight : Life of Dante Gabriel Rossetti, 1887.

W. M. Rossetti : Dante Gabriel Rossetti as Designer and Writer, 1889.

Harry Quilter : Preferences in Art, 1892.

W. Bell Scott : Autobiographical Notes, 1892.

Esther Wood : Dante Rossetti and the Pre-Raphaelite Movement, 1894.

F. G. Stephens : Dante Gabriel Rossetti, 1894.

G. Somes Layard : Tennyson and his Pre-Raphaelite Illustrators, 1894.

Robert de la Sizeranne : La Peinture Anglaise Contemporaine, 1895.

Dante G. Rossetti : Family Letters, with Memoir by W. M. Rossetti, 1895.

Richard Muther : The History of Modern Painting, vols. ii. and iii., 1896.

Ford H. M. Hueffer : Ford Madox Brown, 1896.

Dante G. Rossetti : Letters to William Allingham, edited by Dr. Birkbeck Hill, 1897.

M. H. Spielmann : Millais and his Works, 1898.

Antonio Agresti : Poesie di Dante Gabriele Rossetti. Traduzione, con uno Studio su la Pittura Inglese, etc., 1899.

Fräulein Wilmersdoerffer : Dante Gabriel Rossetti und sein Einflusz, 1899.

Edited by W. M. Rossetti : Ruskin, Rossetti, Præraphaelitism, 1899.

J. Guille Millais : Life and Letters of Sir John Everett Millais, 1899.

Percy H. Bate : The English Præraphaelite Painters, 1899.

H. C. Marillier : Dante Gabriel Rossetti, 1899.

Edited by W. M. Rossetti : Præraphaelite Diaries and Letters, 1899.

There are also books on Burne-Jones and William Morris with which I am not accurately acquainted. It seems strange that no memoir of Thomas Woolner has yet been published ; a fine sculptor and remarkable man known to and appreciated by all sorts of people, and certain to have figured extensively in correspondence. He died in October 1892. Mr. Holman-Hunt is understood to have been engaged for a long while past upon a book on Præraphaelitism

which would cast into the shade most of the earlier literature on the subject.

W. M. ROSSETTI.

LONDON,
 July 1899.

N.B.—When the third number of the magazine was about to appear, with a change of title from "The Germ" to "Art and Poetry," two fly-sheets were drawn up, more, I think, by Messrs. Tupper the printing-firm than by myself. They contain some "Opinions of the Press," already referred to in this Introduction, and an explanation as to the change of title. The fly-sheets appear in facsimile as follows:

No. 1. *(Price One Shilling.)* JANUARY, 1850.

With an Etching by W. HOLMAN HUNT.

The Germ:

Thoughts towards Nature

In Poetry, Literature, and Art.

When whoso merely hath a little thought
　Will plainly think the thought which is in him,—
　Not imaging another's bright or dim,
Not mangling with new words what others taught;
When whoso speaks, from having either sought
　Or only found,—will speak, not just to skim
　A shallow surface with words made and trim,
But in that very speech the matter brought:
Be not too keen to cry—"So this is all!—
　A thing I might myself have thought as well,
　But would not say it, for it was not worth!"
　Ask: "Is this truth?"　For is it still to tell
That, be the theme a point or the whole earth,
Truth is a circle, perfect, great or small?

London:

AYLOTT & JONES, 8, PATERNOSTER ROW.

G. F. TUPPER, Printer, Clement's Lane, Lombard Street.

CONTENTS.

*** It is requested that those who may have by them any un-published Poems, Essays, or other articles appearing to coincide with the views in which this Periodical is established, and who may feel desirous of contributing such papers—will forward them, for the approval of the Editor, to the Office of publication. It may be relied upon that the most sincere attention will be paid to the examination of all manuscripts, whether they be eventually accepted or declined.

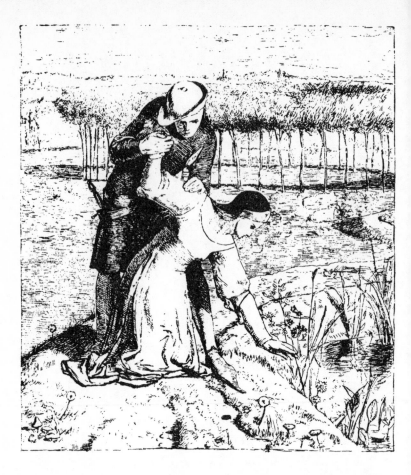

My Beautiful Lady.

I LOVE my lady ; she is very fair ;
Her brow is white, and bound by simple hair ;
 Her spirit sits aloof, and high,
 Altho' it looks thro' her soft eye
 Sweetly and tenderly.

As a young forest, when the wind drives thro',
My life is stirred when she breaks on my view.
 Altho' her beauty has such power,
 Her soul is like the simple flower
 Trembling beneath a shower.

As bliss of saints, when dreaming of large wings,
The bloom around her fancied presence flings,
 I feast and wile her absence, by
 Pressing her choice hand passionately—
 Imagining her sigh.

My lady's voice, altho' so very mild,
Maketh me feel as strong wine would a child ;
 My lady's touch, however slight,
 Moves all my senses with its might,
 Like to a sudden fright.

A hawk poised high in air, whose nerved wing-tips
Tremble with might suppressed, before he dips,—
 In vigilance, not more intense
 Than I ; when her word's gentle sense
 Makes full-eyed my suspense.

Her mention of a thing—august or poor,
Makes it seem nobler than it was before :
 As where the sun strikes, life will gush,
 And what is pale receive a flush,
 Rich hues—a richer blush.

My lady's name, if I hear strangers use,—
Not meaning her—seems like a lax misuse.
 I love none but my lady's name ;
 Rose, Maud, or Grace, are all the same,
 So blank, so very tame.

My lady walks as I have seen a swan
Swim thro' the water just where the sun shone.
 There ends of willow branches ride,
 Quivering with the current's glide,
 By the deep river-side.

Whene'er she moves there are fresh beauties stirred ;
As the sunned bosom of a humming-bird
 At each pant shows some fiery hue,
 Burns gold, intensest green or blue :
 The same, yet ever new.

What time she walketh under flowering May,
I am quite sure the scented blossoms say,
 " O lady with the sunlit hair !
 " Stay, and drink our odorous air—
 " The incense that we bear :

" Your beauty, lady, we would ever shade ;
" Being near you, our sweetness might not fade."
 If trees could be broken-hearted,
 I am sure that the green sap smarted,
 When my lady parted.

This is why I thought weeds were beautiful ;—
Because one day I saw my lady pull
 Some weeds up near a little brook,
 Which home most carefully she took,
 Then shut them in a book.

A deer when startled by the stealthy ounce,—
A bird escaping from the falcon's trounce,
 Feels his heart swell as mine, when she
 Stands statelier, expecting me,
 Than tall white lilies be.

The first white flutter of her robe to trace,
Where binds and perfumed jasmine interlace,
 Expands my gaze triumphantly :
 Even such his gaze, who sees on high
 His flag, for victory.

We wander forth unconsciously, because
The azure beauty of the evening draws :
 When sober hues pervade the ground,
 And life in one vast hush seems drowned,
 Air stirs so little sound.

We thread a copse where frequent bramble spray
With loose obtrusion from the side roots stray,
 (Forcing sweet pauses on our walk) :
 I'll lift one with my foot, and talk
 About its leaves and stalk.

Or may be that the prickles of some stem
Will hold a prisoner her long garment's hem ;
 To disentangle it I kneel,
 Oft wounding more than I can heal ;
 It makes her laugh, my zeal.

Then on before a thin-legged robin hops,
Or leaping on a twig, he pertly stops,
 Speaking a few clear notes, till nigh
 We draw, when quickly he will fly
 Into a bush close by.

A flock of goldfinches may stop their flight,
And wheeling round a birchen tree alight
 Deep in its glittering leaves, until
 They see us, when their swift rise will
 Startle a sudden thrill.

I recollect my lady in a wood,
Keeping her breath and peering—(firm she stood
 Her slim shape balanced on tiptoe—)
 Into a nest which lay below,
 Leaves shadowing her brow.

I recollect my lady asking me,
What that sharp tapping in the wood might be ?
 I told her blackbirds made it, which,
 For slimy morsels they count rich,
 Cracked the snail's curling niche :

She made no answer. When we reached the stone
Where the shell fragments on the grass were strewn,
 Close to the margin of a rill ;
 " The air," she said, "seems damp and chill,
 " We'll go home if you will."

" Make not my pathway dull so soon," I cried,
" See how those vast cloudpiles in sun-glow dyed,
 " Roll out their splendour : while the breeze
 " Lifts gold from leaf to leaf, as these
 " Ash saplings move at ease."

Piercing the silence in our ears, a bird
Threw some notes up just then, and quickly stirred
 The covert birds that startled, sent
 Their music thro' the air ; leaves lent
 Their rustling and blent,

Until the whole of the blue warmth was filled
So much with sun and sound, that the air thrilled.
 She gleamed, wrapt in the dying day's
 Glory : altho' she spoke no praise,
 I saw much in her gaze.

Then, flushed with resolution, I told all ;—
The mighty love I bore her,—how would pall
 My very breath of life, if she
 For ever breathed not hers with me ;—
 Could I a cherub be,

How, idly hoping to enrich her grace,
I would snatch jewels from the orbs of space ;—
 Then back thro' the vague distance beat,
 Glowing with joy her smile to meet,
 And heap them round her feet.

Her waist shook to my arm. She bowed her head,
Silent, with hands clasped and arms straightened :
 (Just then we both heard a church bell)
 O God ! It is not right to tell :
 But I remember well

Each breast swelled with its pleasure, and her whole
Bosom grew heavy with love ; the swift roll
 Of new sensations dimmed her eyes,
 Half closing them in ecstacies,
 Turned full against the skies.

The rest is gone ; it seemed a whirling round—
No pressure of my feet upon the ground :
 But even when parted from her, bright
 Showed all ; yea, to my throbbing sight
 The dark was starred with light.

Of my Lady.

In Death.

ALL seems a painted show. I look
 Up thro' the bloom that's shed
 By leaves above my head,
And feel the earnest life forsook
 All being, when she died :—
 My heart halts, hot and dried
As the parched course where once a brook
 Thro' fresh growth used to flow,—
 Because her past is now
No more than stories in a printed book.

The grass has grown above that breast,
 Now cold and sadly still,
 My happy face felt thrill :—
Her mouth's mere tones so much expressed !
 Those lips are now close set,—
 Lips which my own have met ;
Her eyelids by the earth are pressed ;
 Damp earth weighs on her eyes ;
 Damp earth shuts out the skies.
My lady rests her heavy, heavy rest.

To see her slim perfection sweep,
 Trembling impatiently,
 With eager gaze at me !
Her feet spared little things that creep :—
 " We've no more right," she'd say,
 " In this the earth than they."
Some remember it but to weep.
 Her hand's slight weight was such,
 Care lightened with its touch ;
My lady sleeps her heavy, heavy sleep.

My day-dreams hovered round her brow ;
 Now o'er its perfect forms
 Go softly real worms.
Stern death, it was a cruel blow,
 To cut that sweet girl's life
 Sharply, as with a knife.
Cursed life that lets me live and grow,
 Just as a poisonous root,
 From which rank blossoms shoot ;
My lady's laid so very, very low.

Dread power, grief cries aloud, " unjust,"—
 To let her young life play
 Its easy, natural way ;
Then, with an unexpected thrust,
 Strike out the life you lent,
 Just when her feelings blent
With those around whom she saw trust
 Her willing power to bless,
 For their whole happiness ;
My lady moulders into common dust.

Small birds twitter and peck the weeds
 That wave above her head,
 Shading her lowly bed :
Their brisk wings burst light globes of seeds,
 Scattering the downy pride
 Of dandelions, wide :
Speargrass stoops with watery beads :
 The weight from its fine tips
 Occasionally drips :
The bee drops in the mallow-bloom, and feeds.

About her window, at the dawn,
 From the vine's crooked boughs
 Birds chirupped an arouse :
Flies, buzzing, strengthened with the morn ;—
 She'll not hear them again
 At random strike the pane :
No more upon the close-cut lawn,
 Her garment's sun-white hem
 Bend the prim daisy's stem,
In walking forth to view what flowers are born.

No more she'll watch the dark-green rings
 Stained quaintly on the lea,
 To image fairy glee ;
While thro' dry grass a faint breeze sings,
 And swarms of insects revel
 Along the sultry level :—
No more will watch their brilliant wings,
 Now lightly dip, now soar,
 Then sink, and rise once more.
My lady's death makes dear these trivial things.

Within a huge tree's steady shade,
 When resting from our walk,
 How pleasant was her talk !
Elegant deer leaped o'er the glade,
 Or stood with wide bright eyes,
 Staring a short surprise :
Outside the shadow cows were laid,
 Chewing with drowsy eye
 Their cuds complacently :
Dim for sunshine drew near a milking-maid.

Rooks cawed and labored thro' the heat ;
 Each wing-flap seemed to make
 Their weary bodies ache :
The swallows, tho' so very fleet,
 Made breathless pauses there
 At something in the air :—
All disappeared : our pulses beat
 Distincter throbs : then each
 Turned and kissed, without speech,—
She trembling, from her mouth down to her feet.

My head sank on her bosom's heave,
 So close to the soft skin
 I heard the life within.
My forehead felt her coolly breathe,
 As with her breath it rose :
 To perfect my repose
Her two arms clasped my neck. The eve
 Spread silently around,
 A hush along the ground,
And all sound with the sunlight seemed to leave.

By my still gaze she must have known
 The mighty bliss that filled
 My whole soul, for she thrilled,
Drooping her face, flushed, on my own ;
 I felt that it was such
 By its light warmth of touch.
My lady was with me alone :
 That vague sensation brought
 More real joy than thought.
I am without her now, truly alone.

We had no heed of time : the cause
 Was that our minds were quite
 Absorbed in our delight,
Silently blessed. Such stillness awes,
 And stops with doubt, the breath,
 Like the mute doom of death.
I felt Time's instantaneous pause ;
 An instant, on my eye
 Flashed all Eternity :—
I started, as if clutched by wild beasts' claws,

Awakened from some dizzy swoon :
 I felt strange vacant fears,
 With singings in my ears,
And wondered that the pallid moon
 Swung round the dome of night
 With such tremendous might.
A sweetness, like the air of June,
 Next paled me with suspense,
 A weight of clinging sense—
Some hidden evil would burst on me soon.

My lady's love has passed away,
 To know that it is so
 To me is living woe.
That body lies in cold decay,
 Which held the vital soul
 When she was my life's soul.
Bitter mockery it was to say—
 " Our souls are as the same :"
 My words now sting like shame ;
Her spirit went, and mine did not obey.

It was as if a fiery dart
 Passed seething thro' my brain
 When I beheld her lain
There whence in life she did not part.
 Her beauty by degrees,
 Sank, sharpened with disease :
The heavy sinking at her heart
 Sucked hollows in her cheek,
 And made her eyelids weak,
Tho' oft they'd open wide with sudden start.

The deathly power in silence drew
 My lady's life away.
 I watched, dumb with dismay,
The shock of thrills that quivered thro'
 And tightened every limb :
 For grief my eyes grew dim ;
More near, more near, the moment grew.
 O horrible suspense !
 O giddy impotence !
I saw her fingers lax, and change their hue.

Her gaze, grown large with fate, was cast
 Where my mute agonies
 Made more sad her sad eyes :
Her breath caught with short plucks and fast :—
 Then one hot choking strain.
 She never breathed again :
I had the look which was her last :
 Even after breath was gone,
 Her love one moment shone,—
Then slowly closed, and hope for ever passed.

Silence seemed to start in space
 When first the bell's harsh toll
 Rang for my lady's soul.
Vitality was hell ; her grace
 The shadow of a dream :
 Things then did scarcely seem :
Oblivion's stroke fell like a mace :
 As a tree that's just hewn
 I dropped, in a dead swoon,
And lay a long time cold upon my face.

Earth had one quarter turned before
 My miserable fate
 Pressed on with its whole weight.
My sense came back ; and, shivering o'er,
 I felt a pain to bear
 The sun's keen cruel glare ;
It seemed not warm as heretofore.
 Oh, never more its rays
 Will satisfy my gaze.
No more ; no more ; oh, never any more.

The Love of Beauty.

(Sonnet.)

JOHN BOCCACCIO, love's own squire, deep sworn
 In service to all beauty, joy, and rest,—
 When first the love-earned royal Mary press'd,
To her smooth cheek, his pale brows, passion-worn,—
'Tis said, he, by her grace nigh frenzied, torn
 By longings unattainable, address'd
 To his chief friend most strange misgivings, lest
Some madness in his brain had thence been born.
The artist-mind alone can feel his meaning :—
 Such as have watched the battle-rank'd array
Of sunset, or the face of girlhood seen in
 Line-blending twilight, with sick hope. Oh ! they
May feed desire on some fond bosom leaning :
 But where shall such their thirst of Nature stay ?

The Subject in Art.

(**No. 1.**)

IF Painting and Sculpture delight us like other works of
ingenuity, merely from the difficulties they surmount; like an
'egg in a bottle,' a tree made out of stone, or a face made of
pigment; and the pleasure we receive, is our wonder at the
achievement; then, to such as so believe, this treatise is not written.
But if, as the writer conceives, works of Fine Art delight us by the
interest the objects they depict excite in the beholder, just as those
objects in nature would excite his interest; if by any association of
ideas in the one case, by the same in the other, without reference to
the representations being other than the objects they represent :—
then, to such as so believe, the following upon 'SUBJECT' is
addressed. Whilst, at the same time, it is not disallowed that a
subsequent pleasure may and does result, upon reflecting that the
objects contemplated were the work of human ingenuity.

Now the subject to be treated, is the 'subject' of Painter and
Sculptor; what ought to be the nature of that 'subject,' how far
that subject may be drawn from past or present time with advantage,
how far the subject may tend to confer upon its embodiment the
title, 'High Art,' how far the subject may tend to confer upon its
embodiment the title 'Low Art;' what is 'High Art,' what is
'Low Art'?

To begin then (at the end) with 'High Art.' However we
may differ as to facts, the principle will be readily granted, that
'High Art,' *i. e.* Art, par excellence, Art, in its most exalted
character, addresses pre-eminently the highest attributes of man,
viz. : his mental and his moral faculties.

'Low Art,' or Art in its less exalted character, is that which
addresses the less exalted attributes of man, viz. : his mere sensory
faculties, without affecting the mind or heart, excepting through the
volitional agency of the observer.

These definitions are too general and simple to be disputed; but
before we endeavour to define more particularly, let us analyze the
subject, and see what it will yield.

All the works which remain to us of the Ancients, and this
appears somewhat remarkable, are, with the exception of those by
incompetent artists, universally admitted to be 'High Art.' Now
do we afford them this high title, because all remnants of the
antique world, by tempting a comparison between what was, and
is, will set the mental faculties at work, and thus address the

highest attributes of man? Or, as this is owing to the agency of the observer, and not to the subject represented, are we to seek for the cause in the subjects themselves!

Let us examine the subjects. They are mostly in sculpture; but this cannot be the cause, unless all modern sculpture be considered 'High Art.' This is leaving out of the question in both ages, all works badly executed, and obviously incorrect, of which there are numerous examples both ancient and modern.

The subjects we find in sculpture are, in "the round," mostly men or women in thoughtful or impassioned action : sometimes they are indeed acting physically ; but then, as in the Jason adjusting his Sandal, acting by mechanical impulse, and thinking or looking in another direction. In relievo we have an historical combat, such as that between the Centaurs and Lapithæ; sometimes a group in conversation, sometimes a recitation of verses to the Lyre; a dance, or religious procession.

As to the first class in "the round," as they seem to appeal to the intellectual, and often to the moral faculties, they are naturally, and according to the broad definition, works of 'High Art.' Of the relievo, the historical combat appeals to the passions ; and, being historical, probably to the intellect. The like may be said of the conversational groups, and lyrical recitation which follow. The dance appeals to the passions and the intellect ; since the intellect recognises therein an order and design, her own planning ; while the solemn, modest demeanour in the religious procession speaks to the heart and the mind. The same remarks will apply to the few ancient paintings we possess, always excluding such merely decorative works as are not fine art at all.

Thus it appears that all these works of the ancients *might* rationally have been denominated works of 'High Art;' and here we remark the difference between the hypothetical or rational, and the historical account of facts ; for though here is *reason* enough why ancient art *might* have been denominated 'High Art,' that it *was* so denominated on this account, is a position not capable of proof : whereas, in all probability, the true account of the matter runs thus—The works of antiquity awe us by their time-hallowed presence ; the mind is sent into a serious contemplation of things ; and, the subject itself in nowise contravening, we attribute all this potent effect to the agency of the subject before us, and 'High Art,' it becomes *then* and *for ever*, with all such as "follow its cut." But then as this was so named, not from the abstract cause, but from a result and effect ; when a *new* work is produced in a similar spirit, but clothed in a dissimilar matter, and the critics have to settle to what class

of art it belongs,—then is the new work dragged up to fight with the old one, like the poor beggar Irus in front of Ulysses ; then are they turned over and applied, each to each, like the two triangles in Euclid ; and then, if they square, fit and tally in every quarter— with the nude to the draped in the one, as the nude to the draped in the other—with the standing to the sitting in the one, as the standing to the sitting in the other—with the fat to the lean in the one, as the fat to the lean in the other—with the young to the old in the one, as the young to the old in the other—with head to body, as head to body ; and nose to knee, as nose to knee, &c. &c., (and the critics have done a great deal)—then is the work oracularly pronounced one of 'High Art;' and the obsequious artist is pleased to consider it is.

But if, per contra, as in the former case, the works are not to be literally reconciled, though wrought in the self-same spirit ; then this unfortunate creature of genius is degraded into a lower rank of art ; and the artist, if he have faith in the learned, despairs ; or, if he have none, he *swears*. But listen, an artist speaks : " If I have genius to produce a work in the true spirit of high art, and yet am so ignorant of its principles, that I scarce know whereon the success of the work depends, and scarcely whether I have succeeded or no ; with this ignorance and this power, what needs your knowledge or your reasoning, seeing that nature is all-sufficient, and produces a painter as she produces a plant?" To the artist (the last of his race), who spoke thus, it is answered, that science is not meant for him, if he like it not, seeing he can do without it, and seeing, more-over, that with it *alone* he can never do. Science here does not make ; it unmakes, wonderingly to find the making of what God has made,—of what God has made through the poet, leading him blindly by a path which he has not known ; this path science follows slowly and in wonder. But though science is not to make the artist, there is no reason in nature that the artist reject it. Still, science is pro-perly the birthright of the critic ; 'tis his all in all. It shows him poets, painters, sculptors, his fellow men, often his inferiors in their want of it, his superiors in the ability to do what he cannot do ; it teaches him to love them as angels bringing him food which *he* cannot attain, and to venerate their works as a gift from the Creator.

But to return to the critical errors relating to 'High Art.' While the constituents of high art were unknown, whilst its abstract principles were unsought, and whilst it was only recognized in the concrete, the critics, certainly guilty of the most unpardon-able blindness, blundered up to the masses of 'High Art,' left by

antiquity, saying, "there let us fix our observatory," and here came out perspective glass, and callipers and compasses; and here they made squares and triangles, and circles, and ellipses, for, said they, "this is 'High Art,' and this hath certain proportions;" then in the logic of their hearts, they continued, "all these proportions we know by admeasurement, whatsoever hath these is 'High Art,' whatsoever hath not, is 'Low Art.' This was as certain as the fact that the sun is a globe of glowing charcoal, because forsooth they both yield light and heat. Now if the phantom of a then embryon-electrician had arisen and told them that their "high art marbles possessed an electric influence, which, acting in the brain of the observer, would awake in him emotions of so exalted a character, that he forthwith, inevitably nodding at them, must utter the tremendous syllables 'High Art;'" he, the then embryon-electrician, from that age withheld to bless and irradiate the physiology of ours, would have done something more to the purpose than all the critics and the compasses.

Thus then we see, that the antique, however successfully it may have wrought, is not our model; for, according to that faith demanded at setting out, fine art delights us from its being the semblance of what in nature delights. Now, as the artist does not work by the instrumentality of rule and science, but mainly by an instinctive impulse; if he copy the antique, unable as he is to segregate the merely delectable matter, he must needs copy the whole, and thereby multiply models, which the casting-man can do equally well; whereas if he copy nature, with a like inability to distinguish that delectable attribute which allures him to copy her, and under the same necessity of copying the whole, to make sure of this "tenant of nowhere;" we then have the artist, the instructed of nature, fulfilling his natural capacity, while his works we have as manifold yet various as nature's own thoughts for her children.

But reverting to the subject, it was stated at the beginning that 'Fine Art' delights, by presenting us with objects, which in nature delight us; and 'High Art' was defined, that which addresses the intellect; and hence it might appear, as delight is an emotion of the mind, that 'Low Art,' which addresses the senses, is not Fine Art at all. But then it must be remembered, that it was neither stated of 'Fine Art,' nor of 'High Art,' that it always delights; and again, that delight is not entirely mental. To point out the confines of high and low art, where the one terminates and the other commences, would be difficult, if not impracticable without sub-defining or circumscribing the import of the terms, pain, pleasure, delight, sensory, mental, psychical, intellectual, objective,

subjective, &c. &c. ; and then, as little or nothing would be gained mainly pertinent to the subject, it must be content to receive no better definitions than those broad ones already laid down, with their latitude somewhat corrected by practical examples. Yet before proceeding to give these examples, it might be remarked of ' High Art,' that it always might, if it do not always excite some portion of delight, irrespective of that subsequent delight consequent upon the examination of a curiosity ; that its function is sometimes, with this portion of delight, to commingle grief or distress, and that it may, (though this is *not* its function,) excite mental anguish, and by a reflex action, actual bodily pain. Now then to particularize, by example ; let us suppose a perfect and correct painting of a stone, a common stone such as we walk over. Now although this subject might to a religious man, suggest a text of scripture ; and to the geologist a theory of scientific interest ; yet its general effect upon the average number of observers will be readily allowed to be more that of wonder or admiration at a triumph over the apparently impossible (to make a round stone upon a flat piece of canvass) than at aught else the subject possesses. Now a subject such as this belongs to such very low art, that it narrowly illudes precipitation over the confines of Fine Art ; yet, that it is Fine Art is indisputable, since no mere mechanic artisan, or other than one specially gifted by nature, could produce it. This then shall introduce us to "Subject." This subject then, standing where fine art gradually confines with mechanic art, and almost midway between them ; of no use nor beauty ; but to be wondered at as a curiosity ; is a subject of scandalous import to the artist, to the artist thus gifted by nature with a talent to reproduce her fleeting and wondrous forms. But if, as the writer doubts, nature could afford a monster so qualified for a poet, yet destitute of poetical genius ; then the scandal attaches if he attempt a step in advance, or neglect to join himself to those, a most useful class of mechanic artists, who illustrate the sciences by drawing and diagram.

But as the subject supposed is one never treated in painting ; only instanced, in fact, to exemplify an extreme ; let us consider the merits of a subject really practical, such as 'dead game,' or 'a basket of fruit ;' and the first general idea such a subject will excite is simply that of *food*, 'something to eat.' For though fruit on the tree, or a pheasant in the air, is a portion of nature and properly belongs to the section, 'Landscape,' a division of art intellectual enough ; yet gather the fruit or bring down the pheasant, and you presently bring down the poetry with it ; and although Sterne could sentimentalize upon a dead ass ; and though a dead

pheasant in the larder, or a dead sheep at a butcher's, may excite feelings akin to anything but good living; and though they may *there* be the excitive causes of poetical, nay, of moral reflexion; yet, see them on the canvass, and the first and uppermost idea will be that of ' *Food,*' and how, in the name of decency, they ever came there. It will be vain to argue that gathered fruit is only nature under a certain phase, and that a dead sheep or a dead pheasant is only a dead animal like a dead ass—it will be pitiably vain and miserable sophistry, since we know that the dead pheasant in a picture will always be as *food*, while the same at the poulterer's will be but a dead pheasant.

For we have not one only, but numerous general ideas annexed to every object in nature. Thus one of the series may be that that object is matter, one that it is individual matter, one that it is animal matter, one that it is a bird, one that it is a pheasant, one that it is a dead pheasant, and one that it is food. Now, our general ideas or notions are not evoked in this order as each new object addresses the mind; but that general idea is *first* elicited which accords with the first or principal destination of the object: thus the first general idea of a cowry, to the Indian, is that of money, not of a shell ; and our first general idea of a dead pheasant is that of food, whereas to a zoologist it might have a different effect : but this is the exception. But it was said, that a dead pheasant in a picture would always be as food, while the same at the poulterer's would be but a dead pheasant : what then becomes of the first general idea ? It seems to be disposed of thus : at the first sight of the shop, the idea is that of food, and next (if you are not hungry, and poets never are), the mind will be attracted to the species of animal, and (unless hunger presses) you may be led on to moralize like Sterne : but, amongst pictures, where there is nothing else to excite the general ideas of food, this, whenever adverted to, must ever re-excite that idea; and hence it appears that these *esculent* subjects might be poetical enough if exhibited all together, *i.e.*, they must be surrounded with eatables, like a possibly-poetical-pheasant in a poulterer's shop.

Longer stress has been laid upon this subject, " Still Life," than would seem justified by its insignificance, but as this is a branch of art which has never aspired to be ' High Art,' it contains something definite in its character which makes it better worth the analysis than might appear at first sight; but still, as a latitude has been taken in the investigation which is ever unavoidable in the handling of such mercurial matter as poetry (where one must spread out a broad definition to catch it wherever it runs), and as this is ever

incomprehensible to such as are unaccustomed to abstract thinking, from the difficulty of educing a rule amidst an infinite array of exceptions, and of recognising a principle shrouded in the obscurity of conflicting details; it appears expedient, before pursuing the question, to reinforce the first broad elementary principles with what definite modification they may have acquired in their progress to this point in the argument, together with the additional data which may have resulted from analytic reference to other correlative matter.

First then, as Fine Art delights in proportion to the delectating interest of the objects it depicts, and, as subseqently stated, grieves or distresses in proportion as the objects are grievous or distressing, we have this resultant : " Fine Art *excites* in proportion to the excitor influence of the object;" and then, that "*fine art* excites either the sensory or the mental faculties, in a like proportion to the excitor properties of the objects respectively." Thus then we have, definitely stated, the powers or capabilities of *Fine Art*, as regulated and governed by the objects it selects, and the objects it selects making its subject. Now the question in hand is, " what the nature of that *subject* should be," but the *subject* must be according to what Fine Art proposes to effect ; all then must depend upon this proposition. For if you propose that Fine Art shall excite sensual pleasure, then such objects as excite sensual pleasure should form the *subject* of Fine Art ; and those which excite sensual pleasure in the highest degree, will form the *highest subject*—' High Art.' Or if you propose that Fine Art shall excite a physical energetic activity, by addressing the sensory organism, which is a phase of the former proposition, (for what are popularly called sensual pleasures, are only particular sensory excitements sought by a physical appetite, while this sensory-organic activity is physically appetent also,) then the subjects of art ought to be drawn from such objects as excite a general activity, such as field-sports, bull-fights, battles, executions, court pageants, conflagrations, murders ; and those which most intensely excite this sensory-organic activity, by expressing most of physical human power or suffering, such as battles, executions, regality, murder, would afford the *highest subject* of Fine Art, and consequently these would be '*High Art.*' But if you propose (with the writer) that *Fine Art* shall regard the general happiness of man, by addressing those attributes which are *peculiarly human*, by exciting the activity of his rational and benevolent powers (and the writer would add, man's religious aspirations, but omits it as sufficiently evolvable from the proposition, and since some well-willing men cannot at present recognize man as a religious animal),

then the subject of Fine Art should be drawn from objects which
address and excite the activity of man's rational and benevolent
powers, such as :—acts of justice—of mercy—good government—
order—acts of intellect—men obviously speaking or thinking ab-
stract thoughts, as evinced by one speaking to another, and looking
at, or indicating, a flower, or a picture, or a star, or by looking on
the wall while speaking—or, if the scene be from a *good* play, or
story, or other beneficent work, then not only of men in abstract
thought or meditation, but, it may be, in simple conversation, or in
passion—or a simple representation of a person in a play or story,
as of Jacques, Ferdinand, or Cordelia ; or, in real life, portraits of
those who are honestly beautiful ; or expressive of innocence, happi-
ness, benevolence, or intellectuality, but not of gluttony, wantonness,
anger, hatred, or malevolence, unless in some cases of justifiable
satire—of histrionic or historic portraiture—landscape—natural
phenomena—animals, not *indiscriminately*—in some cases, grand or
beautiful buildings, even without figures—any scene on sea or land
which induces reflection—all subjects from such parts of history as
are morally or intellectually instructive or attractive—and therefore
pageants—battles—and *even* executions—all forms of thought and
poetry, however wild, if consistent with rational benevolence—all
scenes serious or comic, domestic or historical—all religious subjects
proposing good that will not shock any reasonable number of reason-
able men—all subjects that leave the artist wiser and happier—and
none which intrinsically act otherwise—to sum all, every thing or
incident in nature which excites, or may be made to excite, the
mind and the heart of man as a mentally intelligent, not as a brute
animal, is a subject for Fine Art, at all times, in all places, and in
all ages. But as all these subjects in nature affect our hearts or our
understandings in proportion to the heart and understanding we
have to apprehend and to love them, those will excite us most
intensely which we know most of and love most. But as we may
learn to know them all and to love them all, and what is dark to-
day may be luminous to-morrow, and things, dumb to-day, to-morrow
grow voiceful, and the strange voice of to-day be plain and reproach
us to-morrow ; who shall adventure to say that this or that is highest ?
And if it appear that all these subjects in nature *may* affect us with
equal intensity, and that the artist's representations affect as the
subjects affect, then it follows, with all these subjects, Fine Art may
affect us equally ; but the subjects may all be high ; therefore, all
Fine Art may be High Art.

The Seasons.

The crocus, in the shrewd March morn,
 Thrusts up his saffron spear ;
And April dots the sombre thorn
 With gems, and loveliest cheer.

Then sleep the seasons, full of might ;
 While slowly swells the pod,
And rounds the peach, and in the night
 The mushroom bursts the sod.

The winter comes : the frozen rut
 Is bound with silver bars ;
The white drift heaps against the hut ;
 And night is pierced with stars.

Dream Land.

WHERE sunless rivers weep
Their waves into the deep,
She sleeps a charmed sleep ;
 Awake her not.
Led by a single star,
She came from very far,
To seek where shadows are
 Her pleasant lot.

She left the rosy morn,
She left the fields of corn,
For twilight cold and lorn,
 And water-springs.
Thro' sleep, as thro' a veil,
She sees the sky look pale,
And hears the nightingale,
 That sadly sings.

Rest, rest, a perfect rest,
Shed over brow and breast ;
Her face is toward the west,
 The purple land.
She cannot see the grain
Ripening on hill and plain ;
She cannot feel the rain
 Upon her hand.

Rest, rest, for evermore
Upon a mossy shore,
Rest, rest, that shall endure,
 Till time shall cease ;—
Sleep that no pain shall wake,
Night that no morn shall break,
Till joy shall overtake
 Her perfect peace.

Songs of One Household.

My Sister's Sleep.

SHE fell asleep on Christmas Eve.
 Upon her eyes' most patient calms
 The lids were shut ; her uplaid arms
Covered her bosom, I believe.

Our mother, who had leaned all day
 Over the bed from chime to chime,
 Then raised herself for the first time,
And as she sat her down, did pray.

Her little work-table was spread
 With work to finish. For the glare
 Made by her candle, she had care
To work some distance from the bed.

Without, there was a good moon up,
 Which left its shadows far within ;
 The depth of light that it was in
Seemed hollow like an altar-cup.

Through the small room, with subtle sound
 Of flame, by vents the fireshine drove
 And reddened. In its dim alcove
The mirror shed a clearness round.

I had been sitting up some nights,
 And my tir'd mind felt weak and blank ;
 Like a sharp strengthening wine, it drank
The stillness and the broken lights.

Silence was speaking at my side
 With an exceedingly clear voice :
 I knew the calm as of a choice
Made in God for me, to abide.

I said, " Full knowledge does not grieve :
 This which upon my spirit dwells
 Perhaps would have been sorrow else :
But I am glad 'tis Christmas Eve."

Twelve struck. That sound, which all the years
 Hear in each hour, crept off ; and then
 The ruffled silence spread again,
Like water that a pebble stirs.

Our mother rose from where she sat.
 Her needles, as she laid them down,
 Met lightly, and her silken gown
Settled : no other noise than that.

"Glory unto the Newly Born !"
 So, as said angels, she did say ;
 Because we were in Christmas-day,
Though it would still be long till dawn.

She stood a moment with her hands
 Kept in each other, praying much ;
 A moment that the soul may touch
But the heart only understands.

Almost unwittingly, my mind
 Repeated her words after her ;
 Perhaps tho' my lips did not stir ;
It was scarce thought, or cause assign'd.

Just then in the room over us
 There was a pushing back of chairs,
 As some who had sat unawares
So late, now heard the hour, and rose.

Anxious, with softly stepping haste,
 Our mother went where Margaret lay,
 Fearing the sounds o'erhead—should they
Have broken her long-watched for rest !

She stooped an instant, calm, and turned ;
 But suddenly turned back again ;
 And all her features seemed in pain
With woe, and her eyes gazed and yearned.

For my part, I but hid my face,
 And held my breath, and spake no word :
 There was none spoken ; but *I heard*
The silence for a little space.

Our mother bowed herself and wept.
 And both my arms fell, and I said :
 "God knows I knew that she was dead."
And there, all white, my sister slept.

Then kneeling, upon Christmas morn
 A little after twelve o'clock
 We said, ere the first quarter struck,
"Christ's blessing on the newly born !"

Hand and Soul.

" Rivolsimi in quel lato
Là 'nde venia la voce,
E parvemi una luce
Che lucea quanto stella :
La mia mente era quella."

Bonaggiunta Urbiciani, (1250.)

Before any knowledge of painting was brought to Florence, there were already painters in Lucca, and Pisa, and Arezzo, who feared God and loved the art. The keen, grave workmen from Greece, whose trade it was to sell their own works in Italy and teach Italians to imitate them, had already found rivals of the soil with skill that could forestall their lessons and cheapen their crucifixes and *addolorate,* more years than is supposed before the art came at all into Florence. The pre-eminence to which Cimabue was raised at once by his contemporaries, and which he still retains to a wide extent even in the modern mind, is to be accounted for, partly by the circumstances under which he arose, and partly by that extra-ordinary *purpose of fortune* born with the lives of some few, and through which it is not a little thing for any who went before, if they are even remembered as the shadows of the coming of such an one, and the voices which prepared his way in the wilderness. It is thus, almost exclusively, that the painters of whom I speak are now known. They have left little, and but little heed is taken of that which men hold to have been surpassed; it is gone like time gone —a track of dust and dead leaves that merely led to the fountain.

Nevertheless, of very late years, and in very rare instances, some signs of a better understanding have become manifest. A case in point is that of the tryptic and two cruciform pictures at Dresden, by Chiaro di Messer Bello dell' Erma, to which the eloquent pamphlet of Dr. Aemmster has at length succeeded in attracting the students. There is another still more solemn and beautiful work, now proved to be by the same hand, in the gallery at Florence. It is the one to which my narrative will relate.

This Chiaro dell' Erma was a young man of very honorable family in Arezzo ; where, conceiving art almost, as it were, for him-self, and loving it deeply, he endeavoured from early boyhood towards the imitation of any objects offered in nature. The extreme longing after a visible embodiment of his thoughts strengthened as his years increased, more even than his sinews or the blood of his life ; until

he would feel faint in sunsets and at the sight of stately persons. When he had lived nineteen years, he heard of the famous Giunta Pisano ; and, feeling much of admiration, with, perhaps, a little of that envy which youth always feels until it has learned to measure success by time and opportunity, he determined that he would seek out Giunta, and, if possible, become his pupil.

Having arrived in Pisa, he clothed himself in humble apparel, being unwilling that any other thing than the desire he had for knowledge should be his plea with the great painter ; and then, leaving his baggage at a house of entertainment, he took his way along the street, asking whom he met for the lodging of Giunta. It soon chanced that one of that city, conceiving him to be a stranger and poor, took him into his house, and refreshed him ; afterwards directing him on his way.

When he was brought to speech of Giunta, he said merely that he was a student, and that nothing in the world was so much at his heart as to become that which he had heard told of him with whom he was speaking. He was received with courtesy and consideration, and shewn into the study of the famous artist. But the forms he saw there were lifeless and incomplete ; and a sudden exultation possessed him as he said within himself, "I am the master of this man." The blood came at first into his face, but the next moment he was quite pale and fell to trembling. He was able, however, to conceal his emotion ; speaking very little to Giunta, but, when he took his leave, thanking him respectfully.

After this, Chiaro's first resolve was, that he would work out thoroughly some one of his thoughts, and let the world know him. But the lesson which he had now learned, of how small a greatness might win fame, and how little there was to strive against, served to make him torpid, and rendered his exertions less continual. Also Pisa was a larger and more luxurious city than Arezzo ; and, when in his walks, he saw the great gardens laid out for pleasure, and the beautiful women who passed to and fro, and heard the music that was in the groves of the city at evening, he was taken with wonder that he had never claimed his share of the inheritance of those years in which his youth was cast. And women loved Chiaro ; for, in despite of the burthen of study, he was well-favoured and very manly in his walking ; and, seeing his face in front, there was a glory upon it, as upon the face of one who feels a light round his hair.

So he put thought from him, and partook of his life. But, one night, being in a certain company of ladies, a gentleman that was there with him began to speak of the paintings of a youth named

Bonaventura, which he had seen in Lucca; adding that Giunta Pisano might now look for a rival. When Chiaro heard this, the lamps shook before him, and the music beat in his ears and made him giddy. He rose up, alleging a sudden sickness, and went out of that house with his teeth set.

He now took to work diligently; not returning to Arezzo, but remaining in Pisa, that no day more might be lost; only living entirely to himself. Sometimes, after nightfall, he would walk abroad in the most solitary places he could find; hardly feeling the ground under him, because of the thoughts of the day which held him in fever.

The lodging he had chosen was in a house that looked upon gardens fast by the Church of San Rocco. During the offices, as he sat at work, he could hear the music of the organ and the long murmur that the chanting left; and if his window were open, sometimes, at those parts of the mass where there is silence throughout the church, his ear caught faintly the single voice of the priest. Beside the matters of his art and a very few books, almost the only object to be noticed in Chiaro's room was a small consecrated image of St. Mary Virgin wrought out of silver, before which stood always, in summer-time, a glass containing a lily and a rose.

It was here, and at this time, that Chiaro painted the Dresden pictures; as also, in all likelihood, the one—inferior in merit, but certainly his—which is now at Munich. For the most part, he was calm and regular in his manner of study; though often he would remain at work through the whole of a day, not resting once so long as the light lasted; flushed, and with the hair from his face. Or, at times, when he could not paint, he would sit for hours in thought of all the greatness the world had known from of old; until he was weak with yearning, like one who gazes upon a path of stars.

He continued in this patient endeavour for about three years, at the end of which his name was spoken throughout all Tuscany. As his fame waxed, he began to be employed, besides easel-pictures, upon paintings in fresco : but I believe that no traces remain to us of any of these latter. He is said to have painted in the Duomo : and D'Agincourt mentions having seen some portions of a fresco by him which originally had its place above the high altar in the Church of the Certosa; but which, at the time he saw it, being very dilapidated, had been hewn out of the wall, and was preserved in the stores of the convent. Before the period of Dr. Aemmster's researches, however, it had been entirely destroyed.

Chiaro was now famous. It was for the race of fame that he had

girded up his loins ; and he had not paused until fame was reached : yet now, in taking breath, he found that the weight was still at his heart. The years of his labour had fallen from him, and his life was still in its first painful desire.

With all that Chiaro had done during these three years, and even before, with the studies of his early youth, there had always been a feeling of worship and service. It was the peace-offering that he made to God and to his own soul for the eager selfishness of his aim. There was earth, indeed, upon the hem of his raiment ; but *this* was of the heaven, heavenly. He had seasons when he could endure to think of no other feature of his hope than this : and some - times, in the ecstacy of prayer, it had even seemed to him to behold that day when his mistress—his mystical lady (now hardly in her ninth year, but whose solemn smile at meeting had already lighted on his soul like the dove of the Trinity)—even she, his own gracious and holy Italian art—with her virginal bosom, and her un-fathomable eyes, and the thread of sunlight round her brows—should pass, through the sun that never sets, into the circle of the shadow of the tree of life, and be seen of God, and found good : and then it had seemed to him, that he, with many who, since his coming, had joined the band of whom he was one (for, in his dream, the body he had worn on earth had been dead an hundred years), were permitted to gather round the blessed maiden, and to worship with her through all ages and ages of ages, saying, Holy, holy, holy. This thing he had seen with the eyes of his spirit ; and in this thing had trusted, believing that it would surely come to pass.

But now, (being at length led to enquire closely into himself,) even as, in the pursuit of fame, the unrest abiding after attainment had proved to him that he had misinterpreted the craving of his own spirit—so also, now that he would willingly have fallen back on devotion, he became aware that much of that reverence which he had mistaken for faith had been no more than the worship of beauty. Therefore, after certain days passed in perplexity, Chiaro said within himself, " My life and my will are yet before me : I will take another aim to my life."

From that moment Chiaro set a watch on his soul, and put his hand to no other works but only to such as had for their end the presentment of some moral greatness that should impress the be-holder : and, in doing this, he did not choose for his medium the action and passion of human life, but cold symbolism and abstract impersonation. So the people ceased to throng about his pictures as heretofore ; and, when they were carried through town and town to their destination, they were no longer delayed by the crowds

eager to gaze and admire : and no prayers or offerings were brought to them on their path, as to his Madonnas, and his Saints, and his Holy Children. Only the critical audience remained to him ; and these, in default of more worthy matter, would have turned their scrutiny on a puppet or a mantle. Meanwhile, he had no more of fever upon him ; but was calm and pale each day in all that he did and in his goings in and out. The works he produced at this time have perished—in all likelihood, not unjustly. It is said (and we may easily believe it), that, though more laboured than his former pictures, they were cold and unemphatic ; bearing marked out upon them, as they must certainly have done, the measure of that boundary to which they were made to conform.

And the weight was still close at Chiaro's heart : but he held in his breath, never resting (for he was afraid), and would not know it.

Now it happened, within these days, that there fell a great feast in Pisa, for holy matters : and each man left his occupation ; and all the guilds and companies of the city were got together for games and rejoicings. And there were scarcely any that stayed in the houses, except ladies who lay or sat along their balconies between open windows which let the breeze beat through the rooms and over the spread tables from end to end. And the golden cloths that their arms lay upon drew all eyes upward to see their beauty ; and the day was long ; and every hour of the day was bright with the sun.

So Chiaro's model, when he awoke that morning on the hot pavement of the Piazza Nunziata, and saw the hurry of people that passed him, got up and went along with them ; and Chiaro waited for him in vain.

For the whole of that morning, the music was in Chiaro's room from the Church close at hand : and he could hear the sounds that the crowd made in the streets ; hushed only at long intervals while the processions for the feast-day chanted in going under his windows. Also, more than once, there was a high clamour from the meeting of factious persons : for the ladies of both leagues were looking down ; and he who encountered his enemy could not choose but draw upon him. Chiaro waited a long time idle ; and then knew that his model was gone elsewhere. When at his work, he was blind and deaf to all else ; but he feared sloth : for then his stealthy thoughts would begin, as it were, to beat round and round him, seeking a point for attack. He now rose, therefore, and went to the window. It was within a short space of noon ; and underneath him a throng of people was coming out through the porch of San Rocco.

The two greatest houses of the feud in Pisa had filled the church for that mass. The first to leave had been the Gherghiotti; who, stopping on the threshold, had fallen back in ranks along each side of the archway: so that now, in passing outward, the Marotoli had to walk between two files of men whom they hated, and whose fathers had hated theirs. All the chiefs were there and their whole adherence; and each knew the name of each. Every man of the Marotoli, as he came forth and saw his foes, laid back his hood and gazed about him, to show the badge upon the close cap that held his hair. And of the Gherghiotti there were some who tightened their girdles; and some shrilled and threw up their wrists scornfully, as who flies a falcon; for that was the crest of their house.

On the walls within the entry were a number of tall, narrow frescoes, presenting a moral allegory of Peace, which Chiaro had painted that year for the Church. The Gherghiotti stood with their backs to these frescoes: and among them Golzo Ninuccio, the youngest noble of the faction, called by the people Golaghiotta, for his debased life. This youth had remained for some while talking listlessly to his fellows, though with his sleepy sunken eyes fixed on them who passed: but now, seeing that no man jostled another, he drew the long silver shoe off his foot, and struck the dust out of it on the cloak of him who was going by, asking him how far the tides rose at Viderza. And he said so because it was three months since, at that place, the Gherghiotti had beaten the Marotoli to the sands, and held them there while the sea came in; whereby many had been drowned. And, when he had spoken, at once the whole archway was dazzling with the light of confused swords; and they who had left turned back; and they who were still behind made haste to come forth: and there was so much blood cast up the walls on a sudden, that it ran in long streams down Chiaro's paintings.

Chiaro turned himself from the window; for the light felt dry between his lids, and he could not look. He sat down, and heard the noise of contention driven out of the church-porch and a great way through the streets; and soon there was a deep murmur that heaved and waxed from the other side of the city, where those of both parties were gathering to join in the tumult.

Chiaro sat with his face in his open hands. Once again he had wished to set his foot on a place that looked green and fertile; and once again it seemed to him that the thin rank mask was about to spread away, and that this time the chill of the water must leave leprosy in his flesh. The light still swam in his head, and bewil-

dered him at first; but when he knew his thoughts, they were
these :—

"Fame failed me: faith failed me: and now this also,—the hope
that I nourished in this my generation of men,—shall pass from me,
and leave my feet and my hands groping. Yet, because of this, are
my feet become slow and my hands thin. I am as one who, through
the whole night, holding his way diligently, hath smitten the steel
unto the flint, to lead some whom he knew darkling; who hath
kept his eyes always on the sparks that himself made, lest they
should fail; and who, towards dawn, turning to bid them that he
had guided God speed, sees the wet grass untrodden except of his
own feet. I am as the last hour of the day, whose chimes are a
perfect number; whom the next followeth not, nor light ensueth
from him; but in the same darkness is the old order begun afresh.
Men say, 'This is not God nor man; he is not as we are, neither
above us: let him sit beneath us, for we are many.' Where I
write Peace, in that spot is the drawing of swords, and there men's
footprints are red. When I would sow, another harvest is ripe.
Nay, it is much worse with me than thus much. Am I not as a
cloth drawn before the light, that the looker may not be blinded;
but which sheweth thereby the grain of its own coarseness; so that
the light seems defiled, and men say, 'We will not walk by it.'
Wherefore through me they shall be doubly accursed, seeing that
through me they reject the light. May one be a devil and not
know it?"

As Chiaro was in these thoughts, the fever encroached slowly on
his veins, till he could sit no longer, and would have risen; but
suddenly he found awe within him, and held his head bowed,
without stirring. The warmth of the air was not shaken; but
there seemed a pulse in the light, and a living freshness, like rain.
The silence was a painful music, that made the blood ache in his
temples; and he lifted his face and his deep eyes.

A woman was present in his room, clad to the hands and feet
with a green and grey raiment, fashioned to that time. It seemed
that the first thoughts he had ever known were given him as at
first from her eyes, and he knew her hair to be the golden veil through
which he beheld his dreams. Though her hands were joined, her
face was not lifted, but set forward; and though the gaze was
austere, yet her mouth was supreme in gentleness. And as he
looked, Chiaro's spirit appeared abashed of its own intimate
presence, and his lips shook with the thrill of tears; it seemed such
a bitter while till the spirit might be indeed alone.

She did not move closer towards him, but he felt her to be as
much with him as his breath. He was like one who, scaling a

great steepness, hears his own voice echoed in some place much higher than he can see, and the name of which is not known to him. As the woman stood, her speech was with Chiaro : not, as it were, from her mouth or in his ears ; but distinctly between them.

"I am an image, Chiaro, of thine own soul within thee. See me, and know me as I am. Thou sayest that fame has failed thee, and faith failed thee; but because at least thou hast not laid thy life unto riches, therefore, though thus late, I am suffered to come into thy knowledge. Fame sufficed not, for that thou didst seek fame : seek thine own conscience (not thy mind's conscience, but thine heart's), and all shall approve and suffice. For Fame, in noble soils, is a fruit of the Spring : but not therefore should it be said : ' Lo ! my garden that I planted is barren : the crocus is here, but the lily is dead in the dry ground, and shall not lift the earth that covers it : therefore I will fling my garden together, and give it unto the builders.' Take heed rather that thou trouble not the wise secret earth ; for in the mould that thou throwest up shall the first tender growth lie to waste ; which else had been made strong in its season. Yea, and even if the year fall past in all its months, and the soil be indeed, to thee, peevish and incapable, and though thou indeed gather all thy harvest, and it suffice for others, and thou remain vext with emptiness ; and others drink of thy streams, and the drouth rasp thy throat ;—let it be enough that these have found the feast good, and thanked the giver : remembering that, when the winter is striven through, there is another year, whose wind is meek, and whose sun fulfilleth all."

While he heard, Chiaro went slowly on his knees. It was not to her that spoke, for the speech seemed within him and his own. The air brooded in sunshine, and though the turmoil was great outside, the air within was at peace. But when he looked in her eyes, he wept. And she came to him, and cast her hair over him, and, took her hands about his forehead, and spoke again :

"Thou hast said," she continued, gently, " that faith failed thee. This cannot be so. Either thou hadst it not, or thou hast it. But who bade thee strike the point betwixt love and faith ? Wouldst thou sift the warm breeze from the sun that quickens it ? Who bade thee turn upon God and say : "Behold, my offering is of earth, and not worthy : thy fire comes not upon it : therefore, though I slay not my brother whom thou acceptest, I will depart before thou smite me." Why shouldst thou rise up and tell God He is not content ? Had He, of His warrant, certified so to thee ? Be not nice to seek out division ; but possess thy love in sufficiency : assuredly this is faith, for the heart must believe first. What He hath set in thine heart to do, that do thou ; and even though thou do it

without thought of Him, it shall be well done : it is this sacrifice that He asketh of thee, and His flame is upon it for a sign. Think not of Him ; but of His love and thy love. For God is no morbid exactor : He hath no hand to bow beneath, nor a foot, that thou shouldst kiss it."

And Chiaro held silence, and wept into her hair which covered his face ; and the salt tears that he shed ran through her hair upon his lips ; and he tasted the bitterness of shame.

Then the fair woman, that was his soul, spoke again to him, saying :

"And for this thy last purpose, and for those unprofitable truths of thy teaching,—thine heart hath already put them away, and it needs not that I lay my bidding upon thee. How is it that thou, a man, wouldst say coldly to the mind what God hath said to the heart warmly ? Thy will was honest and wholesome ; but look well lest this also be folly,—to say, 'I, in doing this, do strengthen God among men.' When at any time hath he cried unto thee, saying, 'My son, lend me thy shoulder, for I fall ?' Deemest thou that the men who enter God's temple in malice, to the provoking of blood, and neither for his love nor for his wrath will abate their purpose,—shall afterwards stand with thee in the porch, midway between Him and themselves, to give ear unto thy thin voice, which merely the fall of their visors can drown, and to see thy hands, stretched feebly, tremble among their swords? Give thou to God no more than he asketh of thee; but to man also, that which is man's. In all that thou doest, work from thine own heart, simply ; for his heart is as thine, when thine is wise and humble ; and he shall have understanding of thee. One drop of rain is as another, and the sun's prism in all : and shalt not thou be as he, whose lives are the breath of One? Only by making thyself his equal can he learn to hold communion with thee, and at last own thee above him. Not till thou lean over the water shalt thou see thine image therein : stand erect, and it shall slope from thy feet and be lost. Know that there is but this means whereby thou may'st serve God with man :—Set thine hand and thy soul to serve man with God."

And when she that spoke had said these words within Chiaro's spirit, she left his side quietly, and stood up as he had first seen her ; with her fingers laid together, and her eyes steadfast, and with the breadth of her long dress covering her feet on the floor. And, speaking again, she said :

"Chiaro, servant of God, take now thine Art unto thee, and paint me thus, as I am, to know me : weak, as I am, and in the weeds of this time ; only with eyes which seek out labour, and with a faith, not learned, yet jealous of prayer. Do this ; so shall thy soul stand before thee always, and perplex thee no more."

And Chiaro did as she bade him. While he worked, his face grew solemn with knowledge : and before the shadows had turned, his work was done. Having finished, he lay back where he sat, and was asleep immediately : for the growth of that strong sunset was heavy about him, and he felt weak and haggard ; like one just come out of a dusk, hollow country, bewildered with echoes, where he had lost himself, and who has not slept for many days and nights. And when she saw him lie back, the beautiful woman came to him, and sat at his head, gazing, and quieted his sleep with her voice.

The tumult of the factions had endured all that day through all Pisa, though Chiaro had not heard it : and the last service of that Feast was a mass sung at midnight from the windows of all the churches for the many dead who lay about the city, and who had to be buried before morning, because of the extreme heats.

In the Spring of 1847 I was at Florence. Such as were there at the same time with myself—those, at least, to whom Art is something,—will certainly recollect how many rooms of the Pitti Gallery were closed through that season, in order that some of the pictures they contained might be examined, and repaired without the necessity of removal. The hall, the staircases, and the vast central suite of apartments, were the only accessible portions ; and in these such paintings as they could admit from the sealed *penetralia* were profanely huddled together, without respect of dates, schools, or persons.

I fear that, through this interdict, I may have missed seeing many of the best pictures. I do not mean *only* the most talked of : for these, as they were restored, generally found their way somehow into the open rooms, owing to the clamours raised by the students ; and I remember how old Ercoli's, the curator's, spectacles used to be mirrored in the reclaimed surface, as he leaned mysteriously over these works with some of the visitors, to scrutinize and elucidate.

One picture, that I saw that Spring, I shall not easily forget. It was among those, I believe, brought from the other rooms, and had been hung, obviously out of all chronology, immediately beneath that head by Raphael so long known as the "Berrettino," and now said to be the portrait of Cecco Ciulli.

The picture I speak of is a small one, and represents merely the figure of a woman, clad to the hands and feet with a green and grey raiment, chaste and early in its fashion, but exceedingly simple. She is standing : her hands are held together lightly, and her eyes set earnestly open.

The face and hands in this picture, though wrought with great delicacy, have the appearance of being painted at once, in a single sitting : the drapery is unfinished. As soon as I saw the figure, it drew an awe upon me, like water in shadow. I shall not attempt to describe it more than I have already done ; for the most absorbing wonder of it was its literality. You knew that figure, when painted, had been seen ; yet it was not a thing to be seen of men. This language will appear ridiculous to such as have never looked on the work ; and it may be even to some among those who have. On examining it closely, I perceived in one corner of the canvass the words *Manus Animam pinxit,* and the date 1239.

I turned to my Catalogue, but that was useless, for the pictures were all displaced. I then stepped up to the Cavaliere Ercoli, who was in the room at the moment, and asked him regarding the

subject and authorship of the painting. He treated the matter, I thought, somewhat slightingly, and said that he could show me the reference in the Catalogue, which he had compiled. This, when found, was not of much value, as it merely said, " Schizzo d'autore incerto," adding the inscription.* I could willingly have prolonged my inquiry, in the hope that it might somehow lead to some result; but I had disturbed the curator from certain yards of Guido, and he was not communicative. I went back therefore, and stood before the picture till it grew dusk.

The next day I was there again; but this time a circle of students was round the spot, all copying the " Berrettino." I contrived, however, to find a place whence I could see *my* picture, and where I seemed to be in nobody's way. For some minutes I remained undisturbed; and then I heard, in an English voice: "Might I beg of you, sir, to stand a little more to this side, as you interrupt my view."

I felt vext, for, standing where he asked me, a glare struck on the picture from the windows, and I could not see it. However, the request was reasonably made, and from a countryman ; so I complied, and turning away, stood by his easel. I knew it was not worth while; yet I referred in some way to the work underneath the one he was copying. He did not laugh, but he smiled as we do in England : "*Very* odd, is it not?" said he.

The other students near us were all continental ; and seeing an Englishman select an Englishman to speak with, conceived, I suppose, that he could understand no language but his own. They had evidently been noticing the interest which the little picture appeared to excite in me.

One of them, an Italian, said something to another who stood next to him. He spoke with a Genoese accent, and I lost the sense in the villanous dialect. "Che so ?" replied the other, lifting his eyebrows towards the figure ; " roba mistica : 'st' Inglesi son matti sul misticismo : somiglia alle nebbie di là. Li fa pensare alla patria, " E intenerisce il core
Lo dì ch' han detto ai dolci amici adio."

"La notte, vuoi dire," said a third.

There was a general laugh. My compatriot was evidently a novice in the language, and did not take in what was said. I remained silent, being amused.

' Et toi donc ?" said he who had quoted Dante, turning to a student, whose birthplace was unmistakable even had he been addressed in any other language : " que dis-tu de ce genre-là ?"

"Moi ?" returned the Frenchman, standing back from his easel, and looking at me and at the figure, quite politely, though with an evident reservation: " Je dis, mon cher, que c'est une spécialité dont je me fiche pas mal. Je tiens que quand on ne comprend pas une chose, c'est qu' elle ne signifie rien."

My reader thinks possibly that the French student was right.

* I should here say, that in the catalogue for the year just over, (owing, as in cases before mentioned, to the zeal and enthusiasm of Dr. Aemmster) this, and several other pictures, have been more competently entered. The work in question is now placed in the *Sala Sessagona*, a room I did not see—under the number 161. It is described as " Figura mistica di Chiaro dell' Erma," and there is a brief notice of the author appended.

Reviews.

The Bothie of Toper-na-fuosich: a Long-vacation Pastoral. By Arthur Hugh Clough. Oxford: Macpherson. London: Chapman and Hall.—1848.

THE critic who should undertake to speak of all the poetry which issues from the press of these present days, what is so called by courtesy as well as that which may claim the title as of right, would impose on himself a task demanding no little labor, and entailing no little disgust and weariness. Nor is the trouble well repaid. More profit will not accrue to him who studies, if the word can be used, fifty of a certain class of versifiers, than to him who glances over one: and, while a successful effort to warn such that poetry is not their proper sphere, and that they must seek elsewhere for a vocation to work out, might embolden a philanthropist to assume the position of scare-crow, and drive away the unclean birds from the flowers and the green leaves; on the other hand, the small results which appear to have hitherto attended such endeavors are calculated rather to induce those who have yet made, to relinquish them, than to lead others to follow in the same track. It is truly a disheartening task. To the critic himself no good, though some amusement occasionally, can be expected: to the criticised, good but rarely, for he is seldom convinced, and annoyance and rancour almost of course; and, even in those few cases where the voice crying "in the wilderness" produces its effect, the one thistle that abandons the attempt at bearing figs sees its neighbours still believing in their success, and soon has its own place filled up. The sentence of those who do not read is the best criticism on those who will not think.

It is acting on these considerations that we propose not to take count of any works that do not either show a purpose achieved or give promise of a worthy event; while of such we hope to overlook none.

We believe it may safely be assumed that at no previous period has the public been more buzzed round by triviality and common-place; but we hold firm, at the same time, that at none other has there been a greater or a grander body of genius, or so honorable a display of well cultivated taste and talent. Certainly the public do not seem to know this: certainly the critics deny it, or rather speak as though they never contemplated that such a position would be advanced: but, if the fact be so, it will make itself known, and the poets of this day will assert themselves, and take their places.

Of these it is our desire to speak truthfully, indeed, and without compromise, but always as bearing in mind that the inventor is more than the commentator, and the book more than the notes ; and that, if it is we who speak, we do so not for ourselves, nor as of ourselves.

The work of Arthur Hugh Clough now before us, (we feel warranted in dropping the *Mr.* even at his first work,) unites the most enduring forms of nature, and the most unsophisticated conditions of life and character, with the technicalities of speech, of manners, and of persons of an Oxford reading party in the long vacation. His hero is


" Philip Hewson, the poet,

Hewson, the radical hot, hating lords and scorning ladies ;"


and his heroine is no heroine, but a woman, "Elspie, the quiet, the brave."

The metre he has chosen, the hexametral, harmonises with the spirit of primitive simplicity in which the poem is conceived ; is itself a background, as much as are " Knoydart, Croydart, Moydart, Morrer, and Ardnamurchan ;" and gives a new individuality to the passages of familiar narrative and every day conversation. It has an intrinsic appropriateness ; although, at first thought of the subject, this will, perhaps, be scarcely admitted of so old and so stately a rhythmical form.

As regards execution, however, there may be noted, in qualification of much pliancy and vigour, a certain air of experiment in occasional passages, and a license in versification, which more than warrants a warning "to expect every kind of irregularity in these modern hexameters." The following lines defy all efforts at reading in dactyls or spondees, and require an almost complete transposition of accent.

"There was a point which I forgot, which our gallant Highland homes
[have ;"—
"While the little drunken Piper came across to shake hands with
[Lindsay :"—
"Something of the world, of men and women: you will not refuse me."

In the first of these lines, the omission of the former " *which,*" would remove all objection ; and there are others where a final syllable appears clearly deficient ; as thus :—

" Only the road and larches and ruinous millstead between " [*them*] :—
" Always welcome the stranger : I may say, delighted to see [*such*]
Fine young men :"—

"Nay, never talk : listen now. What I say you can't apprehend" [*yet*] :—
" Laid her hand on her lap. Philip took it. She did not resist " [*him*] :—

Yet the following would be scarcely improved by greater exactness :

" Roaring after their prey, do seek their meat from God ;"

Nor, perhaps, ought this to be made correct :

" Close as the bodies and intertwining limbs of athletic wrestlers."

The aspect of *fact* pervading " the Bothie of Toper-na-fuosich," —(in English, " the hut of the bearded well," a somewhat singular title, to say the least,) is so strong and complete as to render necessary the few words of dedication, where, in inscribing the poem, (or, as the author terms it, " trifle,") to his " long-vacation pupils," he expresses a hope, that they " will not be displeased if, in a fiction, purely fiction, they are here and there reminded of times enjoyed together."

As the story opens, the Oxford party are about to proceed to dinner at "the place of the Clansmen's meeting." Their characters, discriminated with the nicest taste, and perfectly worked out, are thus introduced :

" Be it recorded in song who was first, who last, in dressing.
Hope was the first, black-tied, white-waistcoated, simple, his Honor ;
For the postman made out he was son to the Earl of Ilay,
(As, indeed, he was to the younger brother, the Colonel) ;
Treated him therefore with special respect, doffed bonnet, and ever
Called him his Honor : his Honor he therefore was at the cottage ;
Always his Honor at least, sometimes the Viscount of Ilay.

" Hope was the first, his Honor ; and, next to his Honor, the Tutor.
Still more plain the tutor, the grave man nicknamed Adam,
White-tied, clerical, silent, with antique square-cut waistcoat,
Formal, unchanged, of black cloth, but with sense and feeling beneath
Skilful in ethics and logic, in Pindar and poets unrivalled ; [it ;
Shady in Latin, said Lindsay, but *topping* in plays and Aldrich.

" Somewhat more splendid in dress, in a waistcoat work of a lady,
Lindsay succeeded, the lively, the cheery, cigar-loving Lindsay,
Lindsay the ready of speech, the Piper, the Dialectician :
This was his title from Adam, because of the words he invented,
Who in three weeks had created a dialect new for the party.

" Hewson and Hobbes were down at the *matutine* bathing ; of course
Arthur Audley, the bather *par excellence* glory of headers :
Arthur they called him for love and for euphony : so were they bathing
There where in mornings was custom, where, over a ledge of granite,
Into a granite bason descended the amber torrent.
There were they bathing and dressing : it was but a step from the cot-
Only the road and larches and ruinous millstead between. [tage,
Hewson and Hobbes followed quick upon Adam ; on them followed
 [Arthur.

" Airlie descended the last, splendescent as god of Olympus.
When for ten minutes already the fourwheel had stood at the gateway ;
He, like a god, came leaving his ample Olympian chamber."—pp. 5, 6.

A peculiar point of style in this poem, and one which gives a certain classic character to some of its more familiar aspects, is the frequent recurrence of the same line, and the repeated definition of a personage

by the same attributes. Thus, Lindsay is "the Piper, the Dialectician," Arthur Audley "the glory of headers," and the tutor "the grave man nicknamed Adam," from beginning to end ; and so also of the others.

Omitting the after-dinner speeches, with their

"Long constructions strange and plusquam-Thucydidean,"

that only of "Sir Hector, the Chief and the Chairman ;" in honor of the Oxonians, than which nothing could be more unpoetically truthful, is preserved, with the acknowledgment, ending in a sarcasm at the game laws, by Hewson, who, as he is leaving the room, is accosted by "a thin man, clad as the Saxon :"

"'Young man, if ye pass thro' the Braes o'Lochaber,
See by the Loch-side ye come to the Bothie of Toper-na-fuosich.'"—p. 9.

Throughout this scene, as through the whole book, no opportunity is overlooked for giving individuality to the persons introduced : Sir Hector, of whom we lose sight henceforward, the attaché, the Guardsman, are not mere names, but characters : it is not enough to say that two tables were set apart "for keeper and gillie and peasant:" there is something to be added yet; and with others assembled around them were

"Pipers five or six ; *among them the young one, the drunkard.*"

The morrow's conversation of the reading party turns on "noble ladies and rustic girls, their partners." And here speaks out Hewson the chartist :

* * * * * * * * * * *

"'Never (of course you will laugh, but of course all the same I shall say
Never, believe me, revealed itself to me the sexual glory, [it,)
Till, in some village fields, in holidays now getting stupid,
One day sauntering long and listless, as Tennyson has it,
Long and listless strolling, ungainly in hobbydihoyhood,
Chanced it my eye fell aside on a capless bonnetless maiden,
Bending with three-pronged fork in a garden uprooting potatoes.
Was it the air? who can say? or herself? or the charm of the labor?
But a new thing was in me, and longing delicious possessed me,
Longing to take her and lift her, and put her away from her slaving.
Was it to clasp her in lifting, or was it to lift her by clasping,
Was it embracing or aiding was most in my mind? Hard question.
But a new thing was in me: I too was a youth among maidens.
Was it the air? who can say? But, in part, 'twas the charm of the
 [labor.'"

And he proceeds in a rapture of talk on the beauty of household service.

Hereat Arthur remarks :

"'Is not all this just the same that one hears at common room
 [breakfasts,
Or perhaps Trinity-wines, about Gothic buildings and beauty?'"
—p. 13.

The character of Hobbes, called into energy by this observation, is perfectly developed in the lines succeeding:

"And with a start from the sofa came Hobbes; with a cry from the sofa,
There where he lay, the great Hobbes, contemplative, corpulent, witty;
Author forgotten and silent of currentest phrase and fancy;
Mute and exuberant by turns, a fountain at intervals playing,
Mute and abstracted, or strong and abundant as rain in the tropics;
Studious; careless of dress; inobservant; by smooth persuasions
Lately decoyed into kilt on example of Hope and the Piper,
Hope an Antinous mere, Hyperion of calves the Piper.
"'Ah! could they only be taught,' he resumed, 'by a Pugin of women
How even churning and washing, the dairy, the scullery duties,
Wait but a touch to redeem and convert them to charms and attractions;
Scrubbing requires for true grace but frank and artistical handling,
And the removal of slops to be ornamentally treated!"—pp. 13, 14.

Here, in the tutor's answer to Hewson, we come on the moral of the poem, a moral to be pursued through commonplace lowliness of station and through high rank, into the habit of life which would be, in the one, not petty,—in the other, not overweening,—in any, calm and dignified.

"'You are a boy; when you grow a man, you'll find things alter.
You will learn to seek the good, to scorn the attractive,
Scorn all mere cosmetics, as now of rank and fashion,
Delicate hands, and wealth, so then of poverty also,
Poverty truly attractive, more truly, I bear you witness.
Good, wherever found, you will choose, be it humble or stately,
Happy if only you find, and, finding, do not lose it.'"—p. 14.

When the discussion is ended, the party propose to separate, some proceeding on their tour; and Philip Hewson will be of these.

"'Finally, too,' from the kilt and the sofa said Hobbes in conclusion,
'Finally Philip must hunt for that home of the probable poacher,
Hid in the Braes of Lochaber, the Bothie of what-did-he-call-it.
Hopeless of you and of us, of gillies and marquises hopeless,
Weary of ethic and logic, of rhetoric yet more weary,
There shall he, smit by the charm of a lovely potatoe-uprooter,
Study the question of sex in the Bothie of what-did-he-call-it."'—
[p. 18.

The action here becomes divided; and, omitting points of detail, we must confine ourselves to tracing the development of the idea in which the subject of the poem consists.

Philip and his companions, losing their road, are received at a farm, where they stay for three days: and his experience of himself begins. He comes prepared; and, if he seems to love the "golden-haired Katie," it is less that she is "the youngest and comeliest daughter" than because of her position, and that in that she realises his preconceived wishes. For three days he is with her and about her; and he

remains when his friends leave the farm-house. But his love is no
more than the consequence of his principles ; it is his own will uncon-
sidered and but half understood. And a letter to Adam tells how it
had an end :

" ' I was walking along some two miles from the cottage,
Full of my dreamings. A girl went by in a party with others :
She had a cloak on,—was stepping on quickly, for rain was beginning ;
But, as she passed, from the hood I saw her eyes glance at me :—
So quick a glance, so regardless I, that, altho' I felt it,
You couldn't properly say our eyes met ; she cast it, and left it.
It was three minutes, perhaps, ere I knew what it was. I had seen her
Somewhere before, I am sure ; but that wasn't it,—not its import.
No ; it had seemed to regard me with simple superior insight,
Quietly saying to herself : ' Yes, there he is still in his fancy.
Doesn't yet see we have here just the things he is used to elsewhere,
And that the things he likes here, elsewhere he wouldn't have looked at ;
People here, too, are people, and not as fairy-land creatures.
He is in a trance, and possessed,—I wonder how long to continue.
It is a shame and pity,—and no good likely to follow.'—
Something like this ; but, indeed, I cannot the least define it.
Only, three hours thence, I was off and away in the moor-land,
Hiding.myself from myself, if I could, the arrow within me.' "—p. 29.

Philip Hewson has been going on

" Even as cloud passing subtly unseen from mountain to mountain,
Leaving the crest of Benmore to be palpable next on Benvohrlich,
Or like to hawk of the hill, which ranges and soars in its hunting,
Seen and unseen by turns." And these are his words in the
[mountains :

" ' Surely the force that here sweeps me along in its violent impulse,
Surely my strength shall be in her, my help and protection about her,
Surely in inner-sweet gladness and vigor of joy shall sustain her ;
Till, the brief winter o'erpast, her own true sap in the springtide
Rise, and the tree I have bared be verdurous e'en as aforetime :
Surely it may be, it should be, it must be. Yet, ever and ever,
' Would I were dead,' I keep saying, ' that so I could go and uphold
[her.' "—pp. 26, 27.

And, meanwhile, Katie, among the others, is dancing and smiling
still on some one who is to her all that Philip had ever been.

When Hewson writes next, his experience has reached its second
stage. He is at Balloch, with the aunt and the cousin of his friend
Hope : and the lady Maria has made his beliefs begin to fail and totter,
and he feels for something to hold firmly. He seems to think, at one
moment, that the mere knowledge of the existence of such an one
ought to compensate for lives of drudgery hemmed in with want ; then
he turns round on himself with, " How shall that be ?" And, at length,
he appeases his questions, saying that it must and should be so, if it is.

After this, come scraps of letters, crossed and recrossed, from the

Bothie of Toper-na-fuosich. In his travelling towards home, a horse cast a shoe, and they were directed to David Mackaye. Hewson is still in the clachan hard by when he urges his friend to come to him: and he comes.

"There on the blank hill-side, looking down through the loch to the
There, with a runnel beside, and pine-trees twain before it, [ocean
There, with the road underneath, and in sight of coaches and steamers,
Dwelling of David Mackaye and his daughters, Elspie and Bella,
Sends up a column of smoke the Bothie of Toper-na-fuosich.

"So on the road they walk, by the shore of the salt sea-water,
Silent a youth and maid, and elders twain conversing."—pp. 36, 37.

"Ten more days, with Adam, did Philip abide at the changehouse;
Ten more nights they met, they walked with father and daughter.
Ten more nights; and, night by night, more distant away were [39.
Philip and she; every night less heedful, by habit, the father.—pp. 38,

From this point, we must give ourselves up to quotation; and the narrow space remaining to us is our only apology to the reader for making any omission whatever in these extracts.

"For she confessed, as they sat in the dusk, and he saw not her blushes,
Elspie confessed, at the sports, long ago, with her father, she saw him,
When at the door the old man had told him the name of the Bothie;
There, after that, at the dance; yet again at the dance in Rannoch;
And she was silent, confused. Confused much rather Philip
Buried his face in his hands, his face that with blood was bursting.
Silent, confused; yet by pity she conquered her fear, and continued:
'Katie is good and not silly: be comforted, Sir, about her;
Katie is good and not silly; tender, but not, like many,
Carrying off, and at once, for fear of being seen, in the bosom
Locking up as in a cupboard, the pleasure that any man gives them,
Keeping it out of sight as a prize they need be ashamed of:
That is the way, I think, Sir, in England more than in Scotland.
No; she lives and takes pleasure in all, as in beautiful weather;
Sorry to lose it; but just as we would be to lose fine weather.
There were at least five or six,—not there; no, that I don't say,
But in the country about,—you might just as well have been courting.
That was what gave me much pain; and (you won't remember that tho'),
Three days after, I met you, beside my Uncle's walking;
And I was wondering much, and hoped you wouldn't notice;
So, as I passed, I couldn't help looking. You didn't know me;
But I was glad when I heard, next day, you were gone to the teacher.'

"And, uplifting his face at last, with eyes dilated,
Large as great stars in mist, and dim with dabbled lashes,
Philip, with new tears starting,
 'You think I do not remember,'
Said, 'suppose that I did not observe. Ah me! shall I tell you?
Elspie, it was your look that sent me away from Rannoch.'
And he continued more firmly, altho' with stronger emotion.
'Elspie, why should I speak it? You cannot believe it, and should not.
Why should I say that I love, which I all but said to another?

Yet, should I dare, should I say, Oh Elspie you only I love, you,
First and sole in my life that has been, and surely that shall be ;
Could, oh could, you believe it, oh Elspie, believe it, and spurn not ?
Is it possible,—possible, Elspie ?'
 ' Well,' she answered,
Quietly, after her fashion, still knitting ; ' Well, I think of it.
Yes, I don't know, Mr. Philip ; but only it feels to me strangely,—
Like to the high new bridge they used to build at, below there,
Over the burn and glen, on the road. You won't understand me.
Sometimes I find myself dreaming at nights about arches and bridges ;
Sometimes I dream of a great invisible hand coming down, and
Dropping the great key-stone in the middle.'
 " But while she was speaking,—
So it happened,—a moment she paused from her work, and, pondering,
Laid her hand on her lap. Philip took it, she did not resist.
So he retained her fingers, the knitting being stopped. But emotion
Came all over her more and more, from his hand, from her heart, and
Most from the sweet idea and image her brain was renewing.
So he retained her hand, and, his tears down-dropping on it,
Trembling a long time, kissed it at last : and she ended.
And, as she ended, up rose he, saying : ' What have I heard ? Oh !
What have I done, that such words should be said to me? Oh ! I see it,
See the great key-stone coming down from the heaven of heavens.'
And he fell at her feet, and buried his face in her apron.
" But, as, under the moon and stars, they went to the cottage,
Elspie sighed and said : ' Be patient, dear Mr. Philip ;
Do not do anything hasty. It is all so soon, so sudden.
Do not say anything yet to any one.'
 ' Elspie,' he answered,
" Does not my friend go on Friday ? I then shall see nothing of you :
Do not I myself go on Monday ? ' But oh !' he said, ' Elspie,
Do as I bid you, my child ; do not go on calling me *Mr*.
Might I not just as well be calling you *Miss Elspie* ?
Call me, this heavenly night, for once, for the first time, Philip.'
" ' Philip,' she said, and laughed, and said she could not say it.
' Philip,' she said. He turned, and kissed the sweet lips as they said it.
" But, on the morrow, Elspie kept out of the way of Philip ;
And, at the evening seat, when he took her hand by the alders,
Drew it back, saying, almost peevishly :
 " ' No, Mr. Philip ;
I was quite right last night : it is too soon, too sudden,
What I told you before was foolish, perhaps,—was hasty.
When I think it over, I am shocked and terrified at it.' "
" Ere she had spoken two words, had Philip released her fingers ;
As she went on, he recoiled, fell back, and shook, and shivered.
There he stood, looking pale and ghastly ; when she had ended,
Answering in hollow voice :
 " ' It is true ; oh ! quite true, Elspie.
Oh ! you are always right ; oh ! what, what, have I been doing ?
I will depart to-morrow. But oh ! forget me not wholly,
Wholly, Elspie, nor hate me ; no, do not hate me, my Elspie ' "

"But a revulsion passed thro' the brain and bosom of Elspie;
And she got up from her seat on the rock, putting by her knitting,
Went to him where he stood, and answered :

 "'No, Mr. Philip:
No ; you are good, Mr. Philip, and gentle ; and I am the foolish :
No, Mr. Philip ; forgive me.'

 "She stepped right to him, and boldly
Took up his hand, and placed it in her's, he daring no movement ;
Took up the cold hanging hand, up-forcing the heavy elbow.
'I am afraid,' she said ; 'but I will ;' and kissed the fingers.
And he fell on his knees, and kissed her own past counting.
"As he was kissing her fingers, and knelt on the ground before her,
Yielding, backward she sank to her seat, and, of what she was doing
Ignorant, bewildered, in sweet multitudinous vague emotion,
Stooping, knowing not what, put her lips to the curl on his forehead.
And Philip, raising himself, gently, for the first time, round her
Passing his arms, close, close, enfolded her close to his bosom.
"As they went home by the moon, 'Forgive me, Philip,' she whispered :
'I have so many things to talk of all of a sudden,
I who had never once thought a thing in my ignorant Highlands.'"—
 [pp. 39-44.

We may spare criticism here, for what reader will not have felt such poetry ? There is something in this of the very tenderness of tenderness ; this is true delicacy, fearless and unembarrassed. Here it seems almost captious to object : perhaps, indeed, it is rather personal whim than legitimate criticism which makes us take some exception at "the curl on his forehead ;" yet somehow there seems a hint in it of the pet curate.

Elspie's doubts now return upon her with increased force ; and it is not till after many conversations with the "teacher" that she allows her resolve to be fixed. So, at last,

"There, upon Saturday eve, in the gorgeous bright October,
Under the alders knitting, gave Elspie her troth to Philip."

And, after their talk, she feels strong again, and fit to be his.—Then they rise.

"'But we must go, Mr. Philip.'

 "'I shall not go at all,' said
He, 'if you call me *Mr.* Thank Heaven ! that's well over !'
"'No, but it's not,' she said ; 'it is not over, nor will be.
Was it not, then,' she asked, 'the name I called you first by ?
No, Mr. Philip, no. You have kissed me enough for two nights.
No.—Come, Philip, come, or I'll go myself without you.' [47, 48.
"'You never call me Philip,' he answered, 'until I kiss you.'"—pp.

David Mackaye gives his consent ; but first Hewson must return to College, and study for a year.

His views have not been stationary. To his old scorn for the idle of

the earth had succeeded the surprise that overtook him at Balloch: and he would now hold to his creed, yet not as rejecting his experience. Some, he says, were made for use; others for ornament; but let these be so *made*, of a truth, and not such as find themselves merely thrust into exemption from labor. Let each know his place, and take it,

"For it is beautiful only to do the thing we are meant for."

And of his friend urging Providence he can only, while answering that doubtless he must be in the right, ask where the limit comes between circumstance and Providence, and can but wish for a great cause, and the trumpet that should call him to God's battle, whereas he sees

"Only infinite jumble and mess and dislocation,
Backed by a solemn appeal, ' For God's sake, do not stir there.' "

And the year is now out.

" Philip returned to his books, but returned to his Highlands after. . . .
There in the bright October, the gorgeous bright October,
When the brackens are changed, and heather blooms are faded,
And, amid russet of heather and fern, green trees are bonnie,
There, when shearing had ended, and barley-stooks were garnered,
David gave Philip to wife his daughter, his darling Elspie ;
Elspie, the quiet, the brave, was wedded to Philip, the poet.
So won Philip his bride. They are married, and gone to New Zealand.
Five hundred pounds in pocket, with books and two or three pictures,
Tool-box, plough, and the rest, they rounded the sphere to New Zealand.
There he hewed and dug ; subdued the earth and his spirit."—pp. 52-55.

Among the prominent attributes of this poem is its completeness. The elaboration, not only of character and of mental discipline, but of incident also, is unbroken. The absence of all mention of Elspie in the opening scene and again at the dance at Rannoch may at first seem to be a failure in this respect ; but second thoughts will show it to be far otherwise : for, in the former case, her presence would not have had any significance for Hewson, and, in the latter, would have been overlooked by him save so far as might warrant a future vague recollection, pre-occupied as his eyes and thoughts were by another. There is one condition still under which we have as yet had little opportunity of displaying this quality ; but it will be found to be as fully carried out in the descriptions of nature. In the first of our extracts the words are few, but stand for many.

"Meäly glen, the heart of Lochiel's fair forest,
Where Scotch firs are darkest and amplest, and intermingle
Grandly with rowan and ash ;—in Mar you have no ashes ;
There the pine is alone or relieved by birch and alder."—p. 22.

In the next the mere sound and the names go far towards the entire effect ; but not so far as to induce any negligence in essential details :

" As, at return of tide, the total weight of ocean,
Drawn by moon and sun from Labrador and Greenland,

Sets in amain in the open space betwixt Mull and Scarfa,
Heaving, swelling, spreading, the might of the mighty Atlantic ;
There into cranny and slit of the rocky cavernous bottom
Settles down ; and with dimples huge the smooth sea-surface
Eddies, coils, and whirls, by dangerous Corryvreckan."—p. 52.

Two more passages, and they must suffice as examples. Here the
isolation is perfect ; but it is the isolation, not of the place and the actors
only ; it is, as it were, almost our own in an equal degree ;

" Ourselves too seeming
Not as spectators, accepted into it, immingled, as truly
Part of it as are the kine in the field lying there by the birches."
" There, across the great rocky wharves a wooden bridge goes,
Carrying a path to the forest ; below,—three hundred yards, say,—
Lower in level some twenty-five feet, thro' flats of shingle,
Stepping-stones and a cart-track cross in the open valley.
But, in the interval here, the boiling pent-up water
Frees itself by a final descent, attaining a bason
Ten feet wide and eighteen long, with whiteness and fury
Occupied partly, but mostly pellucid, pure, a mirror ;
Beautiful there for the color derived from green rocks under ;
Beautiful most of all where beads of foam uprising
Mingle their clouds of white with the delicate hue of the stillness.
Cliff over cliff for its sides, with rowan and pendent birch-boughs,
Here it lies, unthought of above at the bridge and pathway,
Still more concealed from below by wood and rocky projection.
You are shut in, left alone with yourself and perfection of water,
Hid on all sides, left alone with yourself and the goddess of bathing."—
" So they bathed, they read, they roamed in glen and forest ;
Far amid blackest pines to the waterfall they shadow,
Far up the long long glen to the loch, and the loch beyond it
Deep under huge red cliffs, a secret."

In many of the images of this poem, as also in the volume " Ambar-
valia," the joint production of Clough and Thomas Burbidge, there is
a peculiar modernness, a reference distinctly to the means and habits
of society in these days, a recognition of every-day fact, and a willing-
ness to believe it as capable of poetry as that which, but for having
once been fact, would not now be tradition. There is a certain special
character in passages like the following, the familiarity of the matter
blending with the remoteness of the form of metre, such as should not
be overlooked in attempting to estimate the author's mind and views
of art :

" Still, as before (and as now), balls, dances, and evening parties,
Seemed like a sort of unnatural up-in-the-air balloon work,
As mere gratuitous trifling in presence of business and duty
As does the turning aside of the tourist to look at a landscape
Seem in the steamer or coach to the merchant in haste for the city."—
[p. 12.
" I was as one that sleeps on the railway ; one who, dreaming,

Hears thro' his dream the name of his home shouted out,—hears, and
[hears not,
Faint, and louder again, and less loud, dying in distance,—
Dimly conscious, with something of inward debate and choice, and
Sense of [present] claim and reality present; relapses,
Nevertheless, and continues the dream and fancy, while forward,
Swiftly, remorseless, the ear presses on, he knows not whither."—p. 38.

Indeed, the general adaptation of the style to the immediate matter,
the alternation of the poetic and the familiar, with a certain mixture
even of classical phrase and allusion, is highly appropriate, and may
almost be termed constant, except in occasional instances where more
poetry, and especially more conception and working out of images, is
introduced than squares with a strict observance of nature. Thus the
lines quoted where Elspie applies to herself the incident of "the high
new bridge" and "the great key-stone in the middle" are succeeded
by others (omitted in our extract) where the idea is followed into its
details; and there is another passage in which, through no less than seven-
teen lines, she compares herself to an inland stream disturbed and
hurried on by the mingling with it of the sea's tide. Thus also one of
the most elaborate descriptions in the poem,—an episode in itself of
the extremest beauty and finish, but, as we think, clearly misplaced,—
is a picture of the dawn over a great city, introduced into a letter of
Philip's, and that, too, simply as an image of his own mental condition.
There are but few poets for whom it would be superfluous to reflect
whether pieces of such-like mere poetry might not more properly form
part of the descriptive groundwork, and be altogether banished from
discourse and conversation, where the greater amount of their intrinsic
care and excellence becomes, by its position, a proportionally increasing
load of disregard for truthfulness.

For a specimen of a peculiarly noble spirit which pervades the whole
work, we would refer the reader to the character of Arthur Audley,
unnecessary to the story, but most important to the sentiment; for a
comprehensive instance of minute feeling for individuality, to the nar-
rative of Lindsay and the corrections of Arthur on returning from their
tour.

"He to the great *might have been* upsoaring, sublime and ideal ;
He to the merest *it was* restricting, diminishing, dwarfing ;"
For pleasant ingenuity, involving, too, a point of character, to the final
letter of Hobbes to Philip, wherein, in a manner made up of playful
subtlety and real poetical feeling, he proves how "this Rachel and
Leah is marriage."

"The Bothie of Toper-na-fuosich" will not, it is to be feared, be
extensively read; its length combined with the metre in which it is
written, or indeed a first hasty glance at the contents, does not allure the

majority even of poetical readers ; but it will not be left or forgotten by such as fairly enter upon it. This is a poem essentially thought and studied, if not while in the act of writing, at least as the result of a condition of mind ; and the author owes it to the appreciations of all into whose hands it shall come, and who are willing to judge for themselves, to call it, should a second edition appear, by its true name ;— not a trifle, but a work.

That public attention should have been so little engaged by this poem is a fact in one respect somewhat remarkable, as contrasting with the notice which the " Ambarvalia " has received. Nevertheless, independently of the greater importance of "the Bothie" in length and development, it must, we think, be admitted to be written on sounder and more matured principles of taste,—the style being sufficiently characterized and distinctive without special prominence, whereas not a few of the poems in the other volume are examples rather of style than of thought, and might be held in recollection on account of the former quality alone.

Her First Season.

(Sonnet.)

He gazed her over, from her eyebrows down
 Even to her feet : he gazed so with the good
 Undoubting faith of fools, much as who should
Accost God for a comrade. In the brown
Of all her curls he seemed to think the town
 Would make an acquisition ; but her hood
 Was not the newest fashion, and his brood
Of lady-friends might scarce approve her gown.
If I did smile, 'twas faintly ; for my cheeks
 Burned, thinking she'd be shown up to be sold,
 And cried about, in the thick jostling run
Of the loud world, till all the weary weeks
 Should bring her back to herself and to the old
 Familiar face of nature and the sun.

A Sketch from Nature.

The air blows pure, for twenty miles,
　　Over this vast countrié :
Over hill and wood and vale, it goeth,
　　Over steeple, and stack, and tree :
And there's not a bird on the wind but knoweth
　　How sweet these meadows be.

The swallows are flying beside the wood,
　　And the corbies are hoarsely crying ;
And the sun at the end of the earth hath stood,
And, thorough the hedge and over the road,
　　On the grassy slope is lying :
And the sheep are taking their supper-food
　　While yet the rays are dying.

Sleepy shadows are filling the furrows,
　　And giant-long shadows the trees are making ;
And velvet soft are the woodland tufts,
And misty-gray the low-down crofts ;
But the aspens there have gold-green tops,
　　And the gold-green tops are shaking :
The spires are white in the sun's last light ;—
And yet a moment ere he drops,
Gazes the sun on the golden slopes.

Two sheep, afar from fold,
　　Are on the hill-side straying,
With backs all silver, breasts all gold :
　　The merle is something saying,
Something very very sweet :—
　　' The day—the day—the day is done :'
There answereth a single bleat—
The air is cold, the sky is dimming,
And clouds are long like fishes swimming.

Sydenham Wood, 1849.

An End.

Love, strong as death, is dead.
Come, let us make his bed
 Among the dying flowers :
A green turf at his head ;
And a stone at his feet,
Whereon we may sit
 In the quiet evening hours.

He was born in the spring,
And died before the harvesting.
 On the last warm summer day
 He left us ;—he would not stay
 For autumn twilight cold and grey
Sit we by his grave and sing
 He is gone away.

To few chords, and sad, and low,
 Sing we so.
Be our eyes fixed on the grass,
Shadow-veiled, as the years pass,
While we think of all that was
 In the long ago.

PROVIDENT LIFE OFFICE,
50, REGENT STREET.
CITY BRANCH: 2, ROYAL EXCHANGE BUILDINGS.

ESTABLISHED 1806.

POLICY HOLDERS' CAPITAL, £1,156,783.

ANNUAL INCOME £143,000. BONUSES DECLARED £743.000.

Claims paid since the establishment of the Office, £1,765,000.

President.

THE RIGHT HONOURABLE EARL GREY.

Directors.

SIR RICHARD D. KING, BART., *Chairman.*

CAPT. W. JOHN WILLIAMS, *Deputy-Chairman.*

HENRY B. ALEXANDER, ESQ.
H. BLENCOWE CHURCHILL, ESQ.
GEORGE DACRE, ESQ.
ALEXANDER HENDERSON, M.D.
WILLIAM JUDD, ESQ.
THE HON. ARTHUR KINNAIRD.

WILLIAM OSTLER, ESQ.
GEORGE ROUND, ESQ.
JAMES SEDGWICK, ESQ.
THE REV. JAMES SHERMAN.
FREDERICK SQUIRE, ESQ.
WILLIAM HENRY STONE, ESQ.

J. A. BEAUMONT, ESQ. *Managing Director.*

Physician,

JOHN MACLEAN, M.D., F.S.S., 29, Upper Montague Street, Montague Square.

NINETEEN TWENTIETHS OF THE PROFITS ARE DIVIDED AMONG THE INSURED.

Examples of the Extinction of Premiums by the Surrender of Bonuses.

Date of Policy.	Sum Insured.	Original Premium.		Bonuses added subsequently, to be further increased annually.
1806	£2500	£79 10s.10d.	Extinguished	£1222 2s. 0d.
1811	1000	33 19 2	ditto	231 17 8
1818	1000	34 16 10	ditto	114 18 10

Examples of Bonuses added to other Policies.

Policy No.	Date.	Sum Insured.	Bonuses added.	Total with additions, to be further increased.
521	1807	£ 900	£ 982 12s.1d.	£1882 12s. 1d.
1174	1810	1200	1160 5 6	2360 5 6
3393	1820	5000	3558 17 8	8558 17 8

Prospectuses and full particulars may be obtained upon application to the Agents of the Office in all the principal towns of the United Kingdom, at the City Branch and at the head Office, No. 50, *Regent Street.*

Published Monthly, price 1s.

The Germ.

THIS Periodical will consist of original Poems, Stories to develope thought and principle, Essays concerning Art and other subjects, and analytic Reviews of current Literature—particularly of Poetry. Each number will also contain an Etching; the subject to be taken from the opening article of the month.

An attempt will be made, both intrinsically and by review, to claim for Poetry that place to which its present development in the literature of this country so emphatically entitles it.

The endeavour held in view throughout the writings on Art will be to encourage and enforce an entire adherence to the simplicity of nature; and also to direct attention, as an auxiliary medium, to the comparatively few works which Art has yet produced in this spirit. It need scarcely be added that the chief object of the etched designs will be to illustrate this aim practically, as far as the method of execution will permit; in which purpose they will be produced with the utmost care and completeness.

No. 2. *(Price One Shilling.)* FEBRUARY, 1850.

With an Etching by JAMES COLLINSON.

The Germ:

Thoughts towards Nature

In Poetry, Literature, and Art.

When whoso merely hath a little thought
　　Will plainly think the thought which is in him,—
　　Not imaging another's bright or dim,
Not mangling with new words what others taught;
When whoso speaks, from having either sought
　　Or only found,—will speak, not just to skim
　　A shallow surface with words made and trim,
But in that very speech the matter brought:
Be not too keen to cry—"So this is all!—
　　A thing I might myself have thought as well,
　　But would not say it, for it was not worth!"
　　Ask: "Is this truth?" For is it still to tell
　　That, be the theme a point or the whole earth,
Truth is a circle, perfect, great or small?

London:

AYLOTT & JONES, 8, PATERNOSTER ROW.

G. F. Tupper, Printer, Clement's Lane, Lombard Street.

CONTENTS.

To Correspondents.

All persons from whom Communications have been received, and who have not been otherwise replied to, are requested to accept the Editor's acknowledgments.

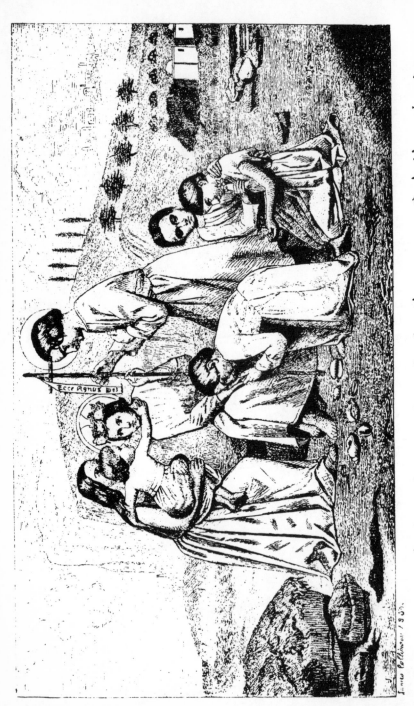

Ex ore infantium et Lactentium perfecizali laudem.

The Child Jesus.

A Record typical of the five Sorrowful Mysteries.

"O all ye that pass by the way, attend and see if there be any sorrow like to my sorrow."--
Lamentations i. 12.

I. The Agony in the Garden.

JOSEPH, a carpenter of Nazareth,
And his wife Mary had an only child,
Jesus : One holy from his mother's womb.
Both parents loved him : Mary's heart alone
Beat with his blood, and, by her love and his,
She knew that God was with her, and she strove
Meekly to do the work appointed her ;
To cherish him with undivided care
Who deigned to call her mother, and who loved
From her the name of son. And Mary gave
Her heart to him, and feared not ; yet she seemed
To hold as sacred that he said or did ;
And, unlike other women, never spake
His words of innocence again ; but all
Were humbly treasured in her memory
With the first secret of his birth. So strong
Grew her affection, as the child increased
In wisdom and in stature with his years,
That many mothers wondered, saying : "These
Our little ones claim in our hearts a place
The next to God ; but Mary's tenderness
Grows almost into reverence for her child.
Is he not of herself ? I' the temple when
Kneeling to pray, on him she bends her eyes,
As though God only heard her prayer through him.
Is he to be a prophet ? Nay, we know
That out of Galilee no prophet comes."

But all their children made the boy their friend.

Three cottages that overlooked the sea
Stood side by side eastward of Nazareth.
Behind them rose a sheltering range of cliffs,
Purple and yellow, verdure-spotted, red,
Layer upon layer built up against the sky.

In front a row of sloping meadows lay,
Parted by narrow streams, that rose above,
Leaped from the rocks, and cut the sands below
Into deep channels widening to the sea.

Within the humblest of these three abodes
Dwelt Joseph, his wife Mary, and their child.
A honeysuckle and a moss-rose grew,
With many blossoms, on their cottage front;
And o'er the gable warmed by the South
A sunny grape vine broadened shady leaves
Which gave its tendrils shelter, as they hung
Trembling upon the bloom of purple fruit.
And, like the wreathed shadows and deep glows
Which the sun spreads from some old oriel
Upon the marble Altar and the gold
Of God's own Tabernacle, where he dwells
For ever, so the blossoms and the vine,
On Jesus' home climbing above the roof,
Traced intricate their windings all about
The yellow thatch, and part concealed the nests
Whence noisy close-housed sparrows peeped unseen.
And Joseph had a little dove-cote placed
Between the gable-window and the eaves,
Where two white turtle doves (a gift of love
From Mary's kinsman Zachary to her child)
Cooed pleasantly; and broke upon the ear
The ever dying sound of falling waves.

And so it came to pass, one Summer morn,
The mother dove first brought her fledgeling out
To see the sun. It was her only one,
And she had breasted it through three long weeks
With patient instinct till it broke the shell;
And she had nursed it with all tender care,
Another three, and watched the white down grow
Into full feather, till it left her nest.
And now it stood outside its narrow home,
With tremulous wings let loose and blinking eyes;
While, hovering near, the old dove often tried
By many lures to tempt it to the ground,
That they might feed from Jesus' hand, who stood
Watching them from below. The timid bird
At last took heart, and, stretching out its wings,

Brushed the light vine-leaves as it fluttered down.
Just then a hawk rose from a tree, and thrice
Wheeled in the air, and poised his aim to drop
On the young dove, whose quivering plumage swelled
About the sunken talons as it died.
Then the hawk fixed his round eye on the child,
Shook from his beak the stained down, screamed, and flapped
His broad arched wings, and, darting to a cleft
I' the rocks, there sullenly devoured his prey.
And Jesus heard the mother's anguished cry,
Weak like the distant sob of some lost child,
Who in his terror runs from path to path,
Doubtful alike of all ; so did the dove,
As though death-stricken, beat about the air ;
Till, settling on the vine, she drooped her head
Deep in her ruffled feathers. She sat there,
Brooding upon her loss, and did not move
All through that day.

 And the child Jesus wept,
And, sitting by her, covered up his face :
Until a cloud, alone between the earth
And sun, passed with its shadow over him.
Then Jesus for a moment looked above ;
And a few drops of rain fell on his brow,
Sad, as with broken hints of a lost dream,
Or dim foreboding of some future ill.

Now, from a garden near, a fair-haired girl
Came, carrying a handful of choice flowers,
Which in her lap she sorted orderly,
As little children do at Easter-time
To have all seemly when their Lord shall rise.
Then Jesus' covered face she gently raised,
Placed in his hand the flowers, and kissed his cheek
And tried with soothing words to comfort him ;
He from his eyes spoke thanks.

 But still the tears,
Fast trickling down his face, drop upon drop,
Fell to the ground. That sad look left him not
Till night brought sleep, and sleep closed o'er his woe.

II. The Scourging.

Again there came a day when Mary sat
Within the latticed doorway's fretted shade,
Working in bright and many colored threads
A girdle for her child, who at her feet
Lay with his gentle face upon her lap.
Both little hands were crossed and tightly clasped
Around her knee. On them the gleams of light
Which broke through overhanging blossoms warm,
And cool transparent leaves, seemed like the gems
Which deck Our Lady's shrine when incense-smoke
Ascends before her, like them, dimly seen
Behind the stream of white and slanting rays
Which came from heaven, as a veil of light,
Across the darkened porch, and glanced upon
The threshold-stone ; and here a moth, just born
To new existence, stopped upon her flight,
To bask her blue-eyed scarlet wings spread out
Broad to the sun on Jesus' naked foot,
Advancing its warm glow to where the grass,
Trimmed neatly, grew around the cottage door.

And the child, looking in his mother's face,
Would join in converse upon holy things
With her, or, lost in thought, would seem to watch
The orange-belted wild bees when they stilled
Their hum, to press with honey-searching trunk
The juicy grape ; or drag their waxed legs
Half buried in some leafy cool recess
Found in a rose ; or else swing heavily
Upon the bending woodbine's fragrant mouth,
And rob the flower of sweets to feed the rock,
Where, in a hazel-covered crag aloft
Parting two streams that fell in mist below,
The wild bees ranged their waxen vaulted cells.

As the time passed, an ass's yearling colt,
Bearing a heavy load, came down the lane
That wound from Nazareth by Joseph's house,
Sloping down to the sands. And two young men,
The owners of the colt, with many blows
From lash and goad wearied its patient sides;
Urging it past its strength, so they might win
Unto the beach before a ship should sail.

Passing the door, the ass turned round its head,
And looked on Jesus : and he knew the look ;
And, knowing it, knew too the strange dark cross
Lying upon its shoulders and its back.
It was a foal of that same ass which bare
The infant and the mother, when they fled
To Egypt from the edge of Herod's sword.
And Jesus watched them, till they reached the sands.
Then, by his mother sitting down once more,
Once more there came that shadow of deep grief
Upon his brow when Mary looked at him :
And she remembered it in days that came.

III. The Crowning with Thorns.

And the time passed.
 And, one bright summer eve,
The child sat by himself upon the beach,
While Joseph's barge freighted with heavy wood,
Bound homewards, slowly labored thro' the calm.
And, as he watched the long waves swell and break,
Run glistening to his feet, and sink again,
Three children, and then two, with each an arm
Around the other, throwing up their songs,
Such happy songs as only children know,
Came by the place where Jesus sat alone.
But, when they saw his thoughtful face, they ceased,
And, looking at each other, drew near him ;
While one who had upon his head a wreath
Of hawthorn flowers, and in his hand a reed,
Put these both from him, saying, " Here is one
Whom you shall all prefer instead of me
To be our king ;" and then he placed the wreath
On Jesus' brow, who meekly bowed his head.
And, when he took the reed, the children knelt,
And cast their simple offerings at his feet :
And, almost wondering why they loved him so,
Kissed him with reverence, promising to yield
Grave fealty. And Jesus did return
Their childish salutations ; and they passed
Singing another song, whose music chimed
With the sea's murmur, like a low sweet chant
Chanted in some wide church to Jesus Christ.

And Jesus listened till their voices sank
Behind the jutting rocks, and died away :
Then the wave broke, and Jesus felt alone.
Who being alone, on his fair countenance
And saddened beauty all unlike a child's
The sun of innocence did light no smile,
As on the group of happy faces gone.

IV. Jesus Carrying his Cross.

And, when the barge arrived, and Joseph bare
The wood upon his shoulders, piece by piece,
Up to his shed, Jesus ran by his side,
Yearning for strength to help the aged man
Who tired himself with work all day for him.
But Joseph said : " My child, it is God's will
That I should work for thee until thou art
Of age to help thyself.—Bide thou his time
Which cometh—when thou wilt be strong enough,
And on thy shoulders bear a tree like this."
So, while he spake, he took the last one up,
Settling it with heaved back, fetching his breath.
Then Jesus lifted deep prophetic eyes
Full in the old man's face, but nothing said,
Running still on to open first the door.

V. The Crucifixion.

Joseph had one ewe-sheep ; and she brought forth,
Early one season, and before her time,
A weakly lamb. It chanced to be upon
Jesus' birthday, when he was eight years old.
So Mary said—" We'll name it after him,"—
(Because she ever thought to please her child)—
" And we will sign it with a small red cross
Upon the back, a mark to know it by."
And Jesus loved the lamb ; and, as it grew
Spotless and pure and loving like himself,
White as the mother's milk it fed upon,
He gave not up his care, till it became
Of strength enough to browse ; and then, because
Joseph had no land of his own, being poor,
He sent away the lamb to feed amongst
A neighbour's flock some distance from his home ;
Where Jesus went to see it every day.

One late Spring eve, their daily work being done,
Mother and child, according to their wont,
Went, hand in hand, their chosen evening walk.
A pleasant wind rose from the sea, and blew
Light flakes of waving silver o'er the fields
Ready for mowing, and the golden West
Warmed half the sky : the low sun flickered through
The hedge-rows, as they passed ; while hawthorn trees
Scattered their snowy leaves and scent around.
The sloping woods were rich in varied leaf,
And musical in murmur and in song.

Long ere they reached the field, the wistful lamb
Saw them approach, and ran from side to side
The gate, pushing its eager face between
The lowest bars, and bleating for pure joy.
And Jesus, kneeling by it, fondled with
The little creature, that could scarce find how
To show its love enough ; licking his hands,
Then, starting from him, gambolled back again,
And, with its white feet upon Jesus' knees,
Nestled its head by his : and, as the sun
Sank down behind them, broadening as it neared
The low horizon, Mary thought it seemed
To clothe them like a glory.—But her look
Grew thoughtful, and she said : "I had, last night,
A wandering dream. This brings it to my mind ;
And I will tell it thee as we walk home.

" I dreamed a weary way I had to go
Alone, across an unknown land : such wastes
We sometimes see in visions of the night,
Barren and dimly lighted. There was not
A tree in sight, save one seared leafless trunk,
Like a rude cross ; and, scattered here and there,
A shrivelled thistle grew : the grass was dead,
And the starved soil glared through its scanty tufts
In bare and chalky patches, cracked and hot,
Chafing my tired feet, that caught upon
Its parched surface ; for a thirsty sun
Had sucked all moisture from the ground it burned,
And, red and glowing, stared upon me like
A furnace eye when all the flame is spent.
I felt it was a dream ; and so I tried

To close my eyes, and shut it out from sight.
Then, sitting down, I hid my face; but this
Only increased the dread; and so I gazed
With open eyes into my dream again.
The mists had thickened, and had grown quite black
Over the sun; and darkness closed round me.
(Thy father said it thundered towards the morn.)
But soon, far off, I saw a dull green light
Break through the clouds, which fell across the earth,
Like death upon a bad man's upturned face.
Sudden it burst with fifty forked darts
In one white flash, so dazzling bright it seemed
To hide the landscape in one blaze of light.
When the loud crash that came down with it had
Rolled its long echo into stillness, through
The calm dark silence came a plaintive sound;
And, looking towards the tree, I saw that it
Was scorched with the lightning; and there stood
Close to its foot a solitary sheep
Bleating upon the edge of a deep pit,
Unseen till now, choked up with briars and thorns;
And into this a little snow white lamb,
Like to thine own, had fallen. It was dead
And cold, and must have lain there very long;
While, all the time, the mother had stood by,
Helpless, and moaning with a piteous bleat.
The lamb had struggled much to free itself,
For many cruel thorns had torn its head
And bleeding feet; and one had pierced its side,
From which flowed blood and water. Strange the things
We see in dreams, and hard to understand;—
For, stooping down to raise its lifeless head,
I thought it changed into the quiet face
Of my own child. Then I awoke, and saw
The dim moon shining through the watery clouds
On thee awake within thy little bed."

Then Jesus, looking up, said quietly:
" We read that God will speak to those he loves
Sometimes in visions. He might speak to thee
Of things to come his mercy partly veils
From thee, my mother; or perhaps, the thought
Floated across thy mind of what we read

Aloud before we went to rest last night ;—
I mean that passage in Isaias' book,
Which tells about the patient suffering lamb,
And which it seems that no one understands."
Then Mary bent her face to the child's brow,
And kissed him twice, and, parting back his hair,
Kissed him again. And Jesus felt her tears
Drop warm upon his cheek, and he looked sad
When silently he put his hand again
Within his mother's. As they came, they went,
Hand in hand homeward.
 And the child abode
With Mary and with Joseph, till the time
When all the things should be fulfilled in him
Which God had spoken by his prophets' mouth
Long since ; and God was with him, and God's grace.

A Pause of Thought.

I LOOKED for that which is not, nor can be,
 And hope deferred made my heart sick, in truth ;
 But years must pass before a hope of youth
 Is resigned utterly.

I watched and waited with a steadfast will :
 And, tho' the object seemed to flee away
 That I so longed for, ever, day by day,
 I watched and waited still.

Sometimes I said,—" This thing shall be no more ;
 My expectation wearies, and shall cease ;
 I will resign it now, and be at peace :"—
 Yet never gave it o'er.

Sometimes I said,—" It is an empty name
 I long for ; to a name why should I give
 The peace of all the days I have to live ?"—
 Yet gave it all the same.

Alas ! thou foolish one,—alike unfit
 For healthy joy and salutary pain,
 Thou knowest the chase useless, and again
 Turnest to follow it.

The Purpose and Tendency of Early Italian Art.

THE object we have proposed to ourselves in writing on Art, has been " an endeavour to encourage and enforce an entire adherence to the simplicity of nature ; and also to direct attention, as an auxiliary medium, to the comparatively few works which Art has yet produced in this spirit." It is in accordance with the former and more prominent of these objects that the writer proposes at present to treat.

An unprejudiced spectator of the recent progress and main direction of Art in England will have observed, as a great change in the character of the productions of the modern school, a marked attempt to lead the taste of the public into a new channel by producing pure transcripts and faithful studies from nature, instead of conventionalities and feeble reminiscences from the Old Masters ; an entire seeking after originality in a more humble manner than has been practised since the decline of Italian Art in the Middle Ages. This has been most strongly shown by the landscape painters, among whom there are many who have raised an entirely new school of natural painting, and whose productions undoubtedly surpass all others in the simple attention to nature in detail as well as in generalities. By this they have succeeded in earning for themselves the reputation of being the finest landscape painters in Europe. But, although this success has been great and merited, it is not of them that we have at present to treat, but rather to recommend their example to their fellow-labourers, the historical painters.

That the system of study to which this would necessarily lead requires a somewhat longer and more devoted course of observation than any other is undoubted ; but that it has a reward in a greater effect produced, and more delight in the searching, is, the writer thinks, equally certain. We shall find a greater pleasure in proportion to our closer communion with nature, and by a more exact adherence to all her details, (for nature has no peculiarities or excentricities) in whatsoever direction her study may conduct.

This patient devotedness appears to be a conviction peculiar to, or at least more purely followed by, the early Italian Painters ; a feeling which, exaggerated, and its object mistaken by them, though still held holy and pure, was the cause of the retirement of many of the greatest men from the world to the monastery ; there, in undisturbed silence and humility,

> " Monotonous to paint
> Those endless cloisters and eternal aisles
> With the same series, Virgin, Babe, and Saint,
> With the same cold, calm, beautiful regard."

Even with this there is not associated a melancholy feeling alone; for, although the object was mistaken, yet there is evinced a consciousness of purpose definite and most elevated; and again, we must remember, as a great cause of this effect, that the Arts were, for the most part, cleric, and not laic, or at least were under the predominant influence of the clergy, who were the most important patrons by far, and their houses the safest receptacles for the works of the great painter.

The modern artist does not retire to monasteries, or practise discipline; but he may show his participation in the same high feeling by a firm attachment to truth in every point of representation, which is the most just method. For how can good be sought by evil means, or by falsehood, or by slight in any degree? By a determination to represent the thing and the whole of the thing, by training himself to the deepest observation of its fact and detail, enabling himself to reproduce, as far as is possible, nature herself, the painter will best evince his share of faith.

It is by this attachment to truth in its most severe form that the followers of the Arts have to show that they share in the peculiar character of the present age,—a humility of knowledge, a diffidence of attainment; for, as Emerson has well observed,

> " The time is infected with Hamlet's unhappiness,—
> ' Sicklied o'er with the pale cast of thought.'

Is this so bad then? Sight is the last thing to be pitied. Would we be blind? Do we fear lest we should outsee nature and God, and drink truth dry?"

It has been said that there is presumption in this movement of the modern school, a want of deference to established authorities, a removing of ancient landmarks. This is best answered by the profession that nothing can be more humble than the pretension to the observation of facts alone, and the truthful rendering of them. If we are not to depart from established principles, how are we to advance at all? Are we to remain still? Remember, no thing remains still; that which does not advance falls backward. That this movement is an advance, and that it is of nature herself, is shown by its going nearer to truth in every object produced, and by its being guided by the very principles the ancient painters followed, as soon as they attained the mere power of representing an object faithfully.

These principles are now revived, not from them, though through their example, but from nature herself.

That the earlier painters came nearer to fact, that they were less of the art, artificial, cannot be better shown than by the statement of a few examples from their works. There is a magnificent Niello work by an unknown Florentine artist, on which is a group of the Saviour in the lap of the Virgin. She is old, (a most touching point) ; lamenting aloud, clutches passionately the heavy-weighted body on her knee ; her mouth is open. Altogether it is one of the most powerful appeals possible to be conceived ; for there are few but will consider this identification with humanity to be of more effect than any refined or emasculate treatment of the same subject by later artists, in which we have the fact forgotten for the sake of the type of religion, which the Virgin was always taken to represent, whence she is shown as still young ; as if, nature being taken typically, it were not better to adhere to the emblem throughout, confident by this means to maintain its appropriateness, and, therefore, its value and force.

In the Niello work here mentioned there is a delineation of the Fall, in which the serpent has given to it a human head with a most sweet, crafty expression. Now in these two instances the style is somewhat rude ; but there are passion and feeling in it. This is not a question of mere execution, but of mind, however developed. Let us not mistake, however, from this that execution should be neglected, but only maintained as a most important *aid,* and in that quality alone, so that we do not forget the soul for the hand. The power of representing an object, that its entire intention may be visible, its lesson felt, is all that is absolutely necessary : mere technicalities of performance are but additions ; and not the real intent and end of painting, as many have considered them to be. For as the knowledge is stronger and more pure in Masaccio than in the Caracci, and the faith higher and greater,—so the first represents nature with more true feeling and love, with a deeper insight into her tenderness ; he follows her more humbly, and has produced to us more of her simplicity ; we feel his appeal to be more earnest : it is the crying out of the man, with none of the strut of the actor.

Let us have the mind and the mind's-workings, not the remains of earnest thought which has been frittered away by a long dreary course of preparatory study, by which all life has been evaporated. Never forget that there is in the wide river of nature something which every body who has a rod and line may catch, precious things which every one may dive for.

It need not be feared that this course of education would lead to a

repetition of the toe-trippings of the earliest Italian school, a sneer which is manifestly unfair ; for this error, as well as several others of a similar kind, was not the result of blindness or stupidity, but of the simple ignorance of what had not been applied to the service of painting at their time. It cannot be shown that they were incorrect in expression, false in drawing, or unnatural in what is called composition. On the contrary, it is demonstrable that they exceeded all others in these particulars, that they partook less of coarseness and of conventional sentiment than 'any school which succeeded them, and that they looked more to nature ; in fact, were more true, and less artificial. That their subjects were generally of a melancholy cast is acknowledged, which was an accident resulting from the positions their pictures were destined to occupy. No man ever complained that the Scriptures were morbid in their tendency because they treat of serious and earnest subjects : then why of the pictures which represent such ? A certain gaunt length and slenderness have also been commented upon most severely ; as if the Italians of the fourteenth century were as so many dray horses, and the artist were blamed for not following his model. The consequence of this direction of taste is that we have life-guardsmen and pugilists taken as models for kings, gentlemen, and philosophers. The writer was once in a studio where a man, six feet two inches in height, with atlantean shoulders, was sitting for King Alfred. That there is no greater absurdity than this will be perceived by any one that has ever read the description of the person of the king given by his historian and friend Asser.

The sciences have become almost exact within the present century. Geology and chemistry are almost re-instituted. The first has been nearly created ; the second expanded so widely that it now searches and measures the creation. And how has this been done but by bringing greater knowledge to bear upon a wider range of experiment ; by being precise in the search after truth ? If this adherence to fact, to experiment and not theory,—to begin at the beginning and not fly to the end,—has added so much to the knowledge of man in science ; why may it not greatly assist the moral purposes of the Arts ? It cannot be well to degrade a lesson by falsehood. Truth in every particular ought to be the aim of the artist. Admit no untruth : let the priest's garment be clean.

Let us now return to the Early Italian Painters. A complete refutation of any charge that the character of their school was necessarily gloomy will be found in the works of Benozzo Gozzoli, as in his ' Vineyard ' where there are some grape-gatherers the most elegant and graceful imaginable ; this painter's children are the

most natural ever painted. In Ghiberti,—in Fra Angilico, (well named),—in Masaccio,—in Ghirlandajo, and in Baccio della Porta, in fact in nearly all the works of the painters of this school, will be found a character of gentleness, grace, and freedom, which cannot be surpassed by any other school, be that which it may ; and it is evident that this result must have been obtained by their peculiar attachment to simple nature alone, their casting aside all ornament, or rather their perfect ignorance of such,—a happy fortune none have shared with them. To show that with all these qualifications they have been pre-eminent in energy and dignity, let us instance the 'Air Demons' of Orcagna, where there is a woman borne through the air by an Evil Spirit. Her expression is the most terrible imaginable ; she grasps her bearer with desperation, looking out around her into space, agonized with terror. There are other figures in the same picture of men who have been cast down, and are falling through the air : one descends with his hands tied, his chin up, and long hair hanging from his head in a mass. One of the Evil Spirits hovering over them has flat wings, as though they were made of plank : this gives a most powerful character to the figure. Altogether, this picture contains perhaps a greater amount of bold imagination and originality of conception than any of the kind ever painted. For sublimity there are few works which equal the 'Archangels' of Giotto, who stand singly, holding their sceptres, and with relapsed wings. The 'Paul' of Masaccio is a well-known example of the dignified simplicity of which these artists possessed so large a share. These instances might be multiplied without end ; but surely enough have been cited in the way of example to show the surpassing talent and knowledge of these painters, and their consequent success, by following natural principles, until the introduction of false and meretricious ornament led the Arts from the simple chastity of nature, which it is as useless to attempt to elevate as to endeavour to match the works of God by those of man. Let the artist be content to study nature alone, and not dream of elevating any of her works, which are alone worthy of representation.*

The Arts have always been most important moral guides. Their

* The sources from which these examples are drawn, and where many more might be found, are principally :—*D'Agincourt :* " *Histoire de l'Art par les Monumens ;*"—*Rossini :* " *Storia della Pittura ;*"—*Ottley :* "*Italian School of Design,*" and his 120 Fac-similes of scarce prints ;—and the " Gates of San Giovanni," by Ghiberti ; of which last a cast of one entire is set up in the Central School of Design, Somerset House ; portions of the same are also in the Royal Academy.

flourishing has always been coincident with the most wholesome period of a nation's: never with the full and gaudy bloom which but hides corruption, but the severe health of its most active and vigorous life; its mature youth, and not the floridity of age, which, like the wide full open petals of a flower, indicates that its glory is about to pass away. There has certainly always been a period like the short warm season the Canadians call the "Indian Summer," which is said to be produced by the burning of the western forests, causing a factitious revival of the dying year: so there always seems to have been a flush of life before the final death of the Arts in each period :—in Greece, in the sculptors and architects of the time after Pericles; in the Germans, with the successors of Albert Durer. In fact, in every school there has been a spring, a summer, an autumn, an "Indian Summer," and then winter; for as surely as the "Indian Summer," (which is, after all, but an unhealthy flush produced by destruction,) so surely does winter come. In the Arts, the winter has been exaggerated action, conventionalism, gaudy colour, false sentiment, voluptuousness, and poverty of invention: and, of all these characters, that which has been the most infallible herald of decease, voluptuousness, has been the most rapid and sure. Corruption lieth under it; and every school, and indeed every individual, that has pandered to this, and departed from the true spirit in which all study should be conducted, sought to degrade and sensualize, instead of chasten and render pure, the humanity it was instructed to elevate. So has that school, and so have those individuals, lost their own power and descended from their high seat, fallen from the priest to the mere parasite, from the law-giver to the mere courtier.

If we have entered upon a new age, a new cycle of man, of which there are many signs, let us have it unstained by this vice of sensuality of mind. The English school has lately lost a great deal of this character; why should we not be altogether free from it? Nothing can degrade a man or a nation more than this meanness; why should we not avoid it? Sensuality is a meanness repugnant to youth, and disgusting in age: a degradation at all times. Let us say

> " My strength is as the strength of ten,
> Because my heart is pure."

Bearing this in mind,—the conviction that, without the pure heart, nothing can be done worthy of us; by this, that the most successful school of painters has produced upon us the intention of their earnestness at this distance of time,—let us follow in their path,

guided by their light : not so subservient as to lose our own freedom, but in the confidence of equal power and equal destiny ; and then rely that we shall obtain the same success and equal or greater power, such as is given to the age in which we live. This is the only course that is worthy of the influence which might be exerted by means of the Arts upon the character of the people : therefore let it be the only one for us to follow if we hope to share in the work.

That the real power of the Arts, in conjunction with Poetry, upon the actions of any age is, or might be, predominant above all others will be readily allowed by all that have given any thought to the subject : and that there is no assignable limit to the good that may be wrought by their influence is another point on which there can be small doubt. Let us then endeavour to call up and exert this power in the worthiest manner, not forgetting that we chose a difficult path in which there are many snares, and holding in mind the motto, " *No Cross, no Crown.*"

Believe that there is that in the fact of truth, though it be only in the character of a single leaf earnestly studied, which may do its share in the great labor of the world : remember that it is by truth alone that the Arts can ever hold the position for which they were intended, as the most powerful instruments, the most gentle guides ; that, of all classes, there is none to whom the celebrated words of Lessing, "That the destinies of a nation depend upon its young men between nineteen and twenty-five years of age," can apply so well as to yourselves. Recollect, that your portion in this is most important : that your share is with the poet's share ; that, in every careless thought or neglected doubt, you shelve your duty, and forsake your trust ; fulfil and maintain these, whether in the hope of personal fame and fortune, or from a sense of power used to its intentions ; and you may hold out both hands to the world. Trust it, and it will have faith in you ; will hearken to the precepts you may have permission to impart.

Song.

Oh ! roses for the flush of youth,
 And laurel for the perfect prime ;
But pluck an ivy-branch for me,
 Grown old before my time.

Oh ! violets for the grave of youth,
 And bay for those dead in their prime ;
Give me the withered leaves I chose
 Before in the olden time.

Morning Sleep.

ANOTHER day hath dawned
Since, hastily and tired, I threw myself
Into the dark lap of advancing sleep.
Meanwhile through the oblivion of the night
The ponderous world its old course hath fulfilled ;
And now the gradual sun begins to throw
Its slanting glory on the heads of trees,
And every bird stirs in its nest revealed,
And shakes its dewy wings.

 A blessed gift
Unto the weary hath been mine to-night,
Slumber unbroken : now it floats away :—
But whether 'twere not best to woo it still,
The head thus properly disposed, the eyes
In a continual dawning, mingling earth
And heaven with vagrant fantasies,—one hour,—
Yet for another hour ? I will not break
The shining woof ; I will not rudely leap
Out of this golden atmosphere, through which
I see the forms of immortalities.
Verily, soon enough the laboring day
With its necessitous unmusical calls
Will force the indolent conscience into life.

The uncouth moth upon the window-panes
Hath ceased to flap, or traverse with blind whirr
The room's dusk corners ; and the leaves without
Vibrate upon their thin stems with the breeze
Flying towards the light. To an Eastern vale
That light may now be waning, and across
The tall reeds by the Ganges, lotus-paved,
Lengthening the shadows of the banyan-tree.
The rice-fields are all silent in the glow,
All silent the deep heaven without a cloud,
Burning like molten gold. A red canoe
Crosses with fan-like paddles and the sound
Of feminine song, freighted with great-eyed maids
Whose unzoned bosoms swell on the rich air ;

A lamp is in each hand ; some mystic rite
Go they to try. Such rites the birds may see,
Ibis or emu, from their cocoa nooks,—
What time the granite sentinels that watch
The mouths of cavern-temples hail the first
Faint star, and feel the gradual darkness blend
Their august lineaments ;—what time Haroun
Perambulated Bagdat, and none knew
He was the Caliph who knocked soberly
By Giafar's hand at their gates shut betimes ;—
What time prince Assad sat on the high hill
'Neath the pomegranate-tree, long wearying
For his lost brother's step ;—what time, as now,
Along our English sky, flame-furrows cleave
And break the quiet of the cold blue clouds,
And the first rays look in upon our roofs.

Let the day come or go ; there is no let
Or hindrance to the indolent wilfulness
Of fantasy and dream-land. Place and time
And bodily weight are for the wakeful only.
Now they exist not : life is like that cloud,
Floating, poised happily in mid-air, bathed
In a sustaining halo, soft yet clear,
Voyaging on, though to no bourne ; all heaven
Its own wide home alike, earth far below
Fading still further, further. Yet we see,
In fancy, its green fields, its towers, and towns
Smoking with life, its roads with traffic thronged
And tedious travellers within iron cars,
Its rivers with their ships, and laborers,
To whose raised eye, as, stretched upon the sward,
They may enjoy some interval of rest,
That little cloud appears no living thing,
Although it moves, and changes as it moves.
There is an old and memorable tale
Of some sound sleeper being borne away
By banded fairies in the mottled hour
Before the cockcrow, through unknown weird woods
And mighty forests, where the boughs and roots
Opened before him, closed behind ;—thenceforth
A wise man lived he, all unchanged by years.
Perchance again these fairies may return,

And evermore shall I remain as now,
A dreamer half awake, a wandering cloud !

 The spell
Of Merlin old that ministered to fate,
The tales of visiting ghosts, or fairy elves,
Or witchcraft, are no fables. But his task
Is ended with the night ;—the thin white moon
Evades the eye, the sun breaks through the trees,
And the charmed wizard comes forth a mere man
From out his circle. Thus it is, whate'er
We know and understand hath lost the power
Over us ;—we are then the master. Still
All Fancy's world is real ; no diverse mark
Is on the stores of memory, whether gleaned
From childhood's early wonder at the charm
That bound the lady in the echoless cave
Where lay the sheath'd sword and the bugle horn,—
Or from the fullgrown intellect, that works
From age to age, exploring darkest truths,
With sympathy and knowledge in one yoke
Ploughing the harvest land.

 The lark is up,
Piercing the dazzling sky beyond the search
Of the acutest love : enough for me
To hear its song : but now it dies away,
Leaving the chirping sparrow to attract
The listless ear,—a minstrel, sooth to say,
Nearly as good. And now a hum like that
Of swarming bees on meadow-flowers comes up.
Each hath its just and yet luxurious joy,
As if to live were to be blessed. The mild
Maternal influence of nature thus
Ennobles both the sentient and the dead ;—
The human heart is as an altar wreathed,
On which old wine pours, streaming o'er the leaves,
And down the symbol-carved sides. Behold !
Unbidden, yet most welcome, who be these ?
The high-priests of this altar, poet-kings ;—
Chaucer, still young with silvery beard that seems
Worthy the adoration of a child ;
And Spenser, perfect master, to whom all
Sweet graces ministered. The shut eye weaves

A picture ;—the immortals pass along
Into the heaven, and others follow still,
Each on his own ray-path, till all the field
Is threaded with the foot-prints of the great.
And now the passengers are lost ; long lines
Only are left, all intertwisted, dark
Upon a flood of light......... I am awake !
I hear domestic voices on the stair.

Already hath the mower finished half
His summer day's ripe task ; already hath
His scythe been whetted often ; and the heaps
Behind him lie like ridges from the tide.
In sooth, it is high time to wave away
The cup of Comus, though with nectar filled,
And sweet as odours to the mariner
From lands unseen, across the wide blank sea.

Sonnet.

When midst the summer-roses the warm bees
 Are swarming in the sun, and thou—so full
 Of innocent glee—dost with thy white hands pull
Pink scented apples from the garden trees
To fling at me, I catch them, on my knees,
 Like those who gather'd manna ; and I cull
 Some hasty buds to pelt thee—white as wool
Lilies, or yellow jonquils, or heartsease ;—
Then I can speak my love, ev'n tho' thy smiles
 Gush out among thy blushes, like a flock
Of bright birds from rose-bowers ; but when thou'rt gone
 I have no speech,—no magic that beguiles,
 The stream of utterance from the harden'd rock :—
The dial cannot speak without the sun !

Stars and Moon.

BENEATH the stars and summer moon
 A pair of wedded lovers walk,
Upon the stars and summer moon
 They turn their happy eyes, and talk.

EDITH.

" Those stars, that moon, for me they shine
 With lovely, but no startling light ;
My joy is much, but not as thine,
 A joy that fills the pulse, like fright."

ALFRED.

" My love, a darken'd conscience clothes
 The world in sackcloth ; and, I fear,
The stain of life this new heart loathes,
 Still clouds my sight ; but thine is clear.

" True vision is no startling boon
 To one in whom it always lies ;
But if true sight of stars and moon
 Were strange to thee, it would surprise.

" Disease it is and dearth in me
 Which thou believest genius, wealth ;
And that imagined want in thee
 Is riches and abundant health.

" O, little merit I my bride !
 And therefore will I love her more ;
Renewing, by her gentle side,
 Lost worth : let this thy smile restore !"

EDITH.

" Ah, love ! we both, with longing deep,
 Love words and actions kind, which are
More good for life than bread or sleep,
 More beautiful than Moon or Star."

On the Mechanism of a Historical Picture.

Part I. The Design.

In tracing these memoranda of the course to be pursued in producing a work of the class commonly denominated " Historic Art," we have no wish to set ourselves in opposition to the practice of other artists. We are quite willing to believe that there may be various methods of working out the same idea, each productive of a satisfactory result. Should any one therefore regard it as a subject for controversy, we would only reply that, if different, or to them better, methods be adopted by other painters, no less certain is it that there are numbers who at the onset of their career have not the least knowledge of any one of these methods ; and that it is chiefly for such that these notes have been penned. In short, that to all about to paint their first picture we address ourselves.

The first advice that should be given, on painting a historical picture, ought undoubtedly to be on the choosing of a fit subject ; but, the object of the present paper being purely practical, it would ill commence with a question which would entail a dissertation bearing upon the most abstract properties of Art. Should it afterwards appear necessary, we may append such a paper to the last number of these articles ; but, for the present, we will content ourselves with beginning where the student may first encounter a difficulty in giving body to his idea.

The first care of the painter, after having selected his subject, should be to make himself thoroughly acquainted with the character of the times, and habits of the people, which he is about to represent; and next, to consult the proper authorities for his costume, and such objects as may fill his canvass ; as the architecture, furniture, vegetation or landscape, or accessories, necessary to the elucidation of the subject. By not pursuing this course, the artist is in danger of imagining an effect, or disposition of lines, incompatible with the costume of his figures, or objects surrounding them ; and it will be found always a most difficult thing to efface an idea that has once taken possession of the mind. Besides which, it is impossible to conceive a design with any truth, not being acquainted with the character, habits, and appearance, of the people represented.

Having, by such means, secured the materials of which his work must be composed, the artist must endeavour, as far as lies in his power, to embody the picture in his thoughts, before having recourse to paper. He must patiently consider his subject, revolving in his

mind every means that may assist the clear development of the story : giving the most prominent places to the most important actors, and carefully rejecting incidents that cannot be expressed by pantomimic art without the aid of text. He must also, in this mental forerunner of his picture, arrange the "grouping" of his figures,—that is, the disposing of them in such agreeable clusters or situations on his canvass as may be compatible with the dramatic truth of the whole, (technically called the lines of a composition.) He must also consider the color, and disposition of light and dark masses in his design, so as to call attention to the principal objects, (technically called the "effect.") Thus, to recapitulate, the painter, in his first conception of his picture, will have to combine three qualities, each subordinate to the other ;—the intellectual, or clear development, dramatic truth, and sentiment, of his incident ;—the construction, or disposition of his groups and lines, as most conducive to clearness, effect, and harmony ;—and the chromatic, or arrangement of colors, light and shade, most suitable to impress and attract the beholder.*

Having settled these points in his mind, as definitely as his faculties will allow of, the student will take pencil and paper, and sketch roughly each separate figure in his composition, studying his own acting, (in a looking-glass) or else that of any friend he may have of an artistic or poetic temperament, but not employing for the purpose the ordinary paid models.—It will be always found that they are stiff and feelingless, and, as such, tend to curb the vivacity of a first conception, so much so that the artist may believe an action impossible, through the want of comprehension of the model, which to himself or a friend might prove easy.

Here let the artist spare neither time nor labor, but exert himself beyond his natural energies, seeking to enter into the character of each actor, studying them one after the other, limb for limb, hand for hand, finger for finger, noting each inflection of joint, or tension of sinew, searching for dramatic truth internally in himself, and in all external nature, shunning affectation and exaggeration, and striving after pathos, and purity of feeling, with patient endeavor and utter simplicity of heart. For on this labor must depend the success of his work with the public. Artists may praise his color,

* Many artists, chiefly of the schools not colorists, are in the habit of making their designs in outline, leaving the colors and light and shade to be thought of afterwards. This plan may offer facilities ; but we doubt if it be possible to arrange satisfactorily the colors of a work which has been designed in outline without consideration of these qualities.

drawing, or manipulation, his chiaroscuro, or his lines; but the clearness, truth, and sentiment, of his work will alone affect the many.

The action of each figure being now determinate, the next step will be to make a sketch in oil of the whole design; after which, living models, as like the artist's conception as can be found, must be procured, to make outlines of the nude of each figure, and again sketches of the same, draped in the proper costume.*

From these studies, the painter will prepare a second sketch, in outline, of the whole, being, in fact, a small and hasty cartoon.†

In this last preparation of the design, the chief care of the student will be the grouping, and the correct size and place of each figure; also the perspective of the architecture and ground plan will now have to be settled; a task requiring much patient calculation, and usually proving a source of disgust to the novice not endowed with much perseverance. But, above all, the quality to be most studied in this outline design will be the *proportion* of the whole work.

And with a few remarks on this quality, which might appropriately be termed "constructive beauty in art," we will close this paper on "the Design," as belonging more properly to the mechanical than the intellectual side of art; as being rather the slow growth of experience than the spontaneous impulse of the artistic temperament. It is a feature in art rather apt to savor of conventionality to such as would look on nature as the only school of art, who would consider it but as the exponent of thought and feeling; while, on the other hand, we fear it likely to be studied to little effect by such as receive with indiscriminate and phlegmatic avidity all that is handed down to them in the shape of experience or time-sanctioned rule. But plastic art claims not merely our sympathy, in its highest capacity to emit thought and sentiment; but as form, colour, light, life, and beauty; and who shall settle the claims be-

* There is always difficulty attending this very necessary portion of the study of the picture ; because, if the dresses be borrowed or hired, at this period they may be only wanted for a few hours, and perhaps not required again for some months to paint into the picture.—Again, if the costume have to be made, and of expensive material, the portion of it seen may be sufficient to pin on to a lay figure, without having the whole made, which could not be worn by the living model. However, with all the larger or loose draperies, it is very necessary to sketch them first from the living model.

† Should the picture be of small dimensions, it will be found more expeditious to make an outline of it on paper the full size, which can be traced on to the canvass, keeping the latter clean. On the contrary, should the painting be large, the outline had better be made small, and squared to transfer to the canvass.

tween thought and beauty? But art has beauties of its own, which
neither impair nor contradict the beauties of nature; but which are
not of nature, and yet are, inasmuch as art itself is but part of
nature: and of such, the beauties of the nature of art, is the feeling
for constructive beauty. It interferes not with truth or sentiment;
it is not the cause of unlikely order and improbable symmetry; it is
not bounded by line or rule, nor taught by theory. It is a feeling
for proportion, ever varying from an infinity of conflicting causes,
that balances the picture as it balances the Gothic edifice; it is a
germ planted in the breast of the artist, that gradually expands by
cultivation.

To those who would foster its development the only rule we could
offer would be never to leave a design, while they imagine they
could alter for the better (subordinate to the truth of nature) the
place of a single figure or group, or the direction of a line.

And to such as think it beneath their care we can only say that
they neglect a refinement, of which every great master takes ad-
vantage to increase the fascination which beauty, feeling, or passion,
exercises over the multitude.

A Testimony.

I said of laughter: It is vain;—
 Of mirth I said: What profits it?—
 Therefore I found a book, and writ
Therein, how ease and also pain,
How health and sickness, every one
Is vanity beneath the sun.

Man walks in a vain shadow; he
 Disquieteth himself in vain.
 The things that were shall be again.
The rivers do not fill the sea,
But turn back to their secret source:
The winds, too, turn upon their course.

Our treasures, moth and rust corrupt;
 Or thieves break through and steal; or they
 Make themselves wings and fly away.
One man made merry as he supp'd,
Nor guessed how when that night grew dim,
His soul would be required of him.

We build our houses on the sand
　　Comely withoutside, and within ;
　　But when the winds and rains begin
To beat on them, they cannot stand ;
They perish, quickly overthrown,
Loose at the hidden basement stone.

All things are vanity, I said :
　　Yea vanity of vanities.
　　The rich man dies ; and the poor dies :
The worm feeds sweetly on the dead.
Whatso thou lackest, keep this trust :—
All in the end shall have but dust.

The one inheritance, which best
　　And worst alike shall find and share.
　　The wicked cease from troubling there,
And there the weary are at rest ;
There all the wisdom of the wise
Is vanity of vanities.

Man flourishes as a green leaf,
　　And as a leaf doth pass away ;
　　Or, as a shade that cannot stay,
And leaves no track, his course is brief :
Yet doth man hope and fear and plan
Till he is dead :—oh foolish man !

Our eyes cannot be satisfied
　　With seeing ; nor our ears be fill'd
　　With hearing : yet we plant and build,
And buy, and make our borders wide :
We gather wealth, we gather care,
But know not who shall be our heir.

Why should we hasten to arise
　　So early, and so late take rest ?
　　Our labor is not good ; our best
Hopes fade ; our heart is stayed on lies :
Verily, we sow wind ; and we
Shall reap the whirlwind, verily.

He who hath little shall not lack ;
　　He who hath plenty shall decay :
　　Our fathers went ; we pass away ;

Our children follow on our track :
So generations fail, and so
They are renewed, and come and go.

The earth is fattened with our dead ;
 She swallows more and doth not cease ;
 Therefore her wine and oil increase
And her sheaves are not numbered ;
Therefore her plants are green, and all
Her pleasant trees lusty and tall.

Therefore the maidens cease to sing,
 And the young men are very sad ;
 Therefore the sowing is not glad,
And weary is the harvesting.
Of high and low, of great and small,
Vanity is the lot of all.

A king dwelt in Jerusalem :
 He was the wisest man on earth ;
 He had all riches from his birth,
And pleasures till he tired of them :
Then, having tested all things, he
Witnessed that all are vanity.

O When and Where.

All knowledge hath taught me,
All sorrow hath brought me,
 Are smothered sighs
 That pleasure lies,
Like the last gleam of evening's ray,
So far and far away,—far away.

Under the cold moist herbs
No wind the calm disturbs.
 O when and where?
 Nor here nor there.
Grass cools my face, grief heats my heart.
Will this life I swoon with never part ?

Fancies at Leisure.

I. Noon Rest.

Following the river's course,
 We come to where the sedges plant
Their thickest twinings at its source ;—
 A spot that makes the heart to pant,
Feeling its rest and beauty. Pull
The reeds' tops thro' your fingers ; dull
Your sense of the world's life ; and toss
The thought away of hap or cross :
Then shall the river seem to call
Your name, and the slow quiet crawl
Between your eyelids like a swoon ;
And all the sounds at heat of noon
And all the silence shall so sing
Your eyes asleep as that no wing
Of bird in rustling by, no prone
Willow-branch on your hair, no drone
Droning about and past you,—nought
May soon avail to rouse you, caught
With sleep thro' heat in the sun's light,—
So good, tho' losing sound and sight,
You scarce would waken, if you might.

II. A Quiet Place.

My friend, are not the grasses here as tall
As you would wish to see ? The runnell's fall
Over the rise of pebbles, and its blink
Of shining points which, upon this side, sink
In dark, yet still are there ; this ragged crane
Spreading his wings at seeing us with vain
Terror, forsooth ; the trees, a pulpy stock
Of toadstools huddled round them ; and the flock—
Black wings after black wings—of ancient rook
By rook ; has not the whole scene got a look
As though we were the first whose breath should fan
In two this spider's web, to give a span

Of life more to three flies ? See, there's a stone
Seems made for us to sit on. Have men gone
By here, and passed ? or rested on that bank
Or on this stone, yet seen no cause to thank
For the grass growing here so green and rank ?

III. A Fall of Rain.

It was at day-break my thought said :
" The moon makes chequered chestnut-shade
There by the south-side where the vine
Grapples the wall ; and if it shine
This evening thro' the boughs and leaves,
And if the wind with silence weaves
More silence than itself, each stalk
Of flower just swayed by it, we'll walk,
Mary and I, when every fowl
Hides beak and eyes in breast, the owl
Only awake to hoot."—But clover
Is beaten down now, and birds hover,
Peering for shelter round ; no blade
Of grass stands sharp and tall ; men wade
Thro' mire with frequent plashing sting
Of rain upon their faces. Sing,
Then, Mary, to me thro' the dark :
But kiss me first : my hand shall mark
Time, pressing yours the while I hark.

IV. Sheer Waste.

Is it a little thing to lie down here
 Beside the water, looking into it,
 And see there grass and fallen leaves interknit,
 And small fish sometimes passing thro' some bit
Of tangled grass where there's an outlet clear ?

And then a drift of wind perhaps will come,
 And blow the insects hovering all about
 Into the water. Some of them get out ;
 Others swim with sharp twitches ; and you doubt
Whether of life or death for other some.

Meanwhile the blueflies sway themselves along
 Over the water's surface, or close by ;
 Not one in ten beyond the grass will fly
 That closely skirts the stream ; nor will your eye
Meet any where the sunshine is not strong.

After a time you find, you know not how,
 That it is quite a stretch of energy
 To do what you have done unconsciously,—
 That is, pull up the grass ; and then you see
You may as well rise and be going now.

So, having walked for a few steps, you fall
 Bodily on the grass under the sun,
 And listen to the rustle, one by one,
 Of the trees' leaves ; and soon the wind has done
For a short space, and it is quiet all ;

Except because the rooks will make a caw
 Just now and then together : and the breeze
 Soon rises up again among the trees,
 Making the grass, moreover, bend and tease
Your face, but pleasantly. Mayhap the paw

Of a dog touches you and makes you rise
 Upon one arm to pat him ; and he licks
 Your hand for that. A child is throwing sticks,
 Hard by, at some half-dozen cows, which fix
Upon him their unmoved contented eyes.

The sun's heat now is painful. Scarce can you
 Move, and even less lie still. You shuffle then,
 Poised on your arms, again to shade. Again
 There comes a pleasant laxness on you. When
You have done enough of nothing, you will go.

Some hours perhaps have passed. Say not you fling
 These hours or such-like recklessly away.
 Seeing the grass and sun and children, say,
 Is not this something more than idle play,
Than careless waste ? Is it a little thing ?

The Light beyond.

I.

Though we may brood with keenest subtlety,
 Sending our reason forth, like Noah's dove,
 To know why we are here to die, hate, love,
With Hope to lead and help our eyes to see
Through labour daily in dim mystery,
 Like those who in dense theatre and hall,
 When fire breaks out or weight-strained rafters fall,
Towards some egress struggle doubtfully ;
Though we through silent midnight may address
 The mind to many a speculative page,
Yearning to solve our wrongs and wretchedness,
Yet duty and wise passiveness are won,—
 (So it hath been and is from age to age)—
Though we be blind, by doubting not the sun.

II.

Bear on to death serenely, day by day,
 Midst losses, gains, toil, and monotony,
 The ignorance of social apathy,
And artifice which men to men display :
Like one who tramps a long and lonely way
 Under the constant rain's inclemency,
 With vast clouds drifting in obscurity,
And sudden lightnings in the welkin grey.
To-morrow may be bright with healthy pleasure,
 Banishing discontents and vain defiance :
The pearly clouds will pass to a slow measure,
 Wayfarers walk the dusty road in joyance,
 The wide heaths spread far in the sun's alliance,
Among the furze inviting us to leisure.

III.

Vanity, say they, quoting him of old.
 Yet, if full knowledge lifted us serene
 To look beyond mortality's stern screen,
A reconciling vision could be told,
Brighter than western clouds or shapes of gold
 That change in amber fires,—or the demesne
 Of ever mystic sleep. Mists intervene,
Which then would melt, to show our eyesight bold
From God a perfect chain throughout the skies,
 Like Jacob's ladder light with winged men.
And as this world, all notched to terrene eyes
 With Alpine ranges, smoothes to higher ken,
So death and sin and social miseries ;
 By God fixed as His bow o'er moor and fen.

The Blessed Damozel.

The blessed Damozel leaned out
 From the gold bar of Heaven :
Her blue grave eyes were deeper much
 Than a deep water, even.
She had three lilies in her hand,
 And the stars in her hair were seven.

Her robe, ungirt from clasp to hem,
 No wrought flowers did adorn,
But a white rose of Mary's gift
 On the neck meetly worn ;
And her hair, lying down her back,
 Was yellow like ripe corn.

Herseemed she scarce had been a day
 One of God's choristers ;
The wonder was not yet quite gone
 From that still look of hers ;
Albeit to them she left, her day
 Had counted as ten years.

(To *one* it is ten years of years :
 Yet now, here in this place
Surely she leaned o'er me,—her hair
 Fell all about my face........
Nothing : the Autumn-fall of leaves.
 The whole year sets apace.)

It was the terrace of God's house
 That she was standing on,—
By God built over the sheer depth
 In which Space is begun ;
So high, that looking downward thence,
 She could scarce see the sun.

It lies from Heaven across the flood
 Of ether, as a bridge.
Beneath, the tides of day and night
 With flame and blackness ridge
The void, as low as where this earth
 Spins like a fretful midge.

But in those tracts, with her, it was
 The peace of utter light
And silence. For no breeze may stir
 Along the steady flight
Of seraphim ; no echo there,
 Beyond all depth or height.

Heard hardly, some of her new friends,
 Playing at holy games,
Spake, gentle-mouthed, among themselves,
 Their virginal chaste names ;
And the souls, mounting up to God,
 Went by her like thin flames.

And still she bowed herself, and stooped
 Into the vast waste calm ;
Till her bosom's pressure must have made
 The bar she leaned on warm,
And the lilies lay as if asleep
 Along her bended arm.

From the fixt lull of heaven, she saw
 Time, like a pulse, shake fierce
Through all the worlds. Her gaze still strove,
 In that steep gulph, to pierce
The swarm : and then she spake, as when
 The stars sang in their spheres.

"I wish that he were come to me,
 For he will come," she said.
" Have I not prayed in solemn heaven ?
 On earth, has he not prayed ?
Are not two prayers a perfect strength ?
 And shall I feel afraid ?

" When round his head the aureole clings,
 And he is clothed in white,
I'll take his hand, and go with him
 To the deep wells of light,
And we will step down as to a stream
 And bathe there in God's sight.

" We two will stand beside that shrine,
 Occult, withheld, untrod,
Whose lamps tremble continually
 With prayer sent up to God ;
And where each need, revealed, expects
 Its patient period.

" We two will lie i' the shadow of
 That living mystic tree
Within whose secret growth the Dove
 Sometimes is felt to be,
While every leaf that His plumes touch
 Saith His name audibly.

" And I myself will teach to him—
 I myself, lying so,—
The songs I sing here ; which his mouth
 Shall pause in, hushed and slow,
Finding some knowledge at each pause
 And some new thing to know."

(Alas ! to *her* wise simple mind
 These things were all but known
Before : they trembled on her sense,—
 Her voice had caught their tone.
Alas for lonely Heaven ! Alas
 For life wrung out alone !

Alas, and though the end were reached ?........
 Was *thy* part understood
Or borne in trust ? And for her sake
 Shall this too be found good ?—
May the close lips that knew not prayer
 Praise ever, though they would ?)

" We two," she said, " will seek the groves
 Where the lady Mary is,
With her five handmaidens, whose names
 Are five sweet symphonies :—
Cecily, Gertrude, Magdalen,
 Margaret, and Rosalys.

" Circle-wise sit they, with bound locks
 And bosoms covered ;
Into the fine cloth, white like flame,
 Weaving the golden thread,
To fashion the birth-robes for them
 Who are just born, being dead.

" He shall fear haply, and be dumb.
 Then I will lay my cheek
To his, and tell about our love,
 Not once abashed or weak :
And the dear Mother will approve
 My pride, and let me speak.

" Herself shall bring us, hand in hand,
 To Him round whom all souls
Kneel—the unnumber'd solemn heads
 Bowed with their aureoles :
And Angels, meeting us, shall sing
 To their citherns and citoles.

" There will I ask of Christ the Lord
 Thus much for him and me :—
To have more blessing than on earth
 In nowise ; but to be
As then we were,—being as then
 At peace. Yea, verily.

" Yea, verily ; when he is come
 We will do thus and thus :
Till this my vigil seem quite strange
 And almost fabulous ;
We two will live at once, one life ;
 And peace shall be with us."

She gazed, and listened, and then said,
 Less sad of speech than mild :
" All this is when he comes." She ceased ;
 The light thrilled past her, filled
With Angels, in strong level lapse.
 Her eyes prayed, and she smiled.

(I saw her smile.) But soon their flight
 Was vague 'mid the poised spheres.
And then she cast her arms along
 The golden barriers,
And laid her face between her hands,
 And wept. (I heard her tears.)

Reviews.

The Strayed Reveller ; and other Poems. By A.—Fellowes, Ludgate-street.—1849.

IF any one quality may be considered common to all living poets, it is that which we have heard aptly described as *self-consciousness.* In this many appear to see the only permanent trace of the now old usurping deluge of Byronism ; but it is truly a fact of the time, —less a characteristic than a portion of it. Every species of composition—the dramatic, the narrative, the lyric, the didactic, the descriptive—is imbued with this spirit ; and the reader may calculate with almost equal certainty on becoming acquainted with the belief of a poet as of a theologian or a moralist. Of the evils resulting from the practice, the most annoying and the worst is that some of the lesser poets, and all mere pretenders, in their desire to emulate the really great, feel themselves under a kind of obligation to assume opinions, vague, incongruous, or exaggerated, often not only not their own, but the direct reverse of their own,—a kind of meanness that has replaced, and goes far to compensate for, the flatteries of our literary ancestors. On the other hand, this quality has created a new tie of interest between the author and his public, enhances the significance of great works, and confers value on even the slightest productions of a true poet.

That the systematic infusion of this spirit into the drama and epic compositions is incompatible with strict notions of art will scarcely be disputed : but such a general objection does not apply in the case of lyric poetry, where even the character of the subject is optional. It is an instance of this kind that we are now about to consider.

"The Strayed Reveller and other Poems," constitutes, we believe, the first published poetical work of its author, although the following would rather lead to the inference that he is no longer young.

> "But my youth reminds me : ' Thou
> Hast lived light as these live now ;
> As these are, thou too wert such.' "—p. 59.

And, in another poem :

> "In vain, all, all, in vain,
> They beat upon mine ear again,
> Those melancholy tones so sweet and still :
> Those lute-like tones which, in long-distant years,
> Did steal into mine ears."—p. 86.

Accordingly, we find but little passion in the volume, only four

pieces (for "The Strayed Reveller" can scarcely be so considered) being essentially connected with it. Of these the "Modern Sappho" appears to us not only inferior, but as evidencing less maturity both of thought and style; the second, "Stagyrus," is an urgent appeal to God; the third, "The New Sirens," though passionate in utterance, is, in purpose, a rejection of passion, as having been weighed in the balance and found wanting; and, in the last, where he tells of the voice which once

> "Blew such a thrilling summons to his will,
> Yet could not shake it;
> Drained all the life his full heart had to spill;
> Yet could not break it :"—

he records the "intolerable change of thought" with which it now comes to his "long-sobered heart." Perhaps "The Forsaken Merman" should be added to these; but the grief here is more nearly approaching to gloomy submission and the sickness of hope deferred.

The lessons that the author would learn of nature are, as set forth in the sonnet that opens the volume,

> "Of toil unsevered from tranquillity;
> Of labor that in one short hour outgrows
> Man's noisy schemes,—accomplished in repose,
> Too great for haste, too high for rivalry."—p. 1.

His conception of the poet is of one who

> "Sees before him life unroll,
> A placid and continuous whole;
> That general life which does not cease;
> Whose secret is, not joy, but peace;
> That life, whose dumb wish is not missed
> If birth proceeds, if things subsist;
> The life of plants and stones and rain;
> The life he craves :—if not in vain
> Fate gave, what chance shall not control,
> His sad lucidity of soul."—pp. 123-4. (*Resignation.*)

Such is the author's purpose in these poems. He recognises in each thing a part of the whole : and the poet must know even as he sees, or breathes, as by a spontaneous, half-passive exercise of a faculty : he must receive rather than seek.

> "Action and suffering tho' he know,
> He hath not lived, if he lives so."

Connected with this view of life as "a placid and continuous whole," is the principle which will be found here manifested in

different modes, and thro' different phases of event, of the permanence and changelessness of natural laws, and of the large necessity wherewith they compel life and man. This is the thought which animates the "Fragment of an 'Antigone:'" "The World and the Quietest" has no other scope than this :—

> "Critias, long since, I know,
> (For fate decreed it so),
> Long since the world hath set its heart to live.
> Long since, with credulous zeal,
> It turns life's mighty wheel :
> Still doth for laborers send ;
> Who still their labor give.
> And still expects an end."—p. 109.

This principle is brought a step further into the relations of life in "The Sick King in Bokhara," the following passage from which claims to be quoted, not less for its vividness as description, than in illustration of this thought :—

> "In vain, therefore, with wistful eyes
> Gazing up hither, the poor man
> Who loiters by the high-heaped booths
> Below there in the Registan
>
> "Says : 'Happy he who lodges there !
> With silken raiment, store of rice,
> And, for this drought, all kinds of fruits,
> Grape-syrup, squares of colored ice,
>
> "'With cherries served in drifts of snow.'
> In vain hath a king power to build
> Houses, arcades, enamelled mosques,
> And to make orchard-closes filled
>
> "With curious fruit trees brought from far,
> With cisterns for the winter rain ;
> And, in the desert, spacious inns
> In divers places ;—if that pain
>
> "Is not more lightened which he feels,
> If his will be not satisfied :
> And that it be not from all time
> The law is planted, to abide."—pp. 47-8.

The author applies this basis of fixity in nature generally to the rules of man's nature, and avows himself a Quietist. Yet he would not despond, but contents himself, and waits. In no poem of the volume is this character more clearly defined and developed than in the sonnets "To a Republican Friend," the first of which expresses

concurrence in certain broad progressive principles of humanity : to the second we would call the reader's attention, as to an example of the author's more firm and serious writing :—

> " Yet when I muse on what life is, I seem
> Rather to patience prompted than that proud
> Prospect of hope which France proclaims so loud ;
> France, famed in all great arts, in none supreme :—
> Seeing this vale, this earth whereon we dream,
> Is on all sides o'ershadowed by the high
> Uno'erleaped mountains of necessity,
> Sparing us narrower margin than we deem.
> Nor will that day dawn at a human nod,
> When, bursting thro' the net-work superposed
> By selfish occupation—plot and plan,
> Lust, avarice, envy,—liberated man,
> All difference with his fellow-man composed,
> Shall be left standing face to face with God."—p. 57.

In the adjuration entitled " Stagyrus," already mentioned, he prays to be set free

> " From doubt, where all is double,
> Where Faiths are built on dust ;"

and there seems continually recurring to him a haunting presage of the unprofitableness of the life, after which men have not " any more a portion for ever in anything that is done under the sun." Where he speaks of resignation, after showing how the less impetuous and self-concentred natures can acquiesce in the order of this life, even were it to bring them back with an end unattained to the place whence they set forth ; after showing how it is the poet's office to live rather than to act in and thro' the whole life round about him, he concludes thus :

> " The world in which we live and move
> Outlasts aversion, outlasts love.
> Nay, and since death, which wipes out man,
> Finds him with many an unsolved plan,
> Still gazing on the ever full
> Eternal mundane spectacle,
> This world in which we draw our breath
> In some sense, Fausta, outlasts death.
>
> Enough, we live :—and, if a life
> With large results so little rife,

> Tho' bearable, seem scarcely worth
> This pomp of worlds, this pain of birth,
> Yet, Fausta, the mute turf we tread,
> The solemn hills around us spread,
> This stream that falls incessantly,
> The strange-scrawled rocks, the lonely sky,
> If I might lend their life a voice,
> Seem to bear rather than rejoice.
> And, even could the intemperate prayer
> Man iterates, while these forbear,
> For movement, for an ampler sphere,
> Pierce fate's impenetrable ear,
> Not milder is the general lot
> Because our spirits have forgot,
> In action's dizzying eddy whirled,
> The something that infects the world."—pp. 125-8.—
> *Resignation.*

"Shall we," he asks, "go hence and find that our vain dreams are not dead? Shall we follow our vague joys, and the old dead faces, and the dead hopes?"

He exhorts man to be "*in utrumque paratus.*" If the world be the materialized thought of one all-pure, let him, "by lonely pureness," seek his way through the colored dream of life up again to that all-pure fount :—

> "But, if the wild unfathered mass no birth
> In divine seats hath known ;
> In the blank echoing solitude, if earth,
> Rocking her obscure body to and fro,
> Ceases not from all time to heave and groan,
> Unfruitful oft, and, at her happiest throe,
> Forms what she forms, alone :"

then man, the only self-conscious being, "seeming sole to awake," must, recognizing his brotherhood with this world which stirs at his feet unknown, confess that he too but seems.

Thus far for the scheme and the creed of the author. Concerning these we leave the reader to draw his own conclusions.

Before proceeding to a more minute notice of the various poems, we would observe that a predilection is apparent throughout for antiquity and classical association ; not that strong love which made Shelley, as it were, the heir of Plato ; not that vital grasp of conception which enabled Keats without, and enables Landor with, the most intimate knowledge of form and detail, to return to and renew

the old thoughts and beliefs of Greece ; still less the mere super-
ficial acquaintance with names and hackneyed attributes which was
once poetry. Of this conventionalism, however, we have detected
two instances ; the first, an allusion to "shy Dian's horn" in
"breathless glades" of the days we live, peculiarly inappropriate in
a sonnet addressed "To George Cruikshank on his Picture of 'The
Bottle ;'" the second a grave call to Memory to bring her
tablets, occurring in, and forming the burden of, a poem strictly
personal, and written for a particular occasion. But the author's
partiality is shown, exclusively of such poems as "Mycerinus" and
"The Strayed Reveller," where the subjects are taken from antiquity,
rather in the framing than in the ground work, as in the titles
"A Modern Sappho," "The New Sirens," "Stagyrus," and "*In
utrumque paratus.*" It is Homer and Epictetus and Sophocles who
"prop his mind ;" the immortal air which the poet breathes is

> "Where Orpheus and where Homer are ;"

and he addresses "Fausta" and "Critias."

There are four narrative poems in the volume :—"Mycerinus,"
"The Strayed Reveller," "The Sick King in Bokhara," and "The
Forsaken Merman." The first of these, the only one altogether
narrative in form, founded on a passage in the 2nd Book of Herodotus,
is the story of the six years of life portioned to a King of Egypt suc-
ceeding a father "who had loved injustice, and lived long ;" and
tells how he who had "loved the good" revels out his "six drops
of time." He takes leave of his people with bitter words, and goes
out

> "To the cool regions of the groves he loved
> Here came the king holding high feast at morn,
> Rose-crowned ; and ever, when the sun went down,
> A hundred lamps beamed in the tranquil gloom,
> From tree to tree, all thro' the twinkling grove,
> Revealing all the tumult of the feast,
> Flushed guests, and golden goblets foamed with wine ;
> While the deep-burnished foliage overhead
> Splintered the silver arrows of the moon."—p. 7.

(a daring image, verging towards a conceit, though not absolutely
such, and the only one of that character that has struck us in the
volume.)

> "So six long years he revelled, night and day :
> And, when the mirth waxed loudest, with dull sound
> Sometimes from the grove's centre echoes came,
> To tell his wondering people of their king ;

In the still night, across the steaming flats,
Mixed with the murmur of the moving Nile."—pp. 8, 9.

Here a Tennysonian influence is very perceptible, more especially
in the last quotation ; and traces of the same will be found in " The
Forsaken Merman."

In this poem the story is conveyed by allusions and reminiscences
whilst the Merman makes his children call after her who had
returned to her own earth, hearing the Easter bells over the bay,
and who is not yet come back for all the voices calling " Margaret !
Margaret !" The piece is scarcely long enough or sufficiently
distinct otherwise than as a whole to allow of extract ; but we can-
not but express regret that a poem far from common-place either in
subject or treatment should conclude with such sing-song as

—— " There dwells a loved one,
But cruel is she ;
She left lonely for ever
The kings of the sea."

" The Strayed Reveller " is written without rhyme—(not being
blank verse, however,)—and not unfrequently, it must be admitted,
without rhythm. Witness the following lines :

" Down the dark valley—I saw."—
" Trembling, I entered ; beheld "—
" Thro' the islands some divine bard."—

Nor are these by any means the only ones that might be cited in
proof ; and, indeed, even where there is nothing precisely contrary
to rhythm, the verse might, generally speaking, almost be read as
prose. Seldom indeed, as it appears to us, is the attempt to write
without some fixed laws of metrical construction attended with
success ; never, perhaps, can it be considered as the most appro-
priate embodiment of thought. The fashion has obtained of late
years ; but it is a fashion, and will die out. But few persons
will doubt the superiority of the established blank verse, after
reading the following passage, or will hesitate in pronouncing that
it ought to be the rule, instead of the exception, in this poem :

" They see the merchants
On the Oxus stream :—but care
Must visit first them too, and make them pale :
Whether, thro' whirling sand,
A cloud of desert robber-horse has burst
Upon their caravan ; or greedy kings,
In the walled cities the way passes thro',

Crushed them with tolls ; or fever airs
 On some great river's marge
 Mown them down, far from home."—p. 25.

The Reveller, going to join the train of Bacchus in his temple, has strayed into the house of Circe and has drunk of her cup : he believes that, while poets can see and know only through participation in endurance, he shares the power belonging to the gods of seeing "without pain, without labour ;" and has looked over the valley all day long at the Mœnads and Fauns, and Bacchus, "sometimes, for a moment, passing through the dark stems." Apart from the inherent defects of the metre, there is great beauty of pictorial description in some passages of the poem, from which the following (where he is speaking of the gods) may be taken as a specimen :—

 " They see the Indian
 Drifting, knife in hand,
 His frail boat moored to
 A floating isle, thick-matted
 With large-leaved low-creeping melon plants,
 And the dark cucumber.
 He reaps and stows them,
 Drifting—drifting :—round him,
 Round his green harvest-plot,
 Flow the cool lake-waves :
 The mountains ring them."—p. 20.

From " the Sick King in Bokhara," we have already quoted at some length. It is one of the most considerable, and perhaps, as being the most simple and life-like, the best of the narrative poems. A vizier is receiving the dues from the cloth merchants, when he is summoned to the presence of the king, who is ill at ease, by Hussein ; " a teller of sweet tales." Arrived, Hussein is desired to relate the cause of the king's sickness ; and he tells how, three days since, a certain Moollah came before the king's path, calling for justice on himself, whom, deemed a fool or a drunkard, the guards pricked off with their spears, while the king passed on into the mosque : and how the man came on the morrow with yesterday's blood-spots on him, and cried out for right. What follows is told with great singleness and truth : " Thou knowest," the man says,

 " ' How fierce
 In these last days the sun hath burned ;
 That the green water in the tanks
 Is to a putrid puddle turned ;
 And the canal that from the stream
 Of Samarcand is brought this way
 Wastes and runs thinner every day.

" ' Now I at nightfall had gone forth
 Alone; and, in a darksome place
Under some mulberry-trees, I found
 A little pool; and, in brief space,
With all the water that was there
 I filled my pitcher, and stole home
Unseen; and, having drink to spare,
I hid the can behind the door,
And went up on the roof to sleep.

" ' But, in the night, which was with wind
 And burning dust, again I creep
Down, having fever, for a drink.

" ' Now, meanwhile, had my brethren found
 The water-pitcher, where it stood
Behind the door upon the ground,
 And called my mother: and they all,
As they were thirsty and the night
 Most sultry, drained the pitcher there;
That they sat with it in my sight,
 Their lips still wet, when I came down.

" ' Now mark: I, being fevered, sick,
(Most unblessed also,) at that sight
 Brake forth and cursed them. Dost thou hear?
One was my mother. Now, do right.'

" But my lord mused a space, and said,
 ' Send him away, sirs, and make on.
It is some madman,' the king said.
 As the king said, so was it done.

" The morrow at the self-same hour,
 In the king's path, behold, the man,
Not kneeling, sternly fixed. He stood
 Right opposite, and thus began,

Frowning grim down: ' Thou wicked king,
 Most deaf where thou shouldst most give ear;
What? Must I howl in the next world,
 Because thou wilt not listen here?

" ' What, wilt thou pray and get thee grace,
 And all grace shall to me be grudged?
Nay but, I swear, from this thy path
 I will not stir till I be judged.'

"Then they who stood about the king
 Drew close together and conferred ;
Till that the king stood forth and said :
 'Before the priests thou shalt be heard.'

"But, when the Ulema were met
 And the thing heard, they doubted not ;
But sentenced him, as the law is,
 To die by stoning on the spot.

"Now the king charged us secretly :
 'Stoned must he be : the law stands so :
Yet, if he seek to fly, give way ;
 Forbid him not, but let him go.'

"So saying, the king took a stone,
 And cast it softly : but the man,
With a great joy upon his face,
 Kneeled down, and cried not, neither ran.

"So they whose lot it was cast stones,
 That they flew thick and bruised him sore :
But he praised Allah with loud voice,
 And remained kneeling as before.

"My lord had covered up his face :
 But, when one told him, 'He is dead ;'
Turning him quickly to go in,
 'Bring thou to me his corpse,' he said.

"And truly, while I speak, oh king,
 I hear the bearers on the stair.
Wilt thou they straightway bring him in ?—
 Ho ! enter ye who tarry there."—pp. 39-43.

The Vizier counsels the king that each man's private grief
suffices him, and that he should not seek increase of it in the griefs
of other men. But he answers him, (this passage we have before
quoted,) that the king's lot and the poor man's is the same, for that
neither has his will ; and he takes order that the dead man be
buried in his own royal tomb.

We know few poems the style of which is more unaffectedly
without labor, and to the purpose, than this. The metre, however,
of the earlier part is not always quite so uniform and intelligible as
might be desired ; and we must protest against the use, for the sake
of rhyme, of *broke* in lieu of *broken*, as also of *stole* for *stolen* in
"the New Sirens." While on the subject of style, we may
instance, from the "Fragment of an Antigone," the following
uncouth stanza, which, at the first reading, hardly appears to be
correctly put together :

"But hush! Hœmon, whom Antigone,
Robbing herself of life in burying,
 Against Creon's laws, Polynices,
Robs of a loved bride, pale, imploring,
 Waiting her passage,
Forth from the palace hitherward comes."—p. 30.

Perhaps the most perfect and elevated in tone of all these poems is "The New Sirens." The author addresses, in imagination, a company of fair women, one of whose train he had been at morning; but in the evening he has dreamed under the cedar shade, and seen the same forms "on shores and sea-washed places,"

"With blown tresses, and with beckoning hands."

He thinks how at sunrise he had beheld those ladies playing between the vines; but now their warm locks have fallen down over their arms. He prays them to s eak and shame away his sadness; but there comes only a broken gleaming from their windows, which

"Reels and shivers on the ruffled gloom."

He asks them whether they have seen the end of all this, the load of passion and the emptiness of reaction, whether they dare look at life's latter days,

"When a dreary light is wading
 Thro' this waste of sunless greens,
When the flashing lights are fading
 On the peerless cheek of queens,
When the mean shall no more sorrow,
 And the proudest no more smile;
While the dawning of the morrow
Widens slowly westward all that while?"

And he implores them to "let fall one tear, and set him free." The past was no mere pretence; it was true while it lasted; but it is gone now, and the East is white with day. Shall they meet again, only that he may ask whose blank face that is?

"Pluck, pluck cypress, oh pale maidens;
 Dusk the hall with yew."

This poem must be read as a whole; for not only would it be difficult to select particular passages for extraction, but such extracts, if made, would fail in producing any adequate impression.

We have already quoted so largely from the concluding piece, "Resignation," that it may here be necessary to say only that it is in the form of speech held with "Fausta" in retracing, after a lapse of ten years, the same way they had once trod with a joyful

company. The tone is calm and sustained, not without touches of familiar truth.

The minor poems comprise eleven sonnets, among which, those " To the Duke of Wellington, on hearing him mispraised," and on " Religious Isolation," deserve mention ; and it is with pleasure we find one, in the tenor of strong appreciation, written on reading the Essays of the great American, Emerson. The sonnet for " Butler's Sermons " is more indistinct, and, as such, less to be approved, in imagery than is usual with this poet. That "To an Independent Preacher who preached that we should be in harmony with nature," seems to call for some remark. The sonnet ends with these words :

> " Man must begin, know this, where nature ends ;
> Nature and man can never be fast friends ;
> Fool, if thou canst not pass her, rest her slave."

Now, as far as this sonnet shows of the discourse which occasioned it, we cannot see anything so absurd in that discourse ; and where the author confutes the Independent preacher by arguing that

> " Nature is cruel ; man is sick of blood :
> Nature is stubborn ; man would fain adore :
> Nature is fickle ; man hath need of rest :"

we cannot but think that, by attributing to nature a certain human degree of qualities, which will not suffice for man, he loses sight of the point really raised : for is not man's nature only a part of nature ? and, if a part, necessary to the completeness of the whole ? and should not the individual, avoiding a factitious life, order himself in conformity with his own rule of being ? And, indeed, the author himself would converse with the self-sufficing progress of nature, with its rest in action, as distinguished from the troublous vexation of man's toiling :—

> " Two lessons, Nature, let me learn of thee,
> Two lessons that in every wind are blown ;
> Two blending duties harmonised in one,
> Tho' the loud world proclaim their enmity."—p. 1.

The short lyric poem, "To Fausta" has a Shelleian spirit and grace in it. "The Hayswater Boat" seems a little *got up*, and is scarcely positive enough. This remark applies also, and in a stronger degree, to the "Stanzas on a Gipsy Child," which, and the "Modern Sappho," previously mentioned, are the pieces least to our taste in the volume. There is a something about them of drawing-room sentimentality ; and they might almost, without losing much save in size, be compressed into poems of the class commonly set to music. It is rather the basis of thought than the writing of the "Gipsy Child,"

which affords cause for objection ; nevertheless, there is a passage in which a comparison is started between this child and a " Seraph in an alien planet born,"—an idea not new, and never, as we think, worth much ; for it might require some subtlety to show how a planet capable of producing a Seraph should be alien from that Seraph.

We may here notice a few cases of looseness, either of thought or of expression, to be met with in these pages ; a point of style to be particularly looked to when the occurrence or the absence of such forms one very sensible difference between the first-rate and the second-rate poets of the present times.

Thus, in the sonnet " Shakspear," the conclusion says,

> " All pains the immortal spirit must endure,
> All weakness that impairs, all griefs that bow,
> Find their sole *voice* in that victorious brow ;"

whereas a brow's voice remains to be uttered : nor, till the nature of the victory gained by the brow shall have been pointed out, are we able to hazard an opinion of the precise value of the epithet.

In the address to George Cruikshank, we find : " Artist, whose hand with horror *winged ;*" where a similar question arises ; and, returning to the " Gipsy Child," we are struck with the unmeaningness of the line :

" Who massed round that slight brow these clouds of doom ?"

Nor does the following, from the first of the sonnets, " To a Republican Friend," appear reconcileable with any ideas of appropriateness :

> —— " While before me *flow*
> The *armies* of the homeless and unfed."

It is but right to state that the only instance of the kind we remember throughout the volume have now been mentioned.

To conclude. Our extracts will enable the reader to judge of this Poet's style : it is clear and comprehensive, and eschews flowery adornment. No particular model has been followed, though that general influence which Tennyson exercises over so many writers of this generation may be traced here as elsewhere. It may be said that the author has little, if anything, to unlearn. Care and consistent arrangement, and the necessary subordination of the parts to the whole, are evident throughout ; the reflective, which appears the more essential form of his thought, does not absorb the due observation or presentment of the outward facts of nature ; and a well-poised and serious mind shows itself in every page.

Contents of the Germ, No. 1.

ERRATA.

Page 19, line 3, for *his*, read *its*.

Page 19, line 10, for *comes*, read *falls*.

Published Monthly, price 1s.

The Germ.

THIS Periodical will consist of original Poems, Stories to develope thought and principle, Essays concerning Art and other subjects, and analytic Reviews of current Literature— particularly of Poetry. Each number will also contain an Etching; the subject to be taken from the opening article of the month.

An attempt will be made, both intrinsically and by review, to claim for Poetry that place to which its present development in the literature of this country so emphatically entitles it

The endeavour held in view throughout the writings on Art will be to encourage and enforce an entire adherence to the simplicity of nature; and also to direct attention, as an auxiliary medium, to the comparatively few works which Art has yet produced in this spirit. It need scarcely be added that the chief object of the etched designs will be to illustrate this aim practically, as far as the method of execution will permit; in which purpose they will be produced with the utmost care and completeness.

No. 3. *(Price One Shilling.)* MARCH, 1850.

With an Etching by F. Madox Brown.

Art and Poetry:

Being Thoughts towards Nature

Conducted principally by Artists.

When whoso merely hath a little thought
 Will plainly think the thought which is in him,—
 Not imaging another's bright or dim,
Not mangling with new words what others taught;
When whoso speaks, from having either sought
 Or only found,—will speak, not just to skim
 A shallow surface with words made and trim,
But in that very speech the matter brought:
Be not too keen to cry—"So this is all!—
 A thing I might myself have thought as well,
 But would not say it, for it was not worth!"
 Ask: "Is this truth?" For is it still to tell
That, be the theme a point or the whole earth,
Truth is a circle, perfect, great or small?

London:

DICKINSON & Co., 114, NEW BOND STREET,

AND

AYLOTT & JONES, 8, PATERNOSTER ROW.

G. F. TUPPER, Printer, Clement's Lane, Lombard Street.

CONTENTS.

The Subscribers to this Work are respectfully informed that the future Numbers will appear on the last day of the Month for which they are dated. Also, that a supplementary, or large-sized Etching will occasionally be given (as with the present Number.)

GONERIL: REGAN: LEAR:

RQOU: CORDELIA: FRRACE:

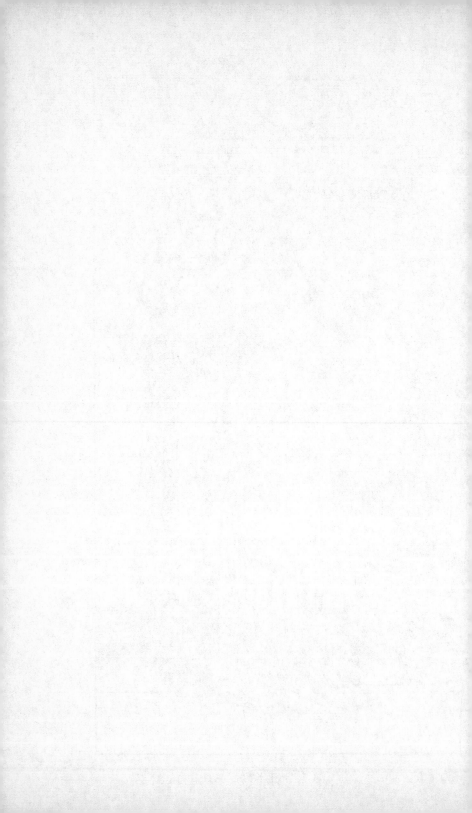

Cordelia.

" The jewels of our father, with washed eyes
Cordelia leaves you. I know you what you are
And, like a sister, am most loth to tell
Your faults, as they are named. Use well our father :
To your professed bosoms I commit him.
But yet, alas !—stood I within his grace,
I would prefer him to a better place.
So farewell to you both."

CORDELIA, unabashed and strong,
 Her voice's quite scarcely less
Than yester-eve, enduring wrong
And curses of her father's tongue,
 Departs, a righteous-souled princess ;
Bidding her sisters cherish him.

They turn on her and fix their eyes,
 But cease not passing inward ;—one
Sneering with lips still curled to lies,
Sinuous of body, serpent-wise ;
 Her footfall creeps, and her looks shun
The very thing on which they dwell.

The other, proud, with heavy cheeks
 And massive forehead, where remains
A mark of frowning. If she seeks
With smiles to tame her eyes, or speaks,
 Her mouth grows wanton : she disdains
The ground with haughty, measured steps.

The silent years had grown between
 Father and daughter. Always she
Had waited on his will, and been
Foremost in doing it,—unseen
 Often : she wished him not to see,
But served him for his sake alone.

He saw her constant love ; and, tho'
 Occasion surely was not scant,
Perhaps had never sought to know
How she could give it wording. So
 His love, not stumbling at a want,
Among the three preferred her first.

Her's is the soul not stubborn, yet
 Asserting self. The heart was rich ;
But, questioned, she had rather let
Men judge her conscious of a debt
 Than freely giving : thus, her speech
Is love according to her bond.

In France the queen Cordelia had
 Her hours well satisfied with love :
She loved her king, too, and was glad :
And yet, at times, a something sad,
 May be, was with her, thinking of
The manner of his life at home.

But this does not usurp her mind.
 It is but sorrow guessed from far
Thro' twilight dimly. She must find
Her duty elsewhere : not resigned—
 Because she knows them what they are,
Yet scarcely ruffled from her peace.

Cordelia—a name well revered ;
 Synonymous with truth and tried
Affection ; which but needs be heard
To raise one selfsame thought endeared
 To men and women far and wide ;
A name our mothers taught to us.

Like placid faces which you knew
 Years since, but not again shall meet ;
On a sick bed like wind that blew ;
An excellent thing, best likened to
 Her own voice, gentle, soft, and sweet ;
SHAKSPERE'S CORDELIA ;—better thus.

Macbeth.*

THE purpose of the following Essay is to demonstrate the exist-
ence of a very important error in the hitherto universally adopted
interpretation of the character of Macbeth. We shall prove that
*a design of illegitimately obtaining the crown of Scotland had been
conceived by Macbeth, and that it had been communicated by him to
his wife, prior to his first meeting with the witches, who are commonly
supposed to have suggested that design.*

Most persons when they commence the study of the great
Shaksperian dramas, already entertain concerning them a set of
traditional notions, generally originated by the representations, or
misrepresentations, of the theatre, afterwards to become strength-
ened or confirmed by desultory reading and corroborative criticism.
With this class of persons it was our misfortune to rank,
when we first entered upon the *study* of "Macbeth," fully be-
lieving that, in the character of the hero, Shakspere intended to
represent a man whose general rectitude of soul is drawn on to ruin
by the temptations of supernatural agents ; temptations which have
the effect of eliciting his latent ambition, and of misdirecting that
ambition when it has been thus elicited.

As long as we continued under this idea, the impression produced
upon us by "Macbeth" came far short of that sense of complete
satisfaction which we were accustomed to receive from every other
of the higher works of Shakspere. But, upon deeper study, the
view now proposed suggested itself, and seemed to render every
thing as it should be. We say that this view suggested *itself*,
because it did not arise directly from any one of the numerous
passages which can be quoted in its support ; it originated in a
general feeling of what seemed to be wanting to the completion of
the entire effect ; a circumstance which has been stated at length
from the persuasion that it is of itself no mean presumption in
favour of the opinion which it is the aim of this paper to establish.

Let us proceed to examine the validity of a position, which,

* It is proper to state that this article was written, and seen, exactly as it at
present stands, by several literary friends of the writer, a considerable time before
the appearance, in the "Westminster Review," of a Paper advocating a view of
"Macbeth," similar to that which is here taken. But although the publication
of the particular view was thus anticipated, nearly all the most forcible argu-
ments for maintaining it were omitted ; and the subject, mixed up, as it was, with
lengthy disquisitions upon very minor topics of Shaksperian acting, &c. made
no very general impression at the time.

if it deserves any attention at all, may certainly claim an investigation more than usually minute. We shall commence by giving an analysis of the first Act, wherein will be considered, successively, every passage which may appear to bear either way upon the point in question.

The inferences which we believe to be deducible from the first scene can be profitably employed only in conjunction with those to be discovered in the third. Our analysis must, therefore, be entered upon by an attempt to ascertain the true character of the impressions which it was the desire of Shakspere to convey by the second.

This scene is almost exclusively occupied with the narrations of the " bleeding Soldier," and of *Rosse*. These narrations are constructed with the express purpose of vividly setting forth the personal valour of Duncan's generals, " Macbeth and Banquo." Let us consider what is the *maximum* worth which the words of Shakspere will, at this period of the play, allow us to attribute to the moral character of the hero :—a point, let it be observed, of first-rate importance to the present argument. We find Macbeth, in this scene, designated by various epithets, *all* of which, either directly or indirectly, arise from feelings of admiration created by his courageous conduct in the war in which he is supposed to have been engaged. " Brave " and " Noble Macbeth," " Bellona's Bridegroom," " Valiant Cousin," and " Worthy Gentleman," are the general titles by which he is here spoken of ; but none of them afford any positive clue whatever to his *moral* character. Nor is any such clue supplied by the scenes in which he is presently received by the messengers of Duncan, and afterwards received and lauded by Duncan himself. Macbeth's moral character, up to the development of his criminal hopes, remains strictly *negative*. Hence it is difficult to fathom the meaning of those critics, (A. Schlegel at their head), who have over and over again made the ruin of Macbeth's " so many noble qualities "* the subject of their comment.

In the third scene we have the meeting of the witches, the announcement of whose intention to re-assemble upon the heath, *there to meet with Macbeth*, forms the certainly most obvious, though not perhaps, altogether the most important, aim of the short scene by which the tragedy is opened. An enquiry of much interest here suggests itself. Did Shakspere intend that in his tragedy of " Macbeth " the witches should figure as originators of gratuitous destruction, in direct opposition to the traditional, and

* A. Schlegel's " Lectures on Dramatic Literature." Vol. II. p. 208.

even proverbial, character of the *genus* ? By that character such personages have been denied the possession of any influence whatever over the untainted soul. Has Shakspere in this instance re tained, or has he abolished, the chief of those characteristics which have been universally attributed to the beings in question?

We think that he has retained it, and for the following reasons : Whenever Shakspere has elsewhere embodied superstitions, he has treated them as direct and unalterable *facts* of human nature; and this he has done because he was too profound a philosopher to be capable of regarding genuine superstition as the product of random spectra of the fancy, having absolute darkness for the prime condition of their being, instead of seeing in it rather the zodiacal light of truth, the concomitant of the uprising, and of the setting of the truth, and a partaker in its essence. Again, Shakspere has in this very play devoted a considerable space to the purpose of suggesting the self-same trait of character now under discussion, and this he appears to have done with the express intent of guarding against a mistake, the probability of the occurrence of which he foresaw, but which, for reasons connected with the construction of the play, he could not hope otherwise to obviate.

We allude to the introductory portion of the present scene. One sister, we learn, has just returned from killing *swine ;* another breathes forth vengeance against a sailor, on account of the uncharitable act of his wife ; but " his bark *cannot be lost,*" though it may be " tempest tossed." The last words are scarcely uttered before the confabulation is interrupted by the approach of Macbeth, to whom they have as yet made no direct allusion whatever, throughout the whole of this opening passage, consisting in all of some five and twenty lines. Now this were a digression which would be a complete anomaly, having place, as it is supposed to have, at this early stage of one of the most consummate of the tragedies of Shakspere. We may be sure, therefore, that it is the chief object of these lines to impress the reader beforehand with an idea that, in the mind of Macbeth, there already exist sure foundations for that great superstructure of evil, to the erection of which, the " metaphysical *aid* " of the weird sisters is now to be offered. An opinion which is further supported by the reproaches of Hecate, who, afterwards, referring to what occurs in this scene, exclaims,

> " All you have done
> Hath been but for a wayward son,
> Spiteful, and wrathful, who, as others do,
> Loves for his own end, not for you."

Words which seem to relate to ends loved of Macbeth before the witches had spurred him on to their acquirement.

The fact that in the old chronicle, from which the plot of the play is taken, the machinations of the witches are not assumed to be *un*-gratuitous, cannot be employed as an argument against our position. In history the sisters figure in the capacity of prophets *merely*. There we have no previous announcement of their intention "to meet with Macbeth." But in Shakspere they are invested with all other of their superstitional attributes, in order that they may become the evil instruments of holy vengeance upon evil; of that most terrible of vengeance which punishes sin, after it has exceeded certain bounds, by deepening it.

Proceeding now with our analysis, upon the entrance of Macbeth and Banquo, the witches wind up their hurried charm. They are first perceived by Banquo. To his questions the sisters refuse to reply; but, at the command of Macbeth, they immediately speak, and forthwith utter the prophecy which seals the fate of Duncan.

Now, assuming the truth of our view, what would be the natural behaviour of Macbeth upon coming into sudden contact with beings who appear to hold intelligence of his most secret thoughts; and upon hearing those thoughts, as it were, spoken aloud in the presence of a third party? His behaviour would be precisely that which is implied by the question of Banquo.

> "Good sir, why do you *start and seem to fear*
> Things which do sound so fair?"

If, on the other hand, our view is *not* true, why, seeing that their characters are in the abstract so much alike, why does the present conduct of Macbeth differ from that of Banquo, when the witches direct their prophecies to him? Why has Shakspere altered the narrative of Holinshed, without the prospect of gaining any advantage commensurate to the licence taken in making that alteration? These are the words of the old chronicle: "This (the rencontre with the witches) was reputed at the first but some vain fantastical illusion by Macbeth and Banquo, insomuch that Banquo would call Macbeth in jest king of Scotland; and Macbeth again would call him in jest likewise the father of many kings." Now it was the invariable practice of Shakspere to give facts or traditions just as he found them, whenever the introduction of those facts or traditions was not totally irreconcileable with the tone of his conception. How then (should we still receive the notion which we are now combating) are we to account for his anomalous practice in this particular case?

When the witches are about to vanish, Macbeth attempts to
delay their departure, exclaiming,

> "Stay, you imperfect speakers, tell me more :
> By Sinel's death, I know I am thane of Glamis ;
> But how of Cawdor ? the thane of Cawdor lives,
> A prosperous gentleman ; *and, to be king*
> *Stands not within the prospect of belief,*
> *No more than to be Cawdor.* Say, from whence
> You owe this strange *intelligence ?"*

" To be king stands not within the prospect of belief, *no more than
to be Cawdor."* No ! it naturally stands much *less* within the
prospect of belief. Here the mind of Macbeth, having long been
accustomed to the nurture of its " royal hope," conceives that it is
uttering a very suitable hyperbole of comparison. Had that mind
been hitherto an honest mind the word " Cawdor " would have
occupied the place of " king," " king " that of " Cawdor." Observe
too the general character of this speech : Although the coincidence
of the principal prophecy with his own thoughts has so strong an
effect upon Macbeth as to induce him to, at once, pronounce the
words of the sisters, " intelligence ;" he nevertheless affects to treat
that prophecy as completely secondary to the other in the strength
of its claims upon his consideration. This is a piece of *over-cautious*
hypocrisy which is fully in keeping with the tenor of his conduct
throughout the rest of the tragedy.

No sooner have the witches vanished than Banquo begins to
doubt whether there had been " such things there as they did speak
about." This is the natural incredulity of a free mind so circum-
stanced. On the other hand, Macbeth, whose manner, since the
first announcement of the sisters, has been that of a man in a
reverie, makes no doubt whatever of the reality of their appearance,
nor does he reply to the expressed scepticism of Banquo, but
abruptly exclaims, " your children shall be kings." To this Banquo
answers, " you shall be king." " And thane of Cawdor too : went
it not so ?" continues Macbeth. Now, what, in either case, is the
condition of mind which can have given rise to this part of the
dialogue ? It is, we imagine, sufficiently evident that the playful
words of Banquo were suggested to Shakspere by the narration of
Holinshed ; but how are we to account for those of Macbeth, other-
wise than by supposing that the question of the crown is now
settled in his mind by the coincidence of the principal prediction,
with the shapings of his own thoughts, and that he is at this
moment occupied with the *wholly unanticipated* revelations, touch-
ing the thaneship of Cawdor, and the future possession of the throne
by the offspring of Banquo ?

Now comes the fulfilment of the first prophecy. Mark the words of these men, upon receiving the announcement of Rosse :

> "*Banquo*. What ! can the devil speak truth ?
>
> *Macbeth*. The thane of Cawdor lives : why do you dress me
> In borrowed robes ?"

Mark how that reception is in either case precisely the reverse of that given to the prophecy itself. Here *Banquo* starts. But what is here done for Banquo, by the coincidence of the prophecy with the truth, has been already done for Macbeth, by the coincidence of his thought with the prophecy. Accordingly, Macbeth is calm enough to play the hypocrite, when he must otherwise have experienced surprise far greater than that of Banquo, because he is much more nearly concerned in the source of it. So far indeed from being overcome with astonishment, Macbeth still continues to dwell upon the prophecy, by which his peace of mind is afterwards constantly disturbed,

> " Do you not hope your children shall be kings,
> When those that gave the thane of Cawdor to me
> Promised no less to them ?"

Banquo's reply to this question has been one of the chief sources of the interpretation, the error of which we are now endeavouring to expose. He says,

> " That, trusted home,
> Might yet enkindle you unto the crown,
> Besides the thane of Cawdor. But, 'tis strange ;
> And often times, to win us to our harm,
> The instruments of darkness tell us truths,
> Win us with honest trifles, to betray us
> In deepest consequence."

Now, these words have usually been considered to afford the clue to the *entire* nature and extent of the supernatural influence brought into play upon the present tragedy ; whereas, in truth, all that they express is a natural suspicion, called up in the mind of Banquo, by Macbeth's remarkable deportment, that *such* is the character of the influence which is at this moment being exerted upon the soul of the man to whom he therefore thinks proper to hint the warning they contain.

The soliloquy which immediately follows the above passage is particularly worthy of comment :

> " This supernatural soliciting
> Cannot be ill ; cannot be good :—if ill,
> Why hath it given me earnest of success,

Commencing in a truth ? I am thane of Cawdor :
If good, why do I yield to that suggestion,
Whose horrid image doth unfix my hair,
And make my seated heart knock at my ribs
Against the use of nature ? Present fears
Are less than horrible imaginings.
My thought, whose murder yet is but fantastical,
Shakes so my single state of man, that function
Is smothered in surmise, and nothing is,
But what is not."

The early portion of this passage assuredly indicates that Macbeth
regards the communications of the witches merely in the light of an
invitation to the carrying out of a design pre-existent in his own
mind. He thinks that the *spontaneous* fulfilment of the chief
prophecy is in no way probable ; the consummation of the lesser
prophecy being held by him, but as an " earnest of success " to his
own efforts in consummating the greater. From the latter portion
of this soliloquy we learn the real extent to which " metaphysical
aid " is implicated in bringing about the crime of Duncan's murder.
It serves to assure Macbeth that *that* is the " nearest way " to the
attainment of his wishes ;—a way to the suggestion of which he now,
for the first time, "*yields*," because the chances of its failure have
been infinitely lessened by the " earnest of success " which he has
just received.

After the above soliloquy Macbeth breaks the long pause, implied
in Banquo's words, " Look how our partner's rapt," by exclaiming,

"If chance will have me king, why chance may crown me,
 Without my stir."

Which is a very logical conclusion; but one at which he would long
ago have arrived, had " soliciting " meant " suggestion," as most
people suppose it to have done ; or at least, under those circum-
stances, he would have been satisfied with that conclusion, instead
of immediately afterwards changing it, as we see that he has done,
when he adds,

" Come what come may,
Time and the hour runs through the roughest day !"

With that the third scene closes ; the parties engaged in it proceed-
ing forthwith to the palace of Duncan at Fores.

Towards the conclusion of the fourth scene, Duncan names his
successor in the realm of Scotland. After this Macbeth hastily
departs, to inform his wife of the king's proposed visit to their
castle, at Inverness. The last words of Macbeth are the following,

"The prince of Cumberland!—That is a step,
On which I must fall down, or else o'erleap.
For in my way it lies. Stars, hide your fires !
Let not light see my black and deep desires ;
The eye wink at the hand ; yet let that be,
Which the eye fears, when it is done, to see."

These lines are equally remarkable for a tone of settled assurance as to the fulfilment of the speaker's royal hope, and for an entire absence of any expression of reliance upon the power of the witches, —the hitherto supposed originators of that hope,—in aiding its consummation. It is particularly noticeable that Macbeth should make no reference whatever, not even in thought, (that is, in soliloquy) to any supernatural agency during the long period intervening between the fulfilment of the two prophecies. Is it probable that this would have been the case had Shakspere intended that such an agency should be understood to have been the first motive and mainspring of that deed, which, with all its accompanying struggles of conscience, he has so minutely pictured to us as having been, during that period, enacted ? But besides this negative argument, we have a positive one for his non-reliance upon their promises in the fact that he attempts to outwit them by the murder of Fleance even after the fulfilment of the second prophecy.

The fifth scene opens with Lady Macbeth's perusal of her husband's narration of his interview with the witches. The order of our investigation requires the postponement of comment upon the contents of this letter. We leave it for the present, merely cautioning the reader against taking up any hasty objections to a very important clause in the enunciation of our view by reminding him that, contrary to Shakspere's custom in ordinary cases, we are made acquainted only with a *portion* of the missive in question. Let us then proceed to consider the soliloquy which immediately follows the perusal of this letter :

"I do fear thy nature.
It is too full o' the milk of human kindness,
To catch the nearest way : thou wouldst be great ;
Art not without ambition ; but without
The illness should attend it. That thou wouldst highly,
That wouldst thou holily ; wouldst not play false
And yet wouldst wrongly win: thou'dst have, great Glamis,
That which cries this thou must do if thou have it,
And that which rather thou dost fear to do,
Thou wishest should be undone."

It is vividly apparent that this passage indicates a knowledge of the character it depicts, which is far too intimate to allow of its being other than a *direct* inference from facts connected with previous communications upon similar topics between the speaker and the writer : unless, indeed, we assume that in this instance Shakspere has notably departed from his usual principles of characterization, in having invested Lady Macbeth with an amount of philosophical acuteness, and a faculty of deduction, much beyond those pretended to by any other of the female creations of the same author.

The above passage is interrupted by the announcement of the approach of Duncan. Observe Lady Macbeth's behaviour upon receiving it. She immediately determines upon what is to be done, and all without (are we to suppose?) in any way consulting, or being aware of, the wishes or inclinations of her husband ! Observe too, that neither does *she* appear to regard the witches' prophecies as anything more than an invitation, and holding forth of "metaphysical *aid*" to the carrying out of an independent project. That this should be the case in both instances vastly strengthens the argument legitimately deducible from each.

At the conclusion of the passage which called for the last remark, Macbeth, after a long and eventful period of absence, let it be recollected, enters to a wife who, we will for a moment suppose, is completely ignorant of the character of her husband's recent cogitations. These are the first words which pass between them,

"*Macbeth.* My dearest love,
 Duncan comes here to-night.
L. Macbeth. And when goes hence?
Macbeth. To-morrow, as he purposes.
L. Macbeth. Oh ! never
 Shall sun that morrow see !
 Your face, my thane, is as a book where men
 May read strange matters :—to beguile the time,
 Look like the time ; bear welcome in your eye,
 Your hand, your tongue : look like the innocent flower,
 But be the serpent under it. He that's coming
 Must be provided for ; and you shall put
 This night's great business into my dispatch,
 Which shall to all our nights and days to come
 Give solely sovereign sway and masterdom.
Macbeth. We will speak further."

Are these words those which would naturally arise from the situation at present, by common consent, attributed to the speakers

of them ? That is to say a situation in which *each speaker is totally ignorant of the sentiments pre-existent in the mind of the other*. Are the words, "we will speak further," those which might in nature form the whole and sole reply made by a man to his wife's completely unexpected anticipation of his own fearful purposes ? If not, if few or none of these lines, thus interpreted, will satisfy the reader's feeling for common truth, does not the view which we have adopted invest them with new light, and improved, or perfected meaning ?

The next scene represents the arrival of Duncan at Inverness, and contains nothing which bears either way upon the point in question. Proceeding, therefore, to the seventh and last scene of the first act we come to what we cannot but consider to be proof positive of the opinion under examination. We shall transcribe at length the portion of this scene containing that proof; having first reminded the reader that a few hours at most can have elapsed between the arrival of Macbeth, and the period at which the words, now to be quoted, are uttered.

> " *Lady Macbeth.* *Was the hope drunk,*
> *Wherein you dressed yourself ? Hath it slept since,*
> *And wakes it now, to look so green and pale*
> *At what it did so freely ?* From this time,
> Such I account thy love. Art thou afeard
> To be the same in thine own act and valour,
> As thou art in desire ? Would'st thou have that
> Which thou esteem'st the ornament of life,
> And live a coward in thine own esteem,
> Letting, I dare not, wait upon, I would,
> Like the poor cat in the adage ?
>
> *Macbeth.* Prithee, peace :
> I dare do all that may become a man ;
> Who dares do more is none.
>
> *Lady Macbeth.* *What beast was't then*
> *That made you break this enterprise to me ?*
> *When you durst do it, then you were a man,*
> *And to be more than what you were you would*
> *Be so much more the man. Nor time nor place*
> *Did then adhere, and yet you would make both.*
> They have made themselves, and that their fitness now
> Does unmake you. I have given suck, and know
> How tender 'tis to love the babe that milks me :

I would, while it was smiling in my face,
Have plucked my nipple from its boneless gums,
And dashed the brains out, *had I so sworn*
As you have done to this."

With respect to the above lines, let us observe that, the words,
" nor time nor place did then adhere," render it evident that they
hold reference to something which passed before Duncan had sig-
nified his intention of visiting the castle of Macbeth. Consequently
the words of Lady Macbeth can have no reference to the previous
communication of any definite intention, on the part of her husband,
to murder the king ; because, not long before, she professes herself
aware that Macbeth's nature is " too full of the milk of human kind-
ness to catch the nearest way ;" indeed, she has every reason to
suppose that she herself has been the means of breaking that enter-
prise to *him*, though, in truth, the crime had already, as we have
seen, suggested itself to his thought, " whose murder was as yet
fantastical."

Again the whole tenor of this passage shews that it refers to ver-
bal communication between them. *But no such communication can
have taken place since Macbeth's rencontre with the witches* ; for,
besides that he is, immediately after that rencontre, conducted to the
presence of the king, who there signifies an intention of proceeding
directly to Macbeth's castle, such a communication would have ren-
dered the contents of the letter to Lady Macbeth completely super-
fluous. What then are we to conclude concerning these problematical
lines? First begging the reader to bear in mind the tone of sophistry
which has been observed by Schlegel to pervade, and which is
indeed manifest throughout the persuasions of Lady Macbeth, we
answer, that she wilfully confounds her husband's,—probably vague
and unplanned—" enterprise " of obtaining the crown, with that
" nearest way " to which she now urges him ; but, at the same time,
she obscurely individualizes the separate purposes in the words,
" and to be *more* than what you were, you would be so much
more the man."

It is a fact which is highly interesting in itself, and one which
strongly impeaches the candour of the majority of Shakspere's
commentators, that the impenetrable obscurity which must have
pervaded the whole of this passage should never have been made
the subject of remark. As far as we can remember, not a word has
been said upon the matter in any one of the many superfluously
explanatory editions of our dramatist's productions. Censures have
been repeatedly lavished upon minor cases of obscurity, none upon
this. In the former case the fault has been felt to be Shakspere's,

for it has usually existed in the expression; but in the latter the language is unexceptional, and the avowal of obscurity might imply the possibility of misapprehension or stupidity upon the part of the avower.

Probably the only considerable obstacle likely to act against the general adoption of those views will be the doubt, whether so important a feature of this consummate tragedy can have been left by Shakspere so obscurely expressed as to be capable of remaining totally unperceived during upwards of two centuries, within which period the genius of a Coleridge and of a Schlegel has been applied to its interpretation. Should this objection be brought forward, we reply, in the first place, that the objector is ‘begging’ his question in assuming that the feature under examination has remained *totally* unperceived. Coleridge by way of comment upon these words of Banquo,

> "Good sir, why do you stand, and seem to fear
> Things that do sound so fair?"

writes thus: "The general idea is all that can be required of a poet—not a scholastic logical consistency in all the parts, so as to meet metaphysical objectors. * * * * * * * * How strictly true to nature it is, that Banquo, and not Macbeth himself, directs our notice to the effects produced in Macbeth's mind, *rendered temptible by previous dalliance with ambitious thoughts.*" Here Coleridge denies the *necessity* of "logical consistency, so as to meet metaphysical objectors," although he has, throughout his criticisms upon Shakspere, endeavored, and nearly always with success, to prove the *existence* of that consistency; and so strongly has he felt the want of it here, that he has, in order to satisfy himself, *assumed* that "previous dalliance with ambitious thoughts," whose existence it has been our object to *prove*.

But, putting Coleridge's imperfect perception of the truth out of the question, surely nothing can be easier than to believe *that* for the belief in which we have so many precedents. How many beauties, lost upon Dryden, were perceived by Johnson; How many, hidden to Johnson and his cotemporaries, have been brought to light by Schlegel and by Coleridge.

Repining.

SHE sat alway thro' the long day
Spinning the weary thread away ;
And ever said in undertone :
"Come, that I be no more alone."

From early dawn to set of sun
Working, her task was still undone ;
And the long thread seemed to increase
Even while she spun and did not cease.
She heard the gentle turtle-dove
Tell to its mate a tale of love ;
She saw the glancing swallows fly,
Ever a social company ;
She knew each bird upon its nest
Had cheering songs to bring it rest ;
None lived alone save only she ;—
The wheel went round more wearily ;
She wept and said in undertone:
"Come, that I be no more alone."

Day followed day, and still she sighed
For love, and was not satisfied ;
Until one night, when the moonlight
Turned all the trees to silver white,
She heard, what ne'er she heard before,
A steady hand undo the door.
The nightingale since set of sun
Her throbbing music had not done,
And she had listened silently ;
But now the wind had changed, and she
Heard the sweet song no more, but heard
Beside her bed a whispered word :
"Damsel, rise up ; be not afraid ;
For I am come at last," it said.

She trembled, tho' the voice was mild ;
She trembled like a frightened child ;—
Till she looked up, and then she saw
The unknown speaker without awe.
He seemed a fair young man, his eyes
Beaming with serious charities ;

His cheek was white, but hardly pale ;
And a dim glory like a veil
Hovered about his head, and shone
Thro' the whole room till night was gone.

So her fear fled ; and then she said,
Leaning upon her quiet bed :
" Now thou art come, I prithee stay,
That I may see thee in the day,
And learn to know thy voice, and hear
It evermore calling me near."

He answered : " Rise, and follow me."
But she looked upwards wonderingly :
" And whither would'st thou go, friend ? stay
Until the dawning of the day."
But he said : " The wind ceaseth, Maid ;
Of chill nor damp be thou afraid."

She bound her hair up from the floor,
And passed in silence from the door.

So they went forth together, he
Helping her forward tenderly.
The hedges bowed beneath his hand ;
Forth from the streams came the dry land
As they passed over ; evermore
The pallid moonbeams shone before ;
And the wind hushed, and nothing stirred ;
Not even a solitary bird,
Scared by their footsteps, fluttered by
Where aspen-trees stood steadily.

As they went on, at length a sound
Came trembling on the air around ;
The undistinguishable hum
Of life, voices that go and come
Of busy men, and the child's sweet
High laugh, and noise of trampling feet.

Then he said : " Wilt thou go and see ?"
And she made answer joyfully ;
" The noise of life, of human life,
Of dear communion without strife,
Of converse held 'twixt friend and friend ;
Is it not here our path shall end ?"
He led her on a little way
Until they reached a hillock : " Stay."

It was a village in a plain.
High mountains screened it from the rain
And stormy wind; and nigh at hand
A bubbling streamlet flowed, o'er sand
Pebbly and fine, and sent life up
Green succous stalk and flower-cup.

Gradually, day's harbinger,
A chilly wind began to stir.
It seemed a gentle powerless breeze
That scarcely rustled thro' the trees;
And yet it touched the mountain's head
And the paths man might never tread.
But hearken: in the quiet weather
Do all the streams flow down together?—
No, 'tis a sound more terrible
Than tho' a thousand rivers fell.
The everlasting ice and snow
Were loosened then, but not to flow;—
With a loud crash like solid thunder
The avalanche came, burying under
The village; turning life and breath
And rest and joy and plans to death.

" Oh ! let us fly, for pity fly ;
Let us go hence, friend, thou and I.
There must be many regions yet
Where these things make not desolate."
He looked upon her seriously ;
Then said : " Arise and follow me."
The path that lay before them was
Nigh covered over with long grass ;
And many slimy things and slow
Trailed on between the roots below.
The moon looked dimmer than before ;
And shadowy cloudlets floating o'er
Its face sometimes quite hid its light,
And filled the skies with deeper night.

At last, as they went on, the noise
Was heard of the sea's mighty voice ;
And soon the ocean could be seen
In its long restlessness serene.

Upon its breast a vessel rode
That drowsily appeared to nod
As the great billows rose and fell,
And swelled to sink, and sank to swell.

Meanwhile the strong wind had come forth
From the chill regions of the North,
The mighty wind invisible.
And the low waves began to swell ;
And the sky darkened overhead ;
And the moon once looked forth, then fled
Behind dark clouds ; while here and there
The lightning shone out in the air ;
And the approaching thunder rolled
With angry pealings manifold.
How many vows were made, and prayers
That in safe times were cold and scarce.
Still all availed not ; and at length
The waves arose in all their strength,
And fought against the ship, and filled
The ship. Then were the clouds unsealed,
And the rain hurried forth, and beat
On every side and over it.

Some clung together, and some kept
A long stern silence, and some wept.
Many half-crazed looked on in wonder
As the strong timbers rent asunder ;
Friends forgot friends, foes fled to foes ;—
And still the water rose and rose.

"Ah woe is me ! Whom I have seen
Are now as tho' they had not been.
In the earth there is room for birth,
And there are graves enough in earth ;
Why should the cold sea, tempest-torn,
Bury those whom it hath not borne ?"

He answered not, and they went on.
The glory of the heavens was gone ;
The moon gleamed not nor any star ;
Cold winds were rustling near and far,
And from the trees the dry leaves fell
With a sad sound unspeakable.

The air was cold ; till from the South
A gust blew hot, like sudden drouth,
Into their faces ; and a light
Glowing and red, shone thro' the night.

A mighty city full of flame
And death and sounds without a name.
Amid the black and blinding smoke,
The people, as one man, awoke.
Oh ! happy they who yesterday
On the long journey went away ;
Whose pallid lips, smiling and chill,
While the flames scorch them smile on still ;
Who murmur not ; who tremble not
When the bier crackles fiery hot ;
Who, dying, said in love's increase :
" Lord, let thy servant part in peace."

Those in the town could see and hear
A shaded river flowing near ;
The broad deep bed could hardly hold
Its plenteous waters calm and cold.
Was flame-wrapped all the city wall,
The city gates were flame-wrapped all.

What was man's strength, what puissance then ?
Women were mighty as strong men.
Some knelt in prayer, believing still,
Resigned unto a righteous will,
Bowing beneath the chastening rod,
Lost to the world, but found of God.
Some prayed for friend, for child, for wife ;
Some prayed for faith ; some prayed for life ;
While some, proud even in death, hope gone,
Steadfast and still, stood looking on.

" Death—death—oh ! let us fly from death ;
Where'er we go it followeth ;
All these are dead ; and we alone
Remain to weep for what is gone.
What is this thing ? thus hurriedly
To pass into eternity ;
To leave the earth so full of mirth ;
To lose the profit of our birth ;
To die and be no more ; to cease,
Having numbness that is not peace.

Let us go hence ; and, even if thus
Death everywhere must go with us,
Let us not see the change, but see
Those who have been or still shall be."

He sighed and they went on together ;
Beneath their feet did the grass wither ;
Across the heaven high overhead
Dark misty clouds floated and fled ;
And in their bosom was the thunder,
And angry lightnings flashed out under,
Forked and red and menacing ;
Far off the wind was muttering ;
It seemed to tell, not understood,
Strange secrets to the listening wood.

Upon its wings it bore the scent
Of blood of a great armament :
Then saw they how on either side
Fields were down-trodden far and wide.
That morning at the break of day
Two nations had gone forth to slay.

As a man soweth so he reaps.
The field was full of bleeding heaps ;
Ghastly corpses of men and horses
That met death at a thousand sources ;
Cold limbs and putrifying flesh ;
Long love-locks clotted to a mesh
That stifled ; stiffened mouths beneath
Staring eyes that had looked on death.

But these were dead : these felt no more
The anguish of the wounds they bore.
Behold, they shall not sigh again,
Nor justly fear, nor hope in vain.
What if none wept above them ?—is
The sleeper less at rest for this ?
Is not the young child's slumber sweet
When no man watcheth over it ?
These had deep calm; but all around
There was a deadly smothered sound,
The choking cry of agony
From wounded men who could not die ;

Who watched the black wing of the raven
Rise like a cloud 'twixt them and heaven,
And in the distance flying fast
Beheld the eagle come at last.

She knelt down in her agony :
" O Lord, it is enough," said she :
" My heart's prayer putteth me to shame ;
" Let me return to whence I came.
" Thou who for love's sake didst reprove,
" Forgive me for the sake of love."

Sweet Death.

The sweetest blossoms die.
And so it was that, going day by day
 Unto the church to praise and pray,
And crossing the green church-yard thoughtfully,
 I saw how on the graves the flowers
 Shed their fresh leaves in showers ;
And how their perfume rose up to the sky
 Before it passed away.

The youngest blossoms die.
They die, and fall, and nourish the rich earth
 From which they lately had their birth.
Sweet life : but sweeter death that passeth by,
 And is as tho' it had not been.
 All colors turn to green :
The bright hues vanish, and the odours fly ;
 The grass hath lasting worth.

And youth and beauty die.
So be it, O my God, thou God of truth.
 Better than beauty and than youth
Are saints and angels, a glad company :
 And Thou, O Lord, our Rest and Ease,
 Are better far than these.
Why should we shrink from our full harvest ? why
 Prefer to glean with Ruth ?

The Subject in Art.

No. II.

Resuming a consideration of the subject-matter suitable in painting and sculpture, it is necessary to repeat those premises, and to re-establish those principles which were advanced or elicited in the first number of this essay.

It was premised then that works of Fine Art affect the beholder in the same ratio as the *natural prototypes* of those works would affect him ; and not in proportion to the difficulties overcome in the artificial representation of those prototypes. Not contending, meanwhile, that the picture painted by the hand of the artist, and then by the hand of nature on the eye of the beholder, is, in amount, the same as the picture painted there by nature alone ; but disregarding, as irrelevant to this investigation, *all concomitants of fine art wherein they involve an ulterior impression as to the relative merits of the work by the amount of its success,* and, for a like reason, disregarding all emotions and impressions which are not the immediate and proximate result of an excitor influence of, or pertaining to, the *things artificial,* as a bona fide equivalent of the *things natural.*

Or the premises may be practically stated thus :—(1st.) When one looks on a certain painting or sculpture for the first time, the first notion is that of a painting or sculpture. (2nd.) In the next place, while the objects depicted are revealing themselves as real objects, the notion of a painting or sculpture has elapsed, and, in its place, there are emotions, passions, actions (moral or intellectual) according in sort and degree to the heart or mind-moving influence of the objects represented. (3rd.) Finally, there is a notion of a painting or sculpture, and a judgment or sentiment commensurate with the estimated merits of the work.—The second statement gives the premised conditions under which Fine Art is about to be treated : the 3rd statement exemplifies a phase in the being of Fine Art under which it is never to be considered: and furthermore, whilst the mental reflection last mentioned (the judgment on the work) is being made, it may occur that certain objects, most difficult of artistic execution, had been most successfully handled : the merits of introducing such objects, in such a manner, are the merits of those concomitants mentioned as equally without the scope of consideration.

Thus much for the premises—next to the re-establishment of principles.

1st. The principle was elicited, that Fine Art should regard the general happiness of man, by addressing those of his attributes which are *peculiarly human,* by exciting the activity of his rational and benevolent powers ; and thereafter :—2nd, that the Subject in Art should be drawn from objects which so address and excite him ; and 3rd, as objects so exciting the mental activity may (in proportion to the mental capacity) excite it to any amount, and so possibly in the highest degree (the function of Fine Art being *mental excitement,* and that of High Art being the *highest mental excitement*) that all objects so exciting mental activity and emotion in the highest degree, may afford subjects for High Art.

Having thus re-stated the premises and principles already deduced, let us proceed to enquire into the propriety of selecting the Subject from the past or the present time ; which enquiry resolves itself fundamentally into the analysis of objects and incidents experienced immediately by the senses, or acquired by mental education.

Here then we have to explore the specific difference between the incidents and objects of to-day, as exposed to our daily observation, and the incidents and objects of time past, as bequeathed to us by history, poetry, or tradition.

In the first place, there is, no doubt, a considerable *real* difference between the things of to-day and those of times past : but as all former times, their incidents and objects differ amongst themselves, this can hardly be the cause of the specific difference sought for—a difference between our share of things past and things present. This real, but not specific difference then, however admitted, shall not be considered here.

It is obvious, in the meanwhile, that all which we have of the past is stamped with an impress of mental assimilation : an impress it has received from the mind of the author who has garnered it up, and disposed it in that form and order which ensure it acceptance with posterity. For let a writer of history be as matter of fact as he will, the very order and classification of events will save us the trouble of confusion, and render them graspable, and more capable of assimilation, than is the raw material of every-day experience. In fact the work of mind is begun, the key of intelligence is given, and we have only to continue the process. Where the vehicle for the transmission of things past is poetry, then we have them presented in that succession, and with that modification of force, a resilient plasticity, now advancing, now recoiling, insinuating and grappling, that ere this material and mental warfare is over, we find the facts thus transmitted are incorporated with our psychical

existence. And in tradition is it otherwise?—Every man tells the tale in his own way; and the merits of the story itself, or the person who tells it, or his way of telling, procures it a lodgment in the mind of the hearer, whence it is ever ready to start up and claim kindred with some external excitement.

Thus it is the luck of all things of the past to come down to us with some poetry about them; while from those of diurnal experience we must extract this poetry ourselves: and although all good men are, more or less, poets, they are passive or recipient poets; while the active or donative poet caters for them what they fail to collect. For let a poet walk through London, and he shall see a succession of incidents, suggesting some moral beauty by a contrast of times with times, unfolding some principle of nature, developing some attribute of man, or pointing to some glory in The Maker: while the man who walked behind him saw nothing but shops and pavement, and coats and faces; neither did he hear the aggregated turmoil of a city of nations, nor the noisy exponents of various desires, appetites and pursuits: each pulsing tremour of the atmosphere was not struck into it by a subtile ineffable something willed forcibly out of a cranium: neither did he see the driver of horses holding a rod of light in his eye and feeling his way, in a world he was rushing through, by the motion of the end of that rod:—he only saw the wheels in motion, and heard the rattle on the stones; and yet this man stopped twice at a book shop to buy 'a Tennyson,' or a 'Browning's Sordello.' Now this man might have seen all that the poet saw; he walked through the same streets: yet the poet goes home and writes a poem; and he who failed to feel the poetry of the things themselves detects it readily in the poet's version. Then why, it is asked, does not this man, schooled by the poet's example, look out for himself for the future, and so find attractions in things of to-day? He does so to a trifling extent, but the reason why he does so rarely will be found in the former demonstration.

It was shown how bygone objects and incidents come down to us invested in peculiar attractions: this the poet knows and feels, and the probabilities are that he transferred the incidents of to-day, with all their poetical and moral suggestions, to the romantic long-ago, partly from a feeling of prudence, and partly that he himself was under this spell of antiquity, How many a Troubadour, who recited tales of king Arthur, had his incidents furnished him by the events of his own time! And thus it is the many are attracted to the poetry of things past, yet impervious to the poetry of things present. But this retrograde movement in the poet, painter, or

sculptor (except in certain cases as will subsequently appear), if not
the result of necessity, is an error in judgment or a culpable dis-
honesty. For why should he not acknowledge the source of his
inspiration, that others may drink of the same spring with himself;
and perhaps drink deeper and a clearer draught ?—For the water is
unebbing and exhaustless, and fills the more it is emptied : why
then should it be filtered through his tank *where* he can teach men
to drink it at the fountain ?

If, as every poet, every painter, every sculptor will acknow-
ledge, his best and most original ideas are derived from his own
times : if his great lessonings to piety, truth, charity, love, honor,
honesty, gallantry, generosity, courage, are derived from the same
source ; why transfer them to distant periods, and make them *not
things of to-day ?* Why teach us to revere the saints of old, and not
our own family-worshippers ? Why to admire the lance-armed
knight, and not the patience-armed hero of misfortune ? Why to
draw a sword we do not wear to aid an oppressed damsel, and not a
purse which we do wear to rescue an erring one ? Why to worship
a martyred St. Agatha, and not a sick woman attending the sick ?
Why teach us to honor an Aristides or a Regulus, and not one who
pays an equitable, though to him ruinous, tax without a railing
accusation ? And why not teach us to help what the laws cannot
help ?—Why teach us to hate a Nero or an Appius, and not an
underselling oppressor of workmen and betrayer of women and
children ? Why to love a *Ladie in bower*, and not a wife's fire-
side ? Why paint or poetically depict the horrible race of Ogres
and Giants, and not show Giant Despair dressed in that modern
habit he walks the streets in ? Why teach men what were great
and good deeds in the old time, neglecting to show them any good
for themselves ?—Till these questions are answered absolutory to
the artist, it were unwise to propose the other question—Why a
poet, painter or sculptor is not honored and loved as formerly ?
" As formerly," says some avowed sceptic in *old world transcendency*
and *golden age affairs*, " I believe *formerly* the artist was as much
respected and cared for as he is now. 'Tis true the Greeks granted
an immunity from taxation to some of their artists, who were often
great men in the state, and even the companions of princes. And
are not some of our poets peers ? Have not some of our artists
received knighthood from the hand of their Sovereign, and have
not some of them received pensions ?"

To answer objections of this latitude demands the assertion of
certain characteristic facts which, tho' not here demonstrated, may
be authenticated by reference to history. Of these, the facts of

Alfred's disguised visit to the Danish camp, and Aulaff's visit to the
Saxon, are sufficient to show in what respect the poets of that
period were held; when a man without any safe conduct whatever
could enter the enemy's camp on the very eve of battle, as was here
the case; could enter unopposed, unquestioned, and return unmo-
lested !—What could have conferred upon the poet of that day so
singular a privilege ? What upon the poet of an earlier time that
sanctity in behoof whereof

> " The great Emathian conqueror bid spare
> The house of Pindarus, when temple and tower
> Went to the ground : and the repeated air
> Of sad Electra's poet had the power
> To save the Athenian walls from ruin bare."

What but an universal recognition of the poet as an universal bene-
factor of mankind ? And did mankind recognize him as such, from
some unaccountable infatuation, or because his labours obtained for
him an indefeasible right to that estimate ? How came it, when a
Greek sculptor had completed some operose performance, that his
countrymen bore him in triumph thro' their city, and rejoiced in his
prosperity as identical with their own ? How but because his art
had embodied some principle of beauty whose mysterious influence
it was their pride to appreciate—or he had enduringly moulded the
limbs of some well-trained Athlete, such as it was their interest to
develop, or he had recorded the overthrow of some barbaric invader
whom their fathers had fallen to repel.

In the middle ages when a knight listened, in the morning, to
some song of brave doing, ere evening he himself might be the hero
of such song.—What wonder then that he held sacred the function
of the poet ! Now-a-days our heroes (and we have them) are left
unchapleted and neglected—and therefore the poet lives and dies
neglected.

Thus it would appear from these facts (which have been collate-
rally evolved in course of enquiring into the propriety of choosing
the subject from past or present time, and in course of the conse-
quent analysis) that Art, to become a more powerful engine of
civilization, assuming a practically humanizing tendency (the admit-
ted function of Art), should be made more directly conversant with
the things, incidents, and influences which surround and constitute
the living world of those whom Art proposes to improve, and,
whether it should appear in event that Art can or can not assume
this attitude without jeopardizing her specific existence, that such a
consummation were desirable must be equally obvious in either
case.

Let us return now to the former consideration. It was stated that the poet is affected by every day incidents, which would have little or no effect on the mind of a general observer : and if you ask the poet, who from his conduct may be the supposed advocate of the past as the fittest medium for poetic eduction, why he embodied the suggestions of to-day in the matter and dress of antiquity ; he is likely to answer as follows.—"You have stated " that men pass by that which furnishes me with my subject : If I " merely reproduce what they slighted, the reproduction will be " slighted equally. It appears then that I must devise some means " of attracting their sympathies—and the medium of antiquity is " the fittest for three several reasons. 1st.—Nothing comes down " to us from antiquity unless fraught with sufficient interest of some " sort, to warrant it being worthy of record. Thus, all incidents " which we possess of the old time being more or less interesting, " there arises an illative impression that all things of old really " were so : and all things in idea associated with that time, " whether real or fictitious, are afforded a favorable entertainment. " Now these associations are neither trivial nor fanciful :* for I " remember to have discovered, after visiting the British Museum " for the first time, that the odour of camphor, for which I had " hitherto no predilection, afforded me a peculiar satisfaction, " seemingly suggestive of things scientific or artistic ; it was in fact " a *literary smell !*. All this was vague and unaccountable until " some time after when this happened again, and I was at once " reminded of an enormous walrus at the British Museum, and " then remembered how the whole collection, from end to end, was " permeated with the odour of camphor ! Still, despite the *con-* " *sciousness* of this, the camphor retains its influence. Now let a " poem, a painting, or sculpture, smell ever so little of antiquity, and " every intelligent reader will be full of delightful imaginations. " 2nd.—All things ancient are mysterious in obscurity :—veneration, " wonder, and curiosity are the result. 3rd.—All things ancient " are dead and gone :—we sympathize with them accordingly. All " these effects of antiquity, as a means of enforcing poetry, declare it " too powerful an ally to be readily abandoned by the poet." To all this the painter will add that the costume of almost any ancient time is more beautiful than that of the present—added to which it exposes more of that most beautiful of all objects, the human figure.

Thus we have a formidable array of objections to the choice of

* Here the author, in the person of respondent, takes occasion to narrate a real fact.

present-day subjects: and first, it was objected and granted, that incidents of the present time are well nigh barren in poetic attraction for the many. Then it was objected, but not granted, that their poetic or pictorial counterparts will be equally unattractive also: but this last remains to be proved. It was said, and is believed by the author, (and such as doubt it he does not address) that all good men are more or less poetical in some way or other; while their poetry shows itself at various times. Thus the business-man in the street has other to think of than poetry; but when he is inclined to look at a picture, or in his more poetical humour, will he neglect the pictorial counterpart of what he neglected before? To test this, show him a camera obscura, where there is a more literal transcript of present-day nature than any painting can be :—what is the result? He expresses no anxiety to quit it, but a great curiosity to investigate; he feels it is very beautiful, indeed more beautiful than nature: and this he will say is because he does not see nature as an artist does. Now the solution of all this is easy : 1st. He is in a mood of mind which renders him accessible to the influences of poetry, which was not before the case. 2nd. He looks at that steadily which he before regarded cursorily; and, as the picture remains in his eye, it acquires an amount of harmony, in behoof of an intrinsic harmony resident in the organ itself, which exerts proportionately modifying influences on all things that enter within it; and of the nervous harmony, and the beautifully apportioned stimuli of alternating ocular spectra. 3rd. There is a resolution of discord effected by the instrument itself, inasmuch as its effects are homogeneous. All these harmonizing influences are equally true of the painting; and though we have no longer the homogeneous effect of the camera, we have the homogoneous effect of one mind, viz., the mind of the artist.

Thus having disproved the supposed poetical obstacles to the rendering of real life or nature in its own real garb and time, as faithfully as Art can render it, nothing need be said to answer the advantages of the antique or mediæval rendering; since they were only called in to neutralize the aforesaid obstacles, which obstacles have proved to be fictitious. It remains then to consider the *artistic* objection of costume, &c., which consideration ranges under the head of *real differences between the things of past and present times,* a consideration formerly postponed. But this requiring a patient analysis, will necessitate a further postponement, and in conclusion, there will be briefly stated the elements of the argument, thus.— It must be obvious to every physicist that physical beauty (which this subject involves on the one side [the ancient] as opposed to the

want of it on the other [the modern]) was in ancient times as superior to physical beauty in the modern, as psychical beauty in the modern is superior to psychical beauty in the ancient. Costume then, as physical, is more beautiful ancient than modern. Now that a certain amount of physical beauty is requisite to constitute Fine Art, will be readily admitted; but what that amount is, must be ever undefined. That the maximum of physical beauty does not constitute the maximum of Fine Art, is apparent from the facts of the physical beauty of *Early Christian* Art being inferior to that of Grecian art; whilst, in the concrete, Early Christian Art is superior to Grecian. Indeed some specimens of Early Christian Art are repulsive rather than beautiful, yet these are in many cases the highest works of Art.

In the " Plague at Ashdod," great physical beauty, resulting from picturesque costume and the exposed human figure, was so far from desirable, that it seems purposely deformed by blotches of livid color; yet the whole is a most noble work of Poussin. Containing as much physical beauty as this picture, the writer remembers to have seen an incident in the streets where a black-haired, sordid, wicked-headed man, was striking the butt of his whip at the neck of a horse, to urge him round an angle of the pavement; a smocked countryman offered him the loan of his mules : a blacksmith standing by, showed him how to free the wheel, by only swerving the animal to the left : he, taking no notice whatever, went on striking and striking ; whilst a woman waiting to cross, with a child in her one hand, and with the other pushing its little head close to her side, looked with wide eyes at this monster.

This familiar incident, affording a subject fraught with more moral interest than, and as much picturesque matter as, many antique or mediæval subjects, is only wanting in that romantic attraction which, by association, attaches to things of the past. Yet, let these modern subjects once excite interest, as it really appears they can, and the incidents of to-day will acquire romantic attractions by the same association of ideas.

The claims of ancient, mediæval, and modern subjects will be considered in detail at a future period.

The Carillon.

(Antwerp and Bruges.)

*** In these and others of the Flemish Towns, the *Carillon*, or chimes which have a most fantastic and delicate music, are played almost continually The custom is very ancient.

At Antwerp, there is a low wall
 Binding the city, and a moat
 Beneath, that the wind keeps afloat.
You pass the gates in a slow drawl
Of wheels. If it is warm at all
 The Carillon will give you thought.

I climbed the stair in Antwerp church,
 What time the urgent weight of sound
 At sunset seems to heave it round.
Far up, the Carillon did search
The wind ; and the birds came to perch
 Far under, where the gables wound.

In Antwerp harbour on the Scheldt
 I stood along, a certain space
 Of night. The mist was near my face :
Deep on, the flow was heard and felt.
The Carillon kept pause, and dwelt
 In music through the silent place.

At Bruges, when you leave the train,
 —A singing numbness in your ears,—
 The Carillon's first sound appears
Only the inner moil. Again
A little minute though—your brain
 Takes quiet, and the whole sense hears.

John Memmeling and John Van Eyck
 Hold state at Bruges. In sore shame
 I scanned the works that keep their name.
The Carillon, which then did strike
Mine ears, was heard of theirs alike :
 It set me closer unto them.

I climbed at Bruges all the flight
 The Belfry has of ancient stone.
 For leagues I saw the east wind blown :
The earth was grey, the sky was white.
I stood so near upon the height
 That my flesh felt the Carillon.

October, 1849.

Emblems.

I LAY through one long afternoon,
　　Vacantly plucking the grass.
I lay on my back, with steadfast gaze
　　Watching the cloud-shapes pass;
Until the evening's chilly damps
　　Rose from the hollows below,
　　Where the cold marsh-reeds grow.

I saw the sun sink down behind
　　The high point of a mountain;
Its last light lingered on the weeds
　　That choked a shattered fountain,
Where lay a rotting bird, whose plumes
　　Had beat the air in soaring.
　　On these things I was poring :—

The sun seemed like my sense of life,
　　Now weak, that was so strong;
The fountain—that continual pulse
　　Which throbbed with human song :
The bird lay dead as that wild hope
　　Which nerved my thoughts when young.
　　These symbols had a tongue,

And told the dreary lengths of years
　　I must drag my weight with me;
Or be like a mastless ship stuck fast
　　On a deep, stagnant sea.
A man on a dangerous height alone,
　　If suddenly struck blind,
　　Will never his home path find.

When divers plunge for ocean's pearls,
　　And chance to strike a rock,
Who plunged with greatest force below
　　Receives the heaviest shock.
With nostrils wide and breath drawn in,
　　I rushed resolved on the race;
　　Then, stumbling, fell in the chase.

Yet with time's cycles forests swell
 Where stretched a desert plain :
Time's cycles make the mountains rise
 Where heaved the restless main :
On swamps where moped the lonely stork,
 In the silent lapse of time
 Stands a city in its prime.

I thought : then saw the broadening shade
 Grow slowly over the mound,
That reached with one long level slope
 Down to a rich vineyard ground :
The air about lay still and hushed,
 As if in serious thought :
 But I scarcely heeded aught,

Till I heard, hard by, a thrush break forth,
 Shouting with his whole voice,
So that he made the distant air
 And the things around rejoice.
My soul gushed, for the sound awoke
 Memories of early joy :
 I sobbed like a chidden boy.

Sonnet.

Early Aspirations.

How many a throb of the young poet heart,
 Aspiring to the ideal bliss of Fame,
 Deems that Time soon may sanctify his claim
Among the sons of song to dwell apart.—
 Time passes—passes ! The aspiring flame
Of Hope shrinks down ; the white flower Poesy
Breaks on its stalk, and from its earth-turned eye
 Drop sleepy tears instead of that sweet dew
 Rich with inspiring odours, insect wings
Drew from its leaves with every changing sky,
 While its young innocent petals unsunn'd grew.
 No more in pride to other ears he sings,
But with a dying charm himself unto :—
 For a sad season : then, to active life he springs.

From the Cliffs: Noon.

The sea is in its listless chime :
 Time's lapse it is, made audible,—
 The murmur of the earth's large shell.
In a sad bluèness beyond rhyme
 It ends : sense, without thought, can pass
 No stadium further. Since time was,
This sound hath told the lapse of time.

No stagnance that death wins,—it hath
 The mournfulness of ancient life,
 Always enduring at dull strife.
As the world's heart of rest and wrath,
 Its painful pulse is in the sands.
 Last utterly, the whole sky stands,
Grey and not known, along its path.

Fancies at Leisure.

I. In Spring.

The sky is blue here, scarcely with a stain
Of grey for clouds : here the young grasses gain
A larger growth of green over this splinter
Fallen from the ruin. Spring seems to have told Winter
He shall not freeze again here. Tho' their loss
Of leaves is not yet quite repaired, trees toss
Sprouts from their boughs. The ash you called so stiff
Curves, daily, broader shadow down the cliff.

II. In Summer.

How the rooks caw, and their beaks seem to clank !
 Let us just move out there,—(it might be cool
Under those trees,) and watch how the thick tank
 By the old mill is black,—a stagnant pool
Of rot and insects. There goes by a lank
 Dead hairy dog floating. Will Nature's rule
Of life return hither no more ? The plank
 Rots in the crushed weeds, and the sun is cruel.

III. The Breadth of Noon.

Long time I lay there, while a breeze would blow
 From the south softly, and, hard by, a slender
 Poplar swayed to and fro to it. Surrender
Was made of all myself to quiet. No
Least thought was in my mind of the least woe :
 Yet the void silence slowly seemed to render
 My calmness not less calm, but yet more tender,
Aud I was nigh to weeping.—' Ere I go,'
I thought, ' I must make all this stillness mine ;
 The sky's blue almost purple, and these three
Hills carved against it, and the pine on pine
 The wood in their shade has. All this I see
 So inwardly I fancy it may be
Seen thus of parted souls by *their* sunshine.'

IV. Sea-Freshness.

Look at that crab there. See if you can't haul
 His backward progress to this spar of a ship
 Thrown up and sunk into the sand here. Clip
His clipping feelers hard, and give him all
Your hand to gripe at : he'll take care not fall :
 So,—but with heed, for you are like to slip
 In stepping on the plank's sea-slime. Your lip—
No wonder—curves in mirth at the slow drawl
Of the squat creature's legs. We've quite a shine
 Of waves round us, and here there comes a wind
 So fresh it must bode us good luck. How long
Boatman, for one and sixpence? Line by line
 The sea comes toward us sun-ridged. Oh ! we sinned
 Taking the crab out : let's redress his wrong.

V. The Fire Smouldering.

I look into the burning coals, and see
 Faces and forms of things ; but they soon pass,
 Melting one into other : the firm mass
Crumbles, and breaks, and fades gradually,
Shape into shape as in a dream may be,
 Into an image other than it was :
 And so on till the whole falls in, and has
Not any likeness,—face, and hand, and tree,

All gone. So with the mind : thought follows thought,
This hastening, and that pressing upon this,
A mighty crowd within so narrow room :
And then at length heavy-eyed slumbers come,
The drowsy fancies grope about, and miss
Their way, and what was so alive is nought.

Papers of " The M. S. Society." *

No. I.

An Incident in the Siege of Troy, seen from a modern Observatory.

Sixteen Specials in Priam's Keep
 Sat down to their mahogany :
The League, just then, had made *busters* cheap,
 And Hesiod writ his " Theogony,"
A work written to prove "that, if men would be men,
And demand their rights again and again,
They might live like gods, have infinite *smokes*,
Drink infinite rum, drive infinite *mokes*,
Which would come from every part of the known
And civilized globe, twice as good as their own,
And, finally, Ilion, the work-shop should be
Of the world—one vast manufactory !"

From arrow-slits, port-holes, windows, what not,
Their sixteen quarrels the Specials had shot
From sixteen arblasts, their daily task ;
Why they'd to do it they didn't ask,
For, after they'd done it, they sat down to dinner ;
The sixteen Specials they didn't get thinner ;
But kept quite loyal, and every day
Asked no questions but fired away.

Would you like me to tell you the reason why
These sixteen Specials kept letting fly
From eleven till one, as the Chronicle speaks ?
They did it, my boys, to annoy the Greeks,
Who kept up a perpetual cannonade
On the walls, and threaten'd an escalade.

* The Editor is requested to state that "M. S." does not here mean Manuscript.

The sixteen Specials were so arranged
That the shots they shot were not shots exchanged,
But every shot so told on the foe
 The Greeks were obliged to draw it mild :
Diomedes—" a fix," Ulysses—" no go "
 Declared it, the " king of men " cried like a child ;
Whilst the Specials, no more than a fine black Tom
I keep to serenade Mary from
The tiles, where he lounges every night,
Knew nor cared what they did, and were perfectly right.

But the fact was thus : one Helenus,
A man much faster than any of us,
More fast than a gent at the top of a " bus,"
More fast than the coming of " Per col. sus."
Which Shakespeare says comes galloping,
(I take his word for anything)
This Helenus had a cure of souls—
 He had cured the souls of several Greeks,
Achilles sole or heel,—the rolls
 Of fame (not French) say Paris :—speaks
 Anatomist Quain thereof. Who seeks
May read the story from z to a ;
He has handled and argued it every way ;—
A subject on which there's a good deal to say.
His work was ever the best, and still is,
Because of this note on the Tendo Achillis.

This Helenus was a man well bred,
 He was *up* in Electricity,
 Fortification, Theology,
 Æsthetics and Pugilicity ;
Celsus and Gregory he'd read ;
 Knew every " dodge " of *glove and fist ;*
Was a capital curate, (I think I've said)
 And Transcendental Anatomist :
Well up in Materia Medica,
 Right up in Toxicology,
And Medical Jurisprudence, that sell !
 And the *dead sell* Physiology :
Knew what and how much of any potation
Would get him through any examination :
With credit not small, had passed the Hall
And the College—and they couldn't *pluck* him at all.

He'd written on Rail-roads, delivered a lecture
 Upon the Electric Telegraph,
Had played at single-stick with Hector,
 And written a paper on half-and-half.

With these and other works of note
He was not at all a "*people's man*,"
Though public, for the works he wrote
Were not that sort the people can
Admire or read; they were Mathematic
The most part, some were Hydrostatic ;
But Algebraic, in the main,
All full of a, b, c, and n—
And other letters which perplex—
The last was full of double x !
In fact, such stuff as one may easily
Imagine didn't go down greasily,
Nor calculated to produce
Such heat as "cooks the public goose,"
And does it of so brown a hue
Men wonder while they relish too.

It therefore was that much alone
He studied ; and a room is shown
In a coffee-house, an upper room,
Where none but hungry devils come,
Wherein 'tis said, with animation
He read "Vestiges of Creation."

Accordingly, a month about
After he'd *chalked up* steak and stout
For the last time, he gave the world
A pamphlet, wherein he unfurled
A tissue of facts which, soon as blown,
Ran like wildfire through the town.
And, first of all, he plainly showed
A capital error in the mode
Of national defences, thus—
" The Greek one thousand miles from us,"
Said he, (for nine hundred and ninety-nine
The citadel stood above the brine
In perpendicular height, allowing
For slope of glacis, thereby showing
An increase of a mile,) " 'tis plain
The force that shot and shell would gain,

By gravitation, with their own,
Would fire the ground by friction alone;
Which, being once in fusion schooled
Ere cool, as *Fire-mist had cooled*"
Would gain a motion, which must soon,
Just as the earth detached the moon
And gave her locomotive birth,
Detach some twenty miles of earth,
And send it swinging in the air,
The Devil only could tell where!
Then came the probability
With what increased facility
The Greeks, by this projectile power,
Might land on Ilion's highest tower,
All safe and sound, in battle array,
With howitzers prepared to play,
And muskets to the muzzles rammed;—
Why, the town would be utterly smashed and jammed,
And positively, as the phrase is
Vernacular, be "sent to blazes"!

In the second place, he then would ask,
(And here he took several members to task,
And wondered—"he really must presume
To wonder" a statesman like—you know whom—
Who ever evinced the deepest sense
Of a crying sin in any expense,
Should so besotted be, and lost
To the fact that now, at public cost,
Powder was being day by day
Wantonly wasted, blown away);—
Yes, he would ask, "with what intent
But to perch the Greeks on a battlement
From which they might o'erlook the town,
The easier to batter it down,
Which he had proved must be the case
(If it hadn't already taken place):
He called on his readers to fear and dread it,
Whilst he wrote it,—whilst they read it!"
"How simple! How beautifully simple," said he,
"And obvious was the remedy!
Look back a century or so—
And there was the ancient Norman bow,

A weapon (he gave them leave to laugh)
Efficient, better, cheaper by half :
(He knew quite well the age abused it
Because, forsooth, the Normans used it)
These, planted in the citadel,
Would reach the walls say,—very well ;
There, having spent their utmost force,
They'd drop down right, as a matter of course,
A thousand miles ! Think—a thousand miles !
What was the weight for driving piles
To this ? He calculated it—
'Twould equal, when both Houses sit,
The weight of the entire building,
Including Members, paint, and gilding ;
But, if a speech or the address
From the throne were given, something less,
Because, as certain snores aver,
The House is then much heavier.

Now this, though very much a rub like
For Ministers, convinced the public ;
And Priam, who liked to hear its brays
To any tune but "the Marseillaise,"
Summoned a Privy Council, where
'Twas shortly settled to confer
On Helenus a sole command
Of Specials.—He headed that daring band !

And sixteen Specials in Priam's keep
 Got up from their mahogany ;
They smoked their pipes in silence deep
 Till there was such a fog—any
Attempt to discover the priest in the smother
Had bothered old Airy and Adams and t'other
And—every son of an *English* mother.

June, 1848.

No. II.
Swift's Dunces.

"When a true genius appears in the world, you may know him by this sign, that the DUNCES are all in confederacy against him."—*Swift*.

How shall we know the dunces from the man of genius, who is no doubt our superior in judgment, yet knows himself for a fool—by the proverb ?

At least, my dear Doctor, you will let me, with the mass of readers, have clearer wits than the dunces—then why should I not know what you are as soon as, or sooner than Bavius, &c.—unless a dunce has a good nose, or a natural instinct for detecting wit.

Now I take it that these people stigmatized as dunces are but men of ill-balanced mental faculties, yet perhaps, in a great degree, superior to the average of minds. For instance, a poet of much merit, but more ambition, has written the "Lampiad," an epic; when he should not have dared beyond the Doric reed: his ambitious pride has prevented the publication of excellent pastorals, therefore the world only knows him for his failure. This, I say, is a likely man to become a detractor; for his good judgment shows the imperfections of most works, his own included; his ambition (an ill-combination of self-conscious worth and spleen) leads him to compare works of the highest repute; the works of contemporaries; and his own. In all cases where success is most difficult, he will be most severe; this naturally leads him to criticise the very best works.

He has himself failed; he sees errors in successful writers; he knows he possesses certain merits, and knows what the perfection of them should be. This is the ground work of envy, which makes a man of parts a comparative fool, and a confederate against "true genius."

No. III.
Mental Scales.

I make out my case thus—

There is an exact balance in the distribution of causes of pleasure and pain: this has been satisfactorily proved in my next paper, upon "Cause and Effect," therefore I shall take it for granted. What, then, is there but the mind to determine its own state of happiness, or misery: just as the motion of the scales depends upon themselves, when two equal weights are put into them. The balance ought to be truly hung; but if the unpleasant scale is heavier, then the motion is in favor of the pleasant scale, and vice versa. Whether the beam stands horizontally, or otherwise, does not matter (that only determines the key): draw a line at right angles to it, then put in your equal weights; if the angle becomes larger on the unpleasant scale's side of the line, happiness is the result, if on the other, misery.

It requires but a slight acquaintance with mechanics to see that he who would be happy should have the unpleasant side heavier. I hate corollaries or we might have a group of them equally applicable to Art and Models.

June, 1848.

Reviews.

Some Account of the Life and Adventures of Sir Reginald Mohun,
Bart. Done in Verse by George John Cayley. Canto 1st.
Pickering. 1849.

Inconsistency, whether in matters of importance or in trifles,
whether in substance or in detail, is never pleasant. We do not here
impute to this poem any inconsistency between one portion and
another; but certainly its form is at variance with its subject and
treatment. In the wording of the title, and the character of typo-
graphy, there is a studious archaism : more modern the poem itself
could scarcely be.

" Sir Reginald Mohun " aims, to judge from the present sample,
at depicting the easy intercourse of high life ; and the author enters
on his theme with a due amount of sympathy. It is in this respect,
if in any, that the mediæval tone of the work lasts beyond the title
page. In Mr. Cayley's eyes, the proof of the comparative prosperity
of England is that

> " Still Queen Victoria sits upon her throne ;
>> Our aristocracy still keep alive,
>> And, on the whole, may still be said to thrive,—
> Tho' now and then with ducal acres groan
>> The honored tables of the auctioneer.
>> Nathless, our aristocracy is dear,
> Tho' their estates go cheap ; and all must own
> That they still give society its tone."—p. 16.

He proceeds in these terms :

> " Our baronets of late appear to be
>> Unjustly snubbed and talked and written down ;
>> Partly from follies of Sir Something Brown,
> Stickling for badges due to their degree,
>> And partly that their honor's late editions
>> Have been much swelled with surgeons and physicians ;
> For ' honor hath small skill in surgery,'
> And skill in surgery small honor."—p. 17.

What "honor" is here meant? and against whom is the taunt
implied?—against the "surgeons and physicians," or against the
depreciation of them. Surely the former can hardly have been in-
tended. The sentence will bear to be cleared of some ambiguity, or
else to be cleared off altogether.

Our introduction to Sir Reginald Mohun, Lord of Nornyth Place, and of " an income clear of 20,000 pounds," and to his friends Raymond St. Oun, De Lacy, Wilton, Tancarville, and Vivian,— (for the author's names are aristocratic, like his predilections)—is effected through the medium of a stanza, new, we believe, in arrangement, though differing but slightly from the established octave, and of verses so easy and flowing as to make us wonder less at the promise of

> " provision plenty
> For cantos twelve, or, may be, four and twenty,"

than at Mr. Cayley's assertion that he

> " Can never get along at all in prose."

The incidents, as might be expected of a first canto, are neither many nor important, and will admit of compression into a very small compass.

Sir Reginald, whose five friends had arrived at Nornyth Place late on the preceding night, is going over the grounds with them in a shooting party after a late breakfast. St. Oun expresses a wish to " prowl about the place " in preference, not feeling in the mood for the required exertion.

> " ' Of lazy dogs the laziest ever fate
> Set on two useless legs you surely are,
> And born beneath some wayward sauntering star
> To sit for ever swinging on a gate,
> And laugh at wiser people passing through.'
> So spake the bard De Lacy : for they two
> In frequent skirmishes of fierce debate
> Would bicker, tho' their mutual love was great."—p. 35.

Mohun, however, sides with St. Oun, and agrees to escort him in his rambles after the first few shots. He accordingly soon resigns his gun to the keeper Oswald, whose position as one who

> " came into possession
> Of the head-keepership by due succession
> Thro' sire and grandsire, who, when one was dead,
> Left his right heir-male keeper in his stead,"

Mr. Cayley evidently regards with some complacence. The friends enter a boat : here, while sailing along a rivulet that winds through the estate, St. Oun falls to talking of wealth, its value and insufficiency, of death, and life, and fame ; and coming at length to ask after the history of Sir Reginald's past life, he suggests "this true epic opening for relation : "

" ' *The sun, from his meridian heights declining*
Mirrored his richest tints upon the shining
Bosom of a lake. In a light shallop, two
 Young men, whose dress, etcætera, proclaims,
 Etcætera,—so would write G. P. R. James—
Glided in silence o'er the waters blue,
Skirting the wooded slopes. Upward they gazed
On Nornyth's ancient pile, whose windows blazed

" ' *In sunset rays, whose crimson fulgence streamed*
Across the flood : wrapped in deep thought they seemed.
' *You are pensive, Reginald,*' *at length thus spake*
 The helmsman : ' ha ! it is the mystic power
 Fraught by the sacred stillness of the hour :
Forgive me if your reverie I break,
Craving, with friendship's sympathy, to share
Your spirit's burden, be it joy or care.' "—pp. 48, 49.

Sir Reginald Mohun's story is soon told.—Born in Italy, and
losing his mother at the moment of his birth, and his father and
only sister dying also soon after, he is left alone in the world.

" ' My father was a melancholy man,
 Having a touch of genius, and a heart,
 But not much of that worldly better part
Called force of character, which finds some plan
 For getting over anguish that will crush
Weak hearts of stronger feeling. He began
 To pine ; was pale ; and had a hectic flush
 At times ; and from his eyelids tears would gush.

" ' Some law of hearts afflicted seems to bind
 A spell by which the scenes of grief grow dear ;
 He never could leave Italy, tho' here
And there he wandered with unquiet mind,—
 Rome, Florence, Mantua, Milan ; once as far
As Venice ; but still Naples had a blind
 Attraction which still drew him thither. There
 He died. Heaven rest his ashes from their care.

" ' He wrote, a month or so before he died,
 To Wilton's father ; (he is Earl of Eure,
 My mother's brother); saying he was sure
That he should soon be gone, and would confide
 Us to his guardian care. My uncle came
Before his death. We stood by his bedside.
 He blessed us. We, who scarcely knew the name
 Of death, yet read in the expiring flame

 " ' Of his sunk eyes some awful mystery,
 And wept we knew not why. There was a grace
 Of radiant joyful hope upon his face,
 Most unaccustomed, and which seemed to be
 All foreign to his wasted frame ; and yet
 So heavenly in its consolation we
 Smiled through the tears with which our lids were wet.
 His lips were cold, as, whispering, ' Do not fret

 " ' When I am gone,' he kissed us : and he took
 Our uncle's hands, which on our heads he laid,
 And said : ' My children, do not be afraid
 Of Death, but be prepared to meet him. Look ;
 Here is your mother's brother ; he to her
 As Reginald to Eve.' His thin voice shook.—
 ' Eve was your Mother's name.' His words did err,
 As dreaming; and his wan lips ceased to stir.'"—pp. 55-57.

(We have quoted this passage, not insensible to its defects,—some common-place in sentiment and diction ; but independently of the good it does really contain, as being the only one of such a character sustained in quality to a moderate length.)

Reginald and his cousin Wilton grew up together friends, though not bound by common sympathies. The latter has known life early, and " earned experience piecemeal :" with the former, thought has already become a custom.

Thus far only does Reginald bring his retrospect ; his other friends come up, and they all return homeward. Here, too, ends the story of this canto ; but not without warranting some surmise of what will furnish out the next. There is evidence of observation adroitly applied in the talk of the two under-keepers who take charge of the boat.

 " They said : ' Oh ! what a gentleman to talk
 Is that there Lacy ! What a tongue he've got !
 But Mr. Vivian *is* a pretty shot.
 And what a pace his lordship wish to walk !
 Which Mr. Tancarville, he seemed quite beat :
 But he's a pleasant gentleman. Good lawk !
 How he do make me laugh ! Dang ! this 'ere seat
 Have wet my smalls slap thro'. Dang ! what a treat !

> " 'There's company coming to the Place to morn :
> Bess housemaid told me. Lord and Lady —— : dash
> My wigs ! I can't think on. But there's a mash
> O' comp'ny and fine ladies ; fit to torn
> The heads of these young chaps. Why now I'd lay
> This here gun to an empty powder-horn
> Sir Reginald be in love, or that-a-way.
> He looks a little downcast-loikish,—eh ?' "—pp. 62, 63.

It will be observed that there is no vulgarity in this vulgarism :
indeed, the gentlemanly good humour of the poem is uninterrupted.
This, combined with neatness of handling, and the habit of not over-
doing, produces that general facility of appearance which it is no
disparagement, in speaking of a first canto, to term the chief result
of so much of these life and adventures as is here " done into verse."
It may be fairly anticipated, however, that no want of variety in the
conception, or of success in the pourtrayal, of character will need to
be complained of : meanwhile, a few passages may be quoted to con-
firm our assertions. The two first extracts are examples of mere
cleverness ; and all that is aimed at is attained. The former follows
out a previous comparison of the world with a " huge churn."

> " Yet some, despising life's legitimate aim,
> Instead of butter, would become " the cheese ;"
> A low term for distinction. Whence the name
> I know not : gents invented it ; and these
> Gave not an etymology. I see no
> Likelier than this, which with their taste agrees ;
> The *caseine* element I conceive to mean no
> Less than the *beau ideal* of the Casino."—p. 12.

> " Wise were the Augurers of old, nor erred
> In substance, deeming that the life of man—
> (This is a new reflection, spick and span)—
> May be much influenced by the flight of birds.
> Our senate can no longer hold their house
> When culminates the evil star of grouse ;
> And stoutest patriots will their shot-belts gird
> When first o'er stubble-field hath partridge whirred."—p. 25.

In these others there is more purpose, with a no less definite
conciseness :

> " Comes forth the first great poet. Then a number
> Of followers leave much literary lumber.

T.G. O

He cuts his phrases in the sapling grain
 Of language ; and so weaves them at his will.
They from his wickerwork extract with pain
 The wands now warped and stiffened, which but ill
Bend to their second-hand employment."—pp. 4, 5.

 "What's life ? A riddle ;
Or sieve which sifts you thro' it in the middle."—p. 45.

The misadventures of the five friends on their road to Nornyth are
very sufficiently described :

"The night was cold and cloudy as they topped
 A moorland slope, and met the bitter blast,
So cutting that their ears it almost cropped ;
 And rain began to fall extremely fast.
A broken sign-post left them in great doubt
 About two roads ; and, when an hour was passed,
They learned their error from a lucid lout ;
Soon after, one by one, their lamps went out."—p. 29.

There remains to point out one fault,—and that the last fault the
occurrence of which could be looked for, after so clearly expressed
an intention as this :

"But, if an Author takes to writing fine,
 (Which means, I think, an artificial tone),
The public sicken and won't read a line.
I hope there's nothing of this sort in mine."—p. 6.

A quotation or two will fully explain our meaning : and we would
seriously ask Mr. Cayley to reflect whether he has always borne his
principle in mind, and avoided " writing fine ;" whether he has not
sometimes fallen into high-flown common-place of the most undis-
guised stamp, rendered, moreover, doubly inexcusable and out of
place by being put into the mouth of one of the personages of the
poem ; It is Sir Reginald Mohun that speaks ; and truly, though
not thrust forward as a " wondrous paragon of praise," he must be
confessed to be,

"Judging by specimens the author quotes,
 An utterer of most ordinary phrases,"

not words only and sentences, but real *phrases*, in the more distinct
and specific sense of the term.

> " 'There, while yet a new born thing,
> Death o'er my cradle waved his darksome wing ;
> My mother died to give me birth : forlorn
> I came into the world, a babe of woe,
> Ill-omened from my childhood's early morn ;
> Yet heir to what the idolaters of show
> Deem life's good things, which earthly bliss bestow.

> " 'The riches of the heart they call a dream ;
> Love, hope, faith, friendship, hollow phantasies :
> Living but for their pockets and their eyes,
> They stifle in their breasts the purer beam
> Of sunshine glanced from heaven upon their clay,
> To be its light and warmth. This is a theme
> For homilies : and I will only say,
> The heart feeds not on fortune's baubles gay.' "—p. 51.

Sir Reginald's narrative concludes after this fashion :

> " ' But what is this ? A dubious compromise ;
> Twilight of cloudy zones, whereon the blaze
> Of sunshine breaks but seldom with its rays
> Of heavenly hope, towards which the spirit sighs
> Its aspirations, and is lost again
> 'Mid doubts : to grasp the wisdom of the skies
> Too feeble, tho' convinced earth's bonds are vain,
> Cowering faint-hearted in the festering chain.' "—p. 60.

A similar instance of conventionality constantly repeated is the sin of inversion, which is no less prevalent, throughout the poem, in the conversational than in the narrative portions. In some cases the exigencies of rhyme may be pleaded in palliation, as for "Cam's marge along" and "breezy willows cool," which occur in two consecutive lines of a speech ; but there are many for which no such excuse can be urged. Does any one talk of "sloth obscure," or of "hearts afflicted?" Or what reason is there for preferring "verses easy" to *easy verses* ? Ought not the principle laid down in the following passage of the introduction to be followed out, not only into the intention, but into the manner and quality also, of the whole work ?

> " ' I mean to be *sincere* in this my lay :
> That which I think I shall write down without
> A drop of pain or varnish. Therefore, pray,
> Whatever I may chance to rhyme about,
> Read it without the shadow of a doubt.' "—p. 12.

Again, the Author appears to us to have acted unwisely in occasionally departing from the usual construction of his stanzas, as in this instance :

> " 'But, as I said, you know my history ;
> And your's—not that you made a mystery
> Of it, nor used reserve, yet, being not
> By nature an Autophonophilete,
> (A word De Lacy fashioned and called me it)—
> Your's you have never told me yet. And what
> Can be a more appropriate occasion
> Than this true epic opening for relation ?' "—p. 48.

Here the lines do not cohere so happily as in the more varied distribution of the rhymes ; and, moreover, as a question of principle, we think it not advisable to allow of minor deviations from the uniformity of a prescribed metre.

It may be well to take leave of Mr. Cayley with a last quotation of his own words,—words which no critic ought to disregard :

> " I shall be deeply grateful to reviews,
> Whether they deign approval, or rebuke,
> For any hints they think may disabuse
> Delusions of my inexperienced muse."—p. 8.

If our remarks have been such as to justify the Author's wish for sincere criticism, our object is attained ; and we look forward for the second canto with confidence in his powers.

PROVIDENT LIFE OFFICE,

50, REGENT STREET.

CITY BRANCH: 2, ROYAL EXCHANGE BUILDINGS.

ESTABLISHED 1806.

POLICY HOLDERS' CAPITAL, £1,156,783.

ANNUAL INCOME £143,000. BONUSES DECLARED £743,000.

Claims paid since the establishment of the Office, £1,765,000.

President.

THE RIGHT HONOURABLE EARL GREY.

Directors.

SIR RICHARD D. KING, BART., *Chairman.*

CAPT. W. JOHN WILLIAMS, *Deputy-Chairman.*

HENRY B. ALEXANDER, ESQ.	WILLIAM OSTLER, ESQ.
H. BLENCOWE CHURCHILL, ESQ.	GEORGE ROUND, ESQ.
GEORGE DACRE, ESQ.	JAMES SEDGWICK, ESQ.
ALEXANDER HENDERSON, M.D.	THE REV. JAMES SHERMAN.
WILLIAM JUDD, ESQ.	FREDERICK SQUIRE, ESQ.
THE HON. ARTHUR KINNAIRD.	WILLIAM HENRY STONE, ESQ.

J. A. BEAUMONT, ESQ. *Managing Director.*

Physician,

JOHN MACLEAN, M.D., F.S.S., 29, Upper Montague Street, Montague Square.

NINETEEN TWENTIETHS OF THE PROFITS ARE DIVIDED AMONG THE INSURED.

Examples of the Extinction of Premiums by the Surrender of Bonuses.

Date of Policy.	Sum Insured.	Original Premium.		Bonuses added subsequently, to be further increased annually.
1806	£2500	£79 10s.10d.	Extinguished	£1222 2s. 0d.
1811	1000	33 19 2	ditto	231 17 8
1818	1000	34 16 10	ditto	114 18 10

Examples of Bonuses added to other Policies.

Policy No.	Date.	Sum Insured.	Bonuses added.	Total with additions, to be further increased.
521	1807	£ 900	£ 982 12s.1d.	£1882 12s. 1d.
1174	1810	1200	1160 5 6	2360 5 6
3392	1820	5000	3558 17 8	8558 17 8

Prospectuses and full particulars may be obtained upon application to the Agents of the Office in all the principal towns of the United Kingdom, at the City Branch and at the head Office, No. 50, *Regent Street.*

Published Monthly.—Price 1s.

Art and Poetry,

Being Thoughts towards Nature.

Conducted principally by Artists.

OF the little worthy the name of writing that has ever been
written upon the principles of Art, (of course excepting that
on the mere mechanism), a very small portion is by Artists
themselves; and that is so scattered, that one scarcely knows
where to find the ideas of an Artist except in his pictures.

With a view to obtain the thoughts of Artists, upon Nature
as evolved in Art, in another language besides their *own
proper* one, this Periodical has been established. Thus, then,
it is not open to the conflicting opinions of all who handle the
brush and palette, nor is it restricted to actual practitioners;
but is intended to enunciate the principles of those who, in
the true spirit of Art, enforce a rigid adherence to the sim-
plicity of Nature either in Art or Poetry, and consequently
regardless whether emanating from practical Artists, or from
those who have studied nature in the Artist's School.

Hence this work will contain such original Tales (in prose
or verse), Poems, Essays, and the like, as may seem conceived
in the spirit, or with the intent, of exhibiting a pure and
unaffected style, to which purpose analytical Reviews of
current Literature—especially Poetry—will be introduced;
as also illustrative Etchings, one of which latter, executed
with the utmost care and completeness, will appear in each
number.

No. 4. *(Price One Shilling.)* MAY, 1850.

With an Etching by W. H. Deverell.

Art and Poetry:

Being Thoughts towards Nature

Conducted principally by Artists.

When whoso merely hath a little thought
Will plainly think the thought which is in him,—
Not imaging another's bright or dim,
Not mangling with new words what others taught;
When whoso speaks, from having either sought
Or only found,—will speak, not just to skim
A shallow surface with words made and trim,
But in that very speech the matter brought:
Be not too keen to cry—"So this is all!—
A thing I might myself have thought as well,
But would not say it, for it was not worth!"
Ask: "Is this truth?" For is it still to tell
That, be the theme a point or the whole earth,
Truth is a circle, perfect, great or small?

London:

DICKINSON & Co., 114, NEW BOND STREET,

AND

AYLOTT & JONES, 8, PATERNOSTER ROW.

G. F TUPPER, Printer, Clement's Lane, Lombard Street.

CONTENTS.

The Subscribers to this Work are respectfully informed that the future Numbers will appear on the last day of the Month for which they are dated. Also, that a supplementary, or large-sized Etching will occasionally be given.

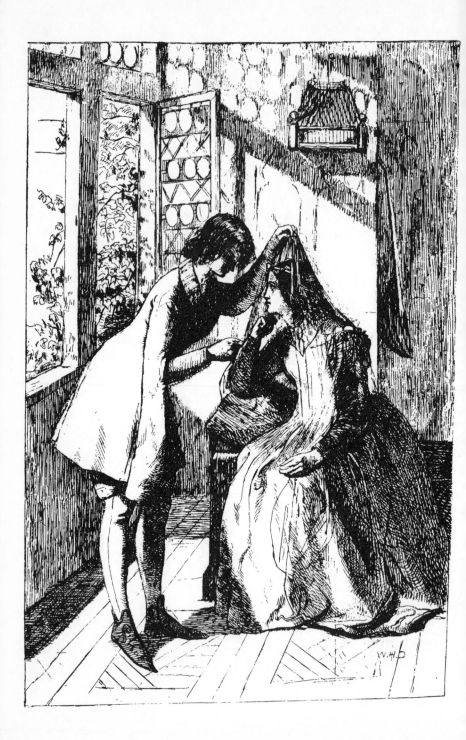

Viola and Olivia.

When Viola, a servant of the Duke,
Of him she loved the page, went, sent by him,
To tell Olivia that great love which shook
His breast and stopt his tongue ; was it a whim,
Or jealousy or fear that she must look
 Upon the face of that Olivia?

'Tis hard to say if it were whim or fear
Or jealousy, but it was natural,
As natural as what came next, the near
Intelligence of hearts : Olivia
Loveth, her eye abused by a thin wall
 Of custom, but her spirit's eyes were clear.

Clear? we have oft been curious to know
The after-fortunes of those lovers dear ;
Having a steady faith some deed must show
That they were married souls—unmarried here—
Having an inward faith that love, called so
In verity, is of the spirit, clear
Of earth and dress and sex—it may be near
 What Viola returned Olivia?

A Dialogue on Art.

[*₊* The following paper had been sent as a contribution to this publication scarcely more than a week before its author, Mr. John Orchard, died. It was written to commence a series of "Dialogues on Art," which death has rendered for ever incomplete : nevertheless, the merits of this commencement are such that they seemed to warrant its publication as a fragment ; and in order that the chain of argument might be preserved, so far as it goes, uninterrupted, the dialogue is printed entire in the present number, despite its length. Of the writer, but little can be said. He was an artist ; but ill health, almost amounting to infirmity—his portion from childhood—rendered him unequal to the bodily labour inseparable from his profession : and in the course of his short life, whose youth was scarcely consummated, he exhibited, from time to time, only a very few small pictures, and these, as regards public recognition, in no way successfully. In art, however, he gave to the "seeing eye," token of that ability and earnestness which the "hearing ear" will not fail to recognize in the dialogue now published ; where the vehicle of expression, being more purely intellectual, was more within his grasp than was the physical and toilsome embodiment of art.

It is possible that a search among the papers he has left, may bring to light a few other fugitive pieces, which will, in such event, as the Poem succeeding this Dialogue, be published in these pages.

To the end that the Author's scheme may be, as far as is now possible, understood and appreciated, we subjoin, in his own words, some explanation of his further intent, and of the views and feelings which guided him in the composition of the dialogue :—

"I have adopted the form of dialogue for several, to me, cogent reasons ; 1st, because it gives the writer the power of exhibiting the question, Art, on all its sides ; 2nd, because the great phases of Art could be represented idiosyncratically ; and, to make this clear, I have named the several speakers accordingly ; 3rd, because dialogue secures the attention ; and, that secured, deeper things strike, and go deeper than otherwise they could be made to ; and, 4th and last, because all my earliest and most delightful pleasures associate themselves with dialogue,—(the old dramatists, Lucian, Walter Savage Landor, &c.)

"You will find that I have not made one speaker say a thing on purpose for another to condemn it ; but that I make each one utter his wisest in the very wisest manner he can, or rather, that I can for him.

"The further continuation of this 1st dialogue embraces the question Nature, and its processes, invention and imitation,—imitation chiefly. Kosmon begins by showing, in illustration of the truth of Christian's concluding sentences, how imperfectly all the Ancients, excepting the Hebrews, loved, understood, or felt Nature, &c. This is not an unimportant portion of Art knowledge.

"I must not forget to say that the last speech of Kosmon will be answered by Christian when they discourse of imitation. It properly belongs to imitation ; and, under that head, it can be most effectively and perfectly confuted. Somewhat after this idea, the "verticalism" and "involution" will be shown to be direct from Nature ; the gilding, &c., disposed of on the ground of the old piety using the most precious materials as the most religious and worthy of them ; and hence, by a very easy and probable transition, they concluded that that which was most soul-worthy, was also most natural."]

Dialogue I., in the House of Kalon.

KALON. Welcome, my friends :—this day above all others; to-day
is the first day of spring. May it be the herald of a bountiful year,
—not alone in harvests of seeds. Great impulses are moving through
man ; swift as the steam-shot shuttle, weaving some mighty pattern,
goes the new birth of mind. As yet, hidden from eyes is the design :
whether it be poetry, or painting, or music, or architecture, or
whether it be a divine harmony of all, no manner of mind can tell ;
but that it is mighty, all manners of minds, moved to involuntary
utterance, affirm. The intellect has at last again got to work upon
thought : too long fascinated by matter and prisoned to motive
geometry, genius—wisdom seem once more to have become human,
to have put on man, and to speak with divine simplicity. Kosmon,
Sophon, again welcome ! your journey is well-timed ; Christian, my
young friend, of whom I have often written to you, this morning
tells me by letter that to-day he will pay me his long-promised visit.
You, I know, must rejoice to meet him : this interchange of knowledge
cannot fail to improve us, both by knocking down and building up :
what is true we shall hold in common ; what is false not less in
common detest. The debateable ground, if at last equally debateable
as it was at first, is yet ploughed ; and some after-comer may sow it
with seed, and reap therefrom a plentiful harvest.

SOPHON. Kalon, you speak wisely. Truth hath many sides like a
diamond with innumerable facets, each one alike brilliant and
piercing. Your information respecting your friend Christian has not
a little interested me, and made me desirous of knowing him.

KOSMON. And I, no less than Sophon, am delighted to hear that
we shall both see and taste your friend.

SOPHON. Kalon, by what you just now said, you would seem to
think a dearth of original thought in the world, at any time, was an
evil : perhaps it is not so ; nay, perhaps, it is a good ! Is not an
interregnum of genius necessary somewhere ? A great genius, sun-
like, compels lesser suns to gravitate with and to him ; and this is
subversive of originality. Age is as visible in thought as it is in
man. Death is indispensably requisite for a *new* life. Genius is like
a tree, sheltering and affording support to numberless creepers and
climbers, which latter die and live many times before their protecting
tree does ; flourishing even whilst that decays, and thus, lending to
it a greenness not its own ; but no new life can come out of that

expiring tree ; it must die : and it is not until it is dead, and fallen, and *rotted into compost,* that another tree can grow there ; and many years will elapse before the new birth can increase and occupy the room the previous one occupied, and flourish anew with a greenness all its own. This on one side. On another ; genius is essentially imitative, or rather, as I just now said, gravitative ; it gravitates towards that point peculiarly important at the moment of its existence ; as air, more rarified in some places than in others, causes the winds to rush towards *them* as toward a centre : so that if poetry, painting, or music slumbers, oratory may ravish the world, or chemistry, or steam-power may seduce and rule, or the sciences sit enthroned. Thus, nature ever compensates one art with another ; her balance alone is the always just one ; for, like her course of the seasons, she grows, ripens, and lies fallow, only that stronger, larger and better food may be reared.

KALON. By your speaking of chemistry, and the mechanical arts and sciences, as periodically ruling the world along with poetry, painting, and music,—am I to understand that you deem them powers intellectually equal, and to require of their respective professors as mighty, original, and *human* a genius for their successful practice ?

KOSMON. Human genius ! why not ? Are they not equally human ?—nay, are they not—especially steam-power, chemistry and the electric telegraph—more—eminently more—useful to man, more radically civilizers, than music, poetry, painting, sculpture, or architecture ?

KALON. Stay, Kosmon ! whither do you hurry ? Between chemistry and the mechanical arts and sciences, and between poetry, painting, and music, there exists the whole totality of genius—of genius as distinguished from talent and industry. To be useful alone is not to be great : *plus* only is *plus,* and the sum is *minus* something and *plus* in nothing if the most unimaginable particle only be absent. The fine arts, poetry, painting, sculpture, music, and architecture, as thought, or idea, Athene-like, are complete, finished, revelations of wisdom at once. Not so the mechanical arts and sciences : they are arts of growth ; they are shaped and formed gradually, (and that, more by a blind sort of guessing than by intuition,) and take many men's lives to win even to one true principle. On all sides they are the exact opposites of each other; for, in the former, the principles from the first are mature, and only the manipulation immature; in the latter, it is the principles that are almost always immature, and the manipulation as constantly mature. The fine arts are always grounded upon truth ; the mechanical arts and sciences almost always upon hypothesis ; the first are unconfined, infinite, immaterial, impossible

of reduction into formulas, or of conversion into machines ; the last are limited, finite, material, can be uttered through formulas, worked by arithmetic, tabulated and seen in machines.

SOPHON. Kosmon, you see that Kalon, true to his nature, prefers the beautiful and good, to the good without the beautiful ; and you, who love nature, and regard all that she, and what man from her, can produce, with equal delight,—true to your's,—cannot perceive wherefore he limits genius to the fine arts. Let me show you why Kalon's ideas are truer than yours. You say that chemistry, steam-power, and the electric telegraph, are more radically civilizers than poetry, painting, or music : but bethink you : what emotions beyond the common and selfish ones of wonder and fear do the mechanical arts or sciences excite, or communicate ? what pity, or love, or other holy and unselfish desires and aspirations, do they elicit ? Inert of themselves in all teachable things, they are the agents only whereby teachable things,—the charities, sympathies and love,—may be more swiftly and more certainly conveyed and diffused : and beyond diffusing media the mechanical arts or sciences cannot get ; for they are merely simple facts; nothing more : they cannot induct ; for they, in or of themselves, have no inductive powers, and their office is confined to that of carrying and spreading abroad the powers which do induct ; which powers make a full, complete, and visible existence only in the fine arts. In FACT and THOUGHT we have the whole question of superiority decided. Fact is merely physical record : Thought is the application of that record to something *human*. Without application, the fact is only fact, and nothing more ; the application, thought, then, certainly must be superior to the record, fact. Also in thought man gets the clearest glimpse he will ever have of soul, and sees the incorporeal make the nearest approach to the corporeal that it is possible for it to do here upon earth. And hence, these noble acts of wisdom are—far—far above the mechanical arts and sciences, and are properly called fine arts, because their high and peculiar office is to refine.

KOSMON. But, certainly thought is as much exercised in deduct-ing from physical facts the sciences and mechanical arts as ever it is in poetry, painting, or music. The act of inventing print, or of applying steam, is quite as soul-like as the inventing of a picture, poem, or statue.

KALON. Quite. The chemist, poet, engineer, or painter, alike, think. But the things upon which they exercise their several faculties are very widely unlike each other ; the chemist or engineer cogitates only the physical; the poet or painter joins to the physical the human, and investigates soul—scans the world in man added to the world

without him—takes in universal creation, its sights, sounds, aspects, and ideas. Sophon says that the fine arts are thoughts; but I think I know a more comprehensive word; for they are something more than thoughts; they are things also; that word is NATURE—Nature fully—thorough nature—the world of creation. All that is *in* man, his mysteries of soul, his thoughts and emotions—deep, wise, holy, loving, touching, and fearful,—or in the world, beautiful, vast, ponderous, gloomy, and awful, moved with rhythmic harmonious utterance—*that* is Poetry. All that is *of* man—his triumphs, glory, power, and passions; or of the world—its sunshine and clouds, its plains, hills, or valleys, its wind-swept mountains and snowy Alps, river and ocean—silent, lonely, severe, and sublime—mocked with living colours, hue and tone,—*that* is Painting. Man—heroic man, his acts, emotions, loves,—aspirative, tender, deep, and calm,—intensified, purified, colourless,—exhibited peculiarly and directly through his own form; *that* is sculpture. All the voices of nature—of man—his bursts of rage, pity, and fear—his cries of joy—his sighs of love; of the winds and the waters—tumultuous, hurrying, surging, tremulous, or gently falling—married to melodious numbers; *that* is music. And, the music of proportions—of nature and man, and the harmony and opposition of light and shadow, set forth in the ponderous; *that* is Architecture.

CHRISTIAN. [*as he enters*] Forbear, Kalon! These I know for your dear friends, Kosmon and Sophon. The moment of discoursing with them has at last arrived: May I profit by it! Kalon, fearful of checking your current of thought, I stood without, and heard that which you said: and, though I agree with you in all your definitions of poetry, painting, sculpture, music, and architecture; yet certainly all things in or of man, or the world, are not, however equally beautiful, equally worthy of being used by the artist. Fine art absolutely rejects all impurities of form; not less absolutely does it reject all impurities of passion and expression. Everything throughout a poem, picture, or statue, or in music, may be sensuously beautiful; but nothing must be sensually so. Sins are only paid for in virtues; thus, every sin found is a virtue lost—lost—not only to the artist, but a cause of loss to others—to all who look upon what he does. He should deem his art a sacred treasure, intrusted to him for the common good; and over it he should build, of the most precious materials, in the simplest, chastest, and truest proportions, a temple fit for universal worship: instead of which, it is too often the case that he raises above it an edifice of clay; which, as mortal as his life, falls, burying both it and himself under a heap of dirt. To preserve him from this corruption of his art, let him erect for

his guidance a standard awfully high above himself. Let him think of Christ ; and what he would not show to as pure a nature as His, let him never be seduced to work on, or expose to the world.

KOSMON. Oh, Kalon, whither do we go ! Greek art is condemned, and Satire hath got its death-stroke. The beautiful is not the beautiful unless it is fettered to the moral ; and Virtue rejects the physical perfections, lest she should fall in love with herself, and sin and cause sin.

CHRISTIAN. Nay, Kosmon. Nothing pure,—nothing that is innocent, chaste, unsensual,—whether Greek or satirical, is condemned : but everything—every picture, poem, statue, or piece of music—which elicits the sensual, viceful, and unholy desires of our nature—is, and that utterly. The beautiful was created the true, morally as well as physically ; vice is a deformment of virtue,— not of form, to which it is a parasitical addition—an accretion which can and must be excised before the beautiful can show itself as it was originally made, morally as well as formally perfect. How we all wish the sensual, indecent, and brutal, away from Hogarth, so that we might show him to the purest virgin without fear or blushing.

SOPHON. And as well from Shakspere. Rotten members, though small in themselves, are yet large enough to taint the whole body. And those impurities, like rank growths of vine, may be lopped away without injuring any vital principle. In perfect art the utmost purity of intention, design, and execution, alone is wisdom. Every tree—every flower, in defiance of adverse contingencies, grows with perfect will to be perfect : and, shall man, who hath what they have not, a soul wherewith he may defy all ill, do less ?

KOSMON. But how may this purity be attained ? I see everywhere close round the pricks ; not a single step may be taken in advance without wounding something vital. Corruption strews thick both earth and ocean ; it is only the heavens that are pure, and man cannot live upon manna alone.

CHRISTIAN. Kosmon, you would seem to mistake what Sophon and I mean. Neither he nor I wish nature to be used less, or otherwise than as it appears ; on the contrary, we wish it used more—more directly. Nature itself is comparatively pure ; all that we desire is the removal of the factitious matter that the vice of fashion, evil hearts, and infamous desires, graft upon it. It is not simple innocent nature that we would exile, but the devilish and libidinous corruptions that sully nature.

KALON. But, if your ideas were strictly carried out, there would be but little of worth left in the world for the artist to use ; for, if

I understand you rightly, you object to his making use of any passion, whether heroic, patriotic, or loving, that is not rigidly virtuous.

CHRISTIAN. I do. Without he has a didactic aim; like as Hogarth had. A picture, poem, or statue, unless it speaks some purpose, is mere paint, paper, or stone. A work of art must have a purpose, or it is not a work of *fine* art : thus, then, if it be a work of fine art, it has a purpose ; and, having purpose, it has either a good or an evil one : there is no alternative. An artist's works are his children, his immortal heirs, to his evil as well as to his good ; as he hath trained them, so will they teach. Let him ask himself why does a parent so tenderly rear his children. Is it not because he knows that evil is evil, whether it take the shape of angels or devils ? And is not the parent's example worthy of the artist's imitation ? What advantage has a man over a child ? Is there any preservative peculiar to manhood that it alone may see and touch sin, and yet be not defiled ? Verily, there is none ! All mere battles, assassinations, immolations, horrible deaths, and terrible situations used by the artist solely to excite,—every passion degrading to man's perfect nature, —should certainly be rejected, and that unhesitatingly.

SOPHON.—Suffer me to extend the just conclusions of Christian. Art—true art—fine art—cannot be either coarse or low. Innocent-like, no taint will cling to it, and a smock frock is as pure as " virginal-chaste robes." And,—sensualism, indecency, and brutality, excepted—sin is not sin, if not in the act ; and, in satire, with the same exceptions, even sin in the act is tolerated when used to point forcibly a moral crime, or to warn society of a crying shame which it can remedy.

KALON. But, my dear Sophon,—and you, Christian,—you do not condemn the oak because of its apples ; and, like them, the sin in the poem, picture, or statue, may be a wormy accretion grafted from without. The spectator often makes sin where the artist intended none. For instance, in the nude,—where perhaps, the poet, painter, or sculptor, imagines he has embodied only the purest and chastest ideas and forms, the sensualist sees—what he wills to see ; and, serpent-like, previous to devouring his prey, he covers it with his saliva.

CHRISTIAN. The Circean poison, whether drunk from the clearest crystal or the coarsest clay, alike intoxicates and makes beasts of men. Be assured that every nude figure or nudity introduced in a poem, picture, or piece of sculpture, merely on physical grounds, and only for effect, is vicious. And, where it is boldly introduced and forms the central idea, it ought never to have a sense

of its condition : it is not nudity that is sinful, but the figure's knowledge of its nudity, (too surely communicated by it to the spectator,) that makes it so. Eve and Adam before their fall were not more utterly shameless than the artist ought to make his inventions. The Turk believes that, at the judgment-day, every artist will be compelled to furnish, from his own soul, soul for every one of his creations. This thought is a noble one, and should thoroughly awake poet, painter, and sculptor, to the awful responsibilities they labour under. With regard to the sensualist, —who is omnivorous, and swine-like, assimilates indifferently pure and impure, degrading everything he hears or sees,—little can be said beyond this ; that for him, if the artist *be* without sin, he is not answerable. But in this responsibility he has two rigid yet just judges, God and himself ;—let him answer there before that tribunal. God will acquit or condemn him only as he can acquit or condemn himself.

KALON. But, under any circumstance, beautiful nude flesh beautifully painted must kindle sensuality ; and, described as beautifully in poetry, it will do the like, almost, if not quite, as readily. Sculpture is the only form of art in which it can be used thoroughly pure, chaste, unsullied, and unsullying. I feel, Christian, that you mean this. And see what you do !—What a vast domain of art you set a Solomon's seal upon ! how numberless are the poems, pictures, and statues—the most beautiful productions of their authors—you put in limbo ! To me, I confess, it appears the very top of prudery to condemn these lovely creations, merely because they quicken some men's pulses.

KOSMON. And, to me, it appears hypercriticism to object to pictures, poems, and statues, calling them not works of art—or fine art —because they have no higher purpose than eye or ear-delight. If this law be held to be good, very few pictures called of the English school—of the English school, did I say ?—very few pictures at all, of any school, are safe from condemnation : almost all the Dutch must suffer judgment, and a very large proportion of modern sculpture, poetry, and music, will not pass. Even "Christabel" and the "Eve of St. Agnes" could not stand the ordeal.

CHRISTIAN. Oh, Kalon, you hardly need an answer ! What ! shall the artist spend weeks and months, nay, sometimes years, in thought and study, contriving and perfecting some beautiful invention,—in order only that men's pulses may be quickened ? What ! —can he, jesuit-like, dwell in the house of soul, only to discover where to sap her foundations ?—Satan-like, does he turn his angel of light into a fiend of darkness, and use his God-delegated might against its giver, making Astartes and Molochs to draw other thou-

sands of innocent lives into the embrace of sin? And as for you, Kosmon, I regard purpose as I regard soul; one is not more the light of the thought than the other is the light of the body; and both, soul and purpose, are necessary for a complete intellect; and intellect, of the intellectual—of which the fine arts are the capital members—is not more to be expected than demanded. I believe that most of the pictures you mean are mere natural history paintings from the animal side of man. The Dutchmen may, certainly, go Letheward; but for their colour, and subtleties of execution, they would not be tolerated by any man of taste.

SOPHON. Christian here, I think, is too stringent. Though walls be necessary round our flower gardens to keep out swine and other vile cattle,—yet I can see no reason why, with excluding beasts, we should also exclude light and air. Purpose is purpose or not, according to the individual capacity to assimilate it. Different plants require different soils, and they will rather die than grow on unfriendly ones; it is the same with animals; they endure existence only through their natural food; and this variety of soils, plants, and vegetables, is the world less man. But man, as well as the other created forms, is subject to the same law : he takes only that aliment he can digest. It is sufficient with some men that their sensoria be delighted with pleasurable and animated grouping, colour, light, and shade : this feeling or desire of their's is, in itself, thoroughly innocent : it is true, it is not a great burden for them to carry ; no, but it is the lightness of the burden that is the merit; for thereby, their step is quickened and not clogged, their intellect is exhilarated and not oppressed. Thus, then, a purpose *is* secured, from a picture or poem or statue, which may not have in it the smallest particle of what Christian and I think necessary for it to possess; he reckons a poem, picture, or statue, to be a work of fine art by the quality and quantity of thought it contains, by the mental leverage it possesses wherewith to move his mind, by the honey which he may hive, and by the heavenly manna he may gather therefrom.

KOSMON. Christian wants art like Magdalen Hospitals, where the windows are so contrived that all of earth is excluded, and only heaven is seen. Wisdom is not only shown in the soul, but also in the body : the bones, nerves, and muscles, are quite as wonderful in idea as is the incorporeal essence which rules them. And the animal part of man wants as much caring for as the spiritual : God made both, and is equally praised through each. And men's souls are as much touchable and teachable through their animal feelings as ever they are through their mental aspirations ; this both Orpheus and Amphion knew when they, with their music, made towns to rise in

savage woods by savage hands. And hence, in that light, nothing is without a purpose; and I maintain,—if they give but the least glimpse of happiness to a single human being,—that even the Dutch masters are useful, I believe that the thought-wrapped philosopher, who, in his close-pent study, designs some valuable blessing for his lower and more animal brethren, only pursues the craving of his nature; and that his happiness is no higher than their's in their several occupations and delights. Sight and sense are fully as powerful for happiness as thought and ratiocination. Nature grows flowers wherever she can; she causes sweet waters to ripple over stony beds, and living wells to spring up in deserts, so that grass and herbs may grow and afford nourishment to *some* of God's creatures. Even the granite and the lava must put forth blossoms.

Kalon. Oh Christian, children cannot digest strong meats! Neither can a blind man be made to see by placing him opposite the sun. The sound of the violin is as innocent as that of the organ. And, though there be a wide difference in the sacredness of the occupations, yet dance, song, and the other amusements common to society, are quite as necessary to a healthy condition of the mind and body, as is to the soul the pursuit and daily practice of religion. The healthy condition of the mind and body is, after all, the happy life; and whether that life be most mental or most animal it matters little, even before God, so long as its delights, amusements, and occupations, be thoroughly innocent and chaste.

Christian. So long as the pursuits, pastimes, and pleasures of mankind be innocent and chaste,—with you all, heartily, I believe it matters little how or in what form they be enjoyed. Pure water is certainly equally pure, whether it trickle from the hill-side or flow through crystal conduits; and equally refreshing whether drunk from the iron bowl or the golden goblet;—only the crystal and gold will better please some natures than the hill-side and the iron. I know also that a star may give more light than the moon,—but that is up in its own heavens and not here on earth. I know that it is not light and shade which make a complete globe, but, as well, the local and neutral tints. Thus, my friends, you perceive that I am neither for building a wall, nor for contriving windows so as to exclude light, air, and earth. As much as any of you, I am for every man's sitting under his own vine, and for his training, pruning, and eating its fruit how he pleases. Let the artist paint, write, or carve, what and how he wills, teach the world through sense or through thought,—I will not dissent; I have no patent to entitle me to do so; nay, I will be thoroughly satisfied with whatsoever he does, so long as it is pure, unsensual, and earnestly true. But, as the mental

is the peculiar feature that places man apart from and above animals, —so ought all that he does to be apart from and above their nature ; especially in the fine arts, which are the intellectual perfection of the intellectual. And nothing short of this intellectual perfection,— however much they may be pictures, poems, statues, or music,—can rank such works to be works of Fine Art. They may have merit— nay, be useful, and hence, in some sort, have a purpose : but they are as much works of Fine Art as Babel was the Temple of Solomon.

SOPHON. And man can be made to understand these truths—can be drawn to crave for and love the fine arts : it is only to take him in hand as we would take some animal—tenderly using it—entreat- ing it, as it were, to do its best—to put forth all its powers with all its capable force and beauty. Nor is it so very difficult a task to raise, in the low, conceptions of things high : the mass of men have a fine appreciation of God and his goodness : and as active, chari- table, and sympathetic a nurture in the beautiful and true as they have given to them in religion, would as surely and swiftly raise in them an equally high appreciation of the fine arts. But, if the artist would essay such a labour, he must show them what fine art is : and, in order to do this effectually, as an architect clears away from some sacred edifice which he restores the shambles and shops, which, like filthy toads cowering on a precious monument, have squatted themselves round its noble proportions ; so must he remove from his art-edifice the deformities which hide—the corruptions which shame it.

CHRISTIAN. How truly Sophon speaks a retrospective look will show. The disfigurements which both he and I deplore are strictly what he compared them to ; they are shambles and shops grafted on a sacred edifice. Still, indigenous art is sacred and devoted to reli- gious purposes : this keeps it pure for a time ; but, like a stream travelling and gathering other streams as it goes through wide stretches of country to the sea, it receives greater and more nume- rous impurities the farther it gets from its source, until, at last, what was, in its rise, a gentle rilling through snows and over whitest stones, roars into the ocean a muddy and contentious river. Men soon long to touch and taste all that they see ; savage-like, him whom to-day they deem a god and worship, they on the morrow get an appetite for and kill, to eat and barter. And thus art is degraded, made a thing of carnal desire—a commodity of the exchange. Yes, Sophon, to be instructive, to become a teaching instrument, the art- edifice must be cleansed from its abominations ; and, with them, must the artist sweep out the improvements and ruthless restora- tions that hang on it like formless botches on peopled tapestry. The

multitude must be brought to stand face to face with the pious and earnest builders, to enjoy the severely simple, beautiful, aspiring, and solemn temple, in all its first purity, the same as they bequeathed it to them as their posterity.

KALON. The peasant, upon acquaintance, quickly prefers wheaten bread to the black and sour mass that formerly served him : and when true jewels are placed before him, counterfeit ones in his eyes soon lose their lustre, and become things which he scorns. The multitude are teachable—teachable as a child ; but, like a child, they are self-willed and obstinate, and will learn in their own way, or not at all. And, if the artist wishes to raise them unto a fit audience, he must consult their very waywardness, or his work will be a Penelope's web of done and undone : he must be to them not only cords of support staying their every weakness against sin and temptation, but also, tendrils of delight winding around them. But I cannot understand why regeneration can flow to them through sacred art alone. All pure art is sacred art. And the artist having soul as well as nature—the lodestar as well as the lodestone—to steer his path by—and seeing that he must circle earth—it matters little from what quarter he first points his course ; all that is necessary is that he go as direct as possible, his knowledge keeping him from quicksands and sunken rocks.

CHRISTIAN. Yes, Kalon ;—and, to compare things humble— though conceived in the same spirit of love—with things mighty, the artist, if he desires to inform the people thoroughly, must imitate Christ, and, like him, stoop down to earth and become flesh of their flesh ; and his work should be wrought out with all his soul and strength in the same world-broad charity, and truth, and virtue, and be, for himself as well as for them, a justification for his teaching. But all art, simply because it is pure and perfect, cannot, for those grounds alone, be called sacred : Christian, it may, and that justly ; for only since Christ taught have morals been considered a religion. Christian and sacred art bear that relation to each other that the circle bears to its generating point ; the first is only volume, the last is power: and though the first—as the world includes God—includes with it the last, still, the last is the greatest, for it makes that which includes it : thus all pure art is Christian, but not all is sacred. Christian art comprises the earth and its humanities, and, by implication, God and Christ also ; and sacred art is the emanating idea— the central causating power—the jasper throne, whereon sits Christ, surrounded by the prophets, apostles, and saints, administering judgment, wisdom, and holiness. In this sense, then, the art you would call sacred is not sacred, but Christian : and, as *all perfect art*

is Christian, regeneration necessarily can only flow thence ; and thus it is, as you say, that, from whatever quarter the artist steers his course, he steers aright.

KOSMON. And, Christian, is a return to this sacred or Christian art by you deemed possible ? I question it. How can you get the art of one age to reflect that of another, when the image to be reflected is without the angle of reflection ? The sun cannot be seen of us when it is night ! and that class of art has got its golden age too remote—its night too long set—for it to hope ever to grasp rule again, or again to see its day break upon it. You have likened art to a river rising pure, and rolling a turbid volume into the ocean. I have a comparison equally just. The career of one artist contains in itself the whole of art-history ; its every phase is presented by him in the course of his life. Savage art is beheld in his childish scratchings and barbarous glimmerings ; Indian, Egyptian, and Assyrian art in his boyish rigidity and crude fixedness of idea and purpose ; Mediæval, or pre-Raffaelle art is seen in his youthful timid darings, his unripe fancies oscillating between earth and heaven ; there where we expect truth, we see conceit ; there where we want little, much is given—now a blank eyed riddle,—dark with excess of self,—now a giant thought—vast but repulsive,—and now angel visitors startling us with wisdom and touches of heavenly beauty. Every where is seen exactness ; but it is the exactness of hesitation, and not of knowledge—the line of doubt, and not of power : all the promises for ripeness are there ; but, as yet, all are immature. And mature art is presented when all these rude scaffoldings are thrown down—when the man steps out of the chrysalis a complete idea— both Pysche and Eros—free-thoughted, free-tongued, and free-handed ;—a being whose soul moves through the heavens and the earth—now choiring it with angels—and now enthroning it, bay-crowned, among the men-kings ;—whose hand passes over all earth, spreading forth its beauties unerring as the seasons--stretches through cloudland, revealing its delectable glories, or, eagle-like, soars right up against the sun ;—or seaward goes seizing the cresting foam as it leaps—the ships and their crews as they wallow in the watery valleys, or climb their steeps, or hang over their flying ridges :—daring and doing all whatsoever it shall dare to do, with boundless fruitfulness of idea, and power, and line ; that is mature art—art of the time of Phidias, of Raffaelle, and of Shakspere. And, Christian, in preferring the art of the period previous to Raffaelle to the art of his time, you set up the worse for the better, elevate youth above manhood, and tell us that the half-formed and unripe berry is wholesomer than the perfect and ripened fruit.

CHRISTIAN. Kosmon, your thoughts seduce you ; or rather, your nature prefers the full and rich to the exact and simple : you do not go deep enough—do not penetrate beneath the image's gilt overlay, and see that it covers only worm-devoured wood. Your very comparison tells against you. What you call ripeness, others, with as much truth, may call over-ripeness, nay, even rottenness ; when all the juices are drunk with their lusciousness, sick with over-sweetness. And the art which you call youthful and immature—may be, most likely is, mature and wholesome in the same degree that it is tasteful, a perfect round of beautiful, pure, and good. You call youth immature ; but in what does it come short of man-hood. Has it not all that man can have,—free, happy, noble, and spiritual thoughts? And are not those thoughts newer, purer, and more unselfish in the youth than in the man ? What eye has the man, that the youth's is not as comprehensive, keen, rapid, and penetrating ? or what hand, that the youth's is not as swift, force-ful, cunning, and true ? And what does the youth gain in becoming man ? Is it freshness, or deepness, or power, or wisdom ? nay rather—is it not languor—the languor of satiety—of indifferentism? And thus soul-rusted and earth-charmed, what mate is he for his former youth ? Drunken with the world-lees, what can he do but pourtray nature drunken as well, and consumed with the same fever or stupor that consumes himself, making up with gilding and filagree what he lacks in truth and sincerity? and what comparison shall exist here and between what his youth might or could have done, with a soul innocent and untroubled as heaven's deep calm of blue, gazing on earth with seraph eyes—looking, but not longing—or, in the spirit rapt away before the emerald-like rainbow-crowned throne, witnessing " things that shall be hereafter," and drawing them down almost as stainless as he beheld them ? What an array of deep, earnest, and noble thinkers, like angels armed with a brightness that withers, stand between Giotto and Raffaelle ; to mention only Orcagna, Ghiberti, Masaccio, Lippi, Fra Beato Ange-lico, and Francia. Parallel *them* with post-Raffaelle artists ? If you think you can, you have dared a labour of which the fruit shall be to you as Dead Sea apples, golden and sweet to the eye, but, in the mouth, ashes and bitterness. And the Phidian era was a youthful one—the highest and purest period of Hellenic art : after that time they added no more gods or heroes, but took for models instead—the Alcibiadeses and Phyrnes, and made Bacchuses and Aphrodites ; not as Phidias would have—clothed with the greatness of thought, or girded with valour, or veiled with modesty ; but dissolved with the voluptuousness of the bath, naked, wanton, and shameless.

SOPHON. You hear, Kosmon, that Christian prefers ripe youth to ripe manhood : and he is right. Early summer is nobler than early autumn ; the head is wiser than the hand. You take the hand to mean too much : you should not judge by quantity, or luxuriance, or dexterity, but by quality, chastity, and fidelity. And colour and tone are only a fair setting to thought and virtue. Perhaps it is the fate, or rather the duty, of mortals to make a sacrifice for all things, withheld as well as given. Hand sometimes succumbs to head, and head in its turn succumbs to hand ; the first is the lot of youth, the last of manhood. The question is—which of the two we can best afford to do without. Narrowed down to this, I think but very few men would be found who would not sacrifice in the loss of hand in preference to its gain at the loss of head.

KOSMON. But, Christian, in advocating a return to this pre-Raffaelle art, are you not—you yourself—urging the committal of "ruthless restorations" and "improvements," new and vile as any that you have denounced ? You tell the artist, that he should restore the sacred edifice to its first purity—the same as it was bequeathed by its pious and earnest builders. But can he do this and be himself original ? For myself, I would above all things urge him to study how to *reproduce*, and not how to represent—to imitate no past perfection, but to create for himself another, as beautiful, wise, and true. I would say to him, "build not on old ground, profaned, polluted, trod into slough by filthy animals ; but break new ground—virgin ground—ground that thought has never imagined or eye seen, and dig into our hearts a foundation, deep and broad as our humanity. Let it not be a temple formed of hands only, but built up of *us*—us of the present—body of our body, soul of our soul."

CHRISTIAN. When men wish to raise a piece of stone, or to move it along, they seek for a fulcrum to use their lever from ; and, this obtained, they can place the stone wheresoever they please. And world-perfections come into existence too slowly for men to reject all the teaching and experience of their predecessors : the labour of learning is trifling compared to the labour of finding out ; the first implies only days, the last, hundreds of years. The discovery of the new world without the compass would have been sheer chance ; but with it, it became an absolute certainty. So, and in such manner, the modern artist seeks to use early mediæval art, as a fulcrum to raise through, but only as a fulcrum ; for he himself holds the lever, whereby he shall both guide and fix the stones of his art temple ; as experience, which shall be to him a

rudder directing the motion of his ship, but in subordination to his control ; and as a compass, which shall regulate his journey, but which, so far from taking away his liberty, shall even add to it, because through it his course is set so fast in the ways of truth as to allow him, undividedly, to give up his whole soul to the purpose of his voyage, and to steer a wider and freer path over the trackless, but to him, with his rudder and compass, no longer the trackless or waste ocean ; for, God and his endeavours prospering him, that shall yield up unto his hands discoveries as man-worthy as any hitherto beheld by men, or conceived by poets.

KALON. But, Christian, another artist with equal justness might use Hellenic art as a means toward making happy discoveries ; formatively, there is nothing in it that is not both beautiful and perfect ; and beautiful things, rainbow-like, are once and for ever beautiful ; and the contemplation and study of its dignified, graceful, and truthful embodiments—which, by common consent, it only is allowed to possess in an eminent and universal degree—is full as likely to awaken in the mind of its student as high revelations of wisdom, and cause him to bear to earth as many perfections for man, as ever the study of pre-Raffaelle art can reveal or give, through its votary.

CHRISTIAN. But beautiful things, to be beautiful in the highest degree, like the rainbow, must have a spiritual as well as a physical voice. Lovely as it is, it is not the arch of colours that glows in the heavens of our hearts ; what does, is the inner and invisible sense for which it was set up of old by God, and of which its many-hued form is only the outward and visible sign. Thus, beautiful things alone, of themselves, are not sufficient for this task ; to be sufficient they must be as vital with soul as they are with shape. To be formatively perfect is not enough ; they must also be spiritually perfect, and this not *locally* but universally. The art of the Greeks was a local art ; and hence, now, it has no spiritual. Their gods speak to us no longer as gods, or teach us divinely : they have become mere images of stone—profane embodiments. False to our spiritual, Hellenic art wants every thing that Christian art is full of. Sacred and universal, this clasps us, as Abraham's bosom did Lazarus, within its infinite embraces, causing every fibre of our being to quicken under its heavenly truths. Ithuriel's golden spear was not more antagonistic to Satan's loathly transformation—than is Christian opposed to pagan art. The wide, the awful gulf, separating one from the other, will be felt instantly in its true force by first thinking ZEUS, and then thinking CHRIST. How pale, shadowy, and shapeless the vision of lust,

revenge, and impotence, that rises at the thought of Zeus ; but at
the thought of Christ, how overwhelming the inrush of sublime
and touching realities ; what height and depth of love and power ;
what humility, and beauty, and immaculate purity are made ours
at the mention of his name ; the Saviour, the Intercessor, the
Judge, the Resurrection and the Life. These—these are the divinely
awful truths taught by our faith ; and which should also be taught
by our art. Hellenic art, like the fig tree that only bore leaves,
withered at Christ's coming ; and thus no " happy discoveries " can
flow thence, or "revelations of wisdom," or other perfections be
borne to earth for man.

SOPHON. Christian thinks and says, that if the spiritual be not
in a thing, it cannot be put upon it ; and hence, if a work of art be
not a god, it must be a man, or a mere image of one ; and that the
faith of the Pagan is the foolishness of the Christian. Nor does
he utter unreason ; for, notwithstanding their perfect forms, their
gods are not gods to us, but only perfect forms : Apollo, Theseus,
the Ilissus, Aphrodite, Artemis, Psyche, and Eros, are only shape-
ful manhood, womanhood, virginhood, and youth, and move us
only by the exact amount of humanity they possess in common with
ourselves. *Homer, and Æschylus, and Sophocles, and Phidias, live not
by the sacred in them, but by the human :* and, but for this common
bond, Hellenic art would have been submerged in the same Lethe
that has drowned the Indian, Egyptian, and Assyrian Theogonies
and arts. And, if we except form, what other thing does Hellenic
art offer to the modern artist, that is not thoroughly opposed to his
faith, wants, and practice ? And thought—thought in accordance
with all the lines of his knowledge, temperament, and habits—
thought through which he makes and shapes for men, and is un-
derstood by them—it is as destitute of, as inorganic matter of soul
and reason. But Christian art, because of the faith upon which
it is built, suffers under no such drawbacks, for that faith is as per-
sonal and vigorous now as ever it was at its origin—every motion
and principle of our being moves to it like a singing harmony ;—
it is the breath which brings out of us, Æolian-harp-like, our most
penetrating and heavenly music—the river of the water of life,
which searches all our dry parts and nourishes them, causing them
to spring up and bear abundantly the happy seed which shall en-
rich and make fat the earth to the uttermost parts thereof.

KALON. With you both I believe, that faith is necessary to a
man, and that without faith sight even is feeble : but I also believe
that a man is as much a part of the religious, moral, and social
system in which he lives, as is a plant of the soil, situation, and

climate in which it exists : and that external applications have just as much power to change the belief of the man, as they have to alter the structure of the plant. A faith once in a man, it is there always ; and, though unfelt even by himself, works actively : and Hellenic art, so far from being an impediment to the Christian belief, is the exact reverse ; for, it is the privilege of that belief, through its sublime alchymy, to be able to transmute all it touches into itself : and the perfect forms of Hellenic art, so touched, move our souls only the more energetically upwards, because of their transcendent beauty ; for through them alone can we see how wonderfully and divinely God wrought—how majestic, powerful, and vigorous he made man—how lovely, soft, and winning, he made woman : and in beholding these things, we are thankful to him that we are permitted to see them—not as Pagans, but altogether as Christians. Whether Christian or Pagan, the highest beauty is still the highest beauty ; and the highest beauty alone, to the total exclusion of gods and their myths, compels our admiration.

KOSMON. Another thing we ought to remember, when judging Hellenic Art, is, but for its existence, all other kinds—pre-Raffaelle as well—could not have had being. The Greeks were, by far, more inclined to worship nature as contained in themselves, than the gods—if the gods are not reflexes of themselves, which is most likely. And, thus impelled, they broke through the monstrous symbolism of Egypt, and made them gods after their own hearts ; that is, fashioned them out of themselves. And herein, I think we may discern something of providence ; for, suppose their natures had not been so powerfully antagonistic to the traditions and conventions of their religion, what other people in the world could or would have done their work ? Cast about a brief while in your memories, and endeavour to find whether there has ever existed a people who in their nature, nationality, and religion, have been so eminently fitted to perform such a task as the Hellenic ? You will then feel that we have reason to be thankful that they were allowed to do what else had never been done ; and, which not done, all posterity would have suffered to the last throe of time. And, if they have not made a thorough perfection—a spiritual as well as a physical one—forget not that, at least, they have made this physical representation a finished one. They took it from the Egyptians, rude, clumsy, and seated ; its head stony—pinned to its chest ; its hands tied to its side, and its legs joined ; they shaped it, beautiful, majestic, and erect ; elevated its head ; breathed into it animal fire ; gave movement and action to its arms and hands ; opened its legs and made it walk—made it human at all points—the radical

impersonation of physical and sensuous beauty. And, if the god has receded into the past and become a " pale, shadowy, and shapeless vision of lust, revenge, and impotence," the human lives on graceful, vigorous, and deathless, as at first, and excites in us admiration as unbounded as ever followed it of old in Greece or Italy.

CHRISTIAN. Yes, Kosmon, yes! they are flourished all over with the rhetoric of the body ; but nowhere is to be seen in them that diviner poetry, the oratory of the soul ! Truly they are a splendid casket enclosing nothing—at least nothing now of importance to us ; for what they once contained, the world, when stirred with nobler matter, disregarded, and left to perish. But, Kosmon, we cannot discuss probabilities. Our question is—not whether the Greeks only could have made such masterpieces of nature and art ; but whether their works are of that kind the *most fitted* to carry forward to a more ultimate perfection that idea which is peculiarly our's. All art, more or less, is a species of symbolism ; and the Hellenic, notwithstanding its more universal method of typification, was fully as symbolic as the Egyptian ; and hence its language is not only dead, but forgotten, and is now past recovery : and, if it were not, what purpose would be served by its republication ? For, for whom does the artist work ? The inevitable answer is, "For his nation !" His statue, or picture, poem, or music, must be made up and out of them ; they are at once his exemplars, his audience, and his worshippers ; and he is their mirror in which they behold themselves as they are : he breathes them vitally as an atmosphere, and they breathe him. Zeus, Athene, Heracles, Prometheus, Agamemnon, Orestes, the House of Œdipus, Clytemnestra, Iphigenia, and Antigone, spoke something to the Hellenic nations ; woke their piety, pity, or horror,—thrilled, soothed, or delighted them ; but they have no charm for our ears ; for us, they are literally disembodied ghosts, and voiceless as shapeless. But not so are Christ, and the holy Apostles and saints, and the Blessed Virgin ; and not so is Hamlet, or Richard the Third, or Macbeth, or Shylock, or the House of Lear, Ophelia, Desdemona, Grisildis, or Una, or Genevieve. No : *they* all speak and move real and palpable before our eyes, and are felt deep down in the heart's core of every thinking soul among us :—they all grapple to us with holds that only life will loose. Of all this I feel assured, because, a brief while since, we agreed together that man could only be raised through an incarnation of himself. Tacitly, we would also seem to have limited the uses of Hellenic art to the serving as models of proportion, or as a gradus for form : and, though I cannot deny them any merit they may have in this respect, still, I would wish to deal cautiously with them : the artist,—most

especially the young one, and who is and would be most subject to them and open to their influence,—should never have his soul asleep when his hand is awake; but, like voice and instrument, one should always accompany the other harmoniously.

KOSMON. But surely you will deal no less cautiously with early mediæval art. Archaisms are not more tolerable in pictures than they are in statues, poems, or music; and the archaisms of this kind of art are so numerous as to be at first sight the most striking feature belonging to it. Most remarkable among these unnatural peculiarities are gilded backgrounds, gilded hair, gilded ornaments and borders to draperies and dresses, the latter's excessive verticalism of lines and tedious involution of folds, and the childlike passivity of countenance and expression : all of which are very prominent, and operate as serious drawbacks to their merits; which—as I have freely admitted—are in truth not a few, nor mean.

CHRISTIAN. The artist is only a man, and living with other men in a state of being called society; and,—though perhaps in a lesser degree—he is as subject to its influences—its fashions and customs —as they are. But in this respect his failings may be likened to the dross which the purest metal in its molten state continually throws up to its surface, but which is mere excrement, and so little essential that it can be skimmed away : and, as the dross to the metal, just so little essential are the archaisms you speak of to the early art, and just so easily can they be cast aside. But bethink you, Kosmon. Is Hellenic art without archaisms? And that feature of it held to be its crowning perfection—its head—is not that a very marked one? And, is it not so completely opposed to the artist's experience in the forms of nature that—except in subjects from Greek history and mythology—he dares not use it—at least without modifying it so as to destroy its Hellenism?

SOPHON. Then Hellenic Art is like a musical bell with a flaw in it; before it can be serviceable it must be broken up and recast. If its sum of beauty—its line of lines, the facial angle, must be destroyed—as it undoubtedly must—before it can be used for the general purposes of art, then its claims over early mediæval art, in respect of form, are small indeed. But is it not altogether a great archaism?

KALON. Oh, Sophon! weighty as are the reasons urged against Hellenic art by Christian and yourself, they are not weighty enough to outbalance its beauty, at least to me : at present they may have set its sun in gloom; yet I know that that obscuration, like a dark foreground to a bright distance, will make its rising again only the more surpassingly glorious. I admire its exquisite creations, because

they are beautiful, and noble, and perfect, and they elevate me because I think them so ; and their silent capabilities, like the star-dust of heaven before the intellectual insight, resolve themselves into new worlds of thoughts and things so ever as I contemplate their perfections : like a prolonged music, full of sweet yet melancholy cadences, they have sunk into my heart—my brain—my soul—never, never to cease while life shall hold with me. But, for all that, my hands are not full ; and, whithersoever the happy seed shall require me, I am not for withholding plough or spade, planting or watering ; and that which I am called in the spirit to do—will I do manfully and with my whole strength.

SOPHON. Kalon, the conclusion of your speech is better than the commencement. It is better to sacrifice myrrh and frankincense than virtue and wisdom, thoughts than deeds. Would that all men were as ready as yourself to dispark their little selfish enclosures, and burn out all their hedges of prickly briers and brambles—turning the evil into the good—the seed-catching into the seed-nourishing. Of the too consumptions let us prefer the active, benevolent, and purifying one of fire, to the passive, self-eating, and corrupting one of rust : one half minute's clear shining may touch some watching and waiting soul, and through him kindle whole ages of light.

CHRISTIAN. Men do not stumble over what they know ; and the day fades so imperceptibly into night that were it not for experience, darkness would surprise us long before we believed the day done : and, in relation to art, its revolutions are still more imperceptible in their gradations ; and, in fulfilling themselves, they spread over such an extent of time, that in their knowledge the experience of one artist is next to nothing ; and its twilight is so lengthy, that those who never saw other, believe its gloom to be day ; nor are their successors more aware that the deepening darkness is the contrary, until night drops big like a great clap of thunder, and awakes them staringly to a pitiable sense of their condition. But, if we cannot have this experience through ourselves, we can through others ; and that will show us that Pagan art has once—nay twice —already brought over Christian art a "darkness which might be felt ;" from a little handful cloud out of the studio of Squarcione, it gathered density and volume through his scholar Mantegna—made itself a nucleus in the Academy of the Medici, and thence it issued in such a flood of "heathenesse" that Italy finally became covered with one vast deep and thick night of Pagandom. But in every deep there is a lower deep ; and, through the same gods-worship, a night intenser still fell upon art when the pantomime of David

made its appearance. With these two fearful lessons before his eyes, the modern artist can have no other than a settled conviction that Pagan art, Devil-like, glozes but to seduce—tempts but to betray ; and hence, he chooses to avoid that which he believes to be bad, and to follow that which he holds to be good, and blots out from his eye and memory all art between the present and its first taint of heathenism, and ascends to the art previous to Raffaelle ; and he ascends thither, not so much for its forms as he does for its Thought and Nature—the root and trunk of the art-tree, of whose numerous branches form is only one—though the most important one : and he goes to pre-Raffaelle art for those two things, because the stream at that point is clearer and deeper, and less polluted with animal impurities, than at any other in its course. And, Kalon and Kosmon, had you remembered this, and at the same time recollected that the words " Nature " and " Thought " express very peculiar ideas to modern eyes and ears—ideas which are totally unknown to Hellenic Art—you would have instantly felt, that the artist cannot study from it things chiefest in importance to him—of which it is destitute, even as is a shore-driven boulder of life and verdure.

On a Whit-sunday morn in the month of May.

THE sun looked over the highest hills,
 And down in the vales looked he ;
And sprang up blithe all things of life,
 And put forth their energy ;
The flowers creeped out their tender cups,
 And offered their dewy fee ;
And rivers and rills they shimmered along
 Their winding ways to the sea ;
And the little birds their morning song
 Trilled forth from every tree,
On a Whit-sunday morn in the month of May.

Lord Thomas he rose and donned his clothes ;
 For he was a sleepless man :
And ever he tried to change his thoughts,
 Yet ever they one way ran.

He to catch the breeze through the apple trees,
 By the orchard path did stray,
Till he was aware of a lady there
 Came walking adown that way :
Out gushed the song the trees among
 Then soared and sank away,
On a Whit-sunday morn in the month of May.

With eyes down-cast care-slow she came,
 Heedless of shine or shade,
Or the dewy grass that wetted her feet,
 And heavy her dress all made :
Oh trembled the song the trees among,
 And all at once was stayed,
On a Whit-sunday morn in the month of May.

Lord Thomas he was a truth-fast knight,
 And a calm-eyed man was he.
He pledged his troth to his mother's maid
 A damsel of low degree :
He spoke her fair, he spoke her true
 And well to him listened she.
He gave her a kiss, she gave him twain
 All beneath an apple tree :
The little birds trilled, the little birds filled
 The air with their melody,
On a Whit-sunday morn in the month of May.

A goodly sight it was, I ween,
 This loving couple to see,
For he was a tall and a stately man,
 And a queenly shape had she.
With arms each laced round other's waist,
 Through the orchard paths they tread
With gliding pace, face mixed with face,
 Yet never a word they said :
Oh ! soared the song the birds among,
 And seemed with a rapture sped,
On a Whit-sunday morn in the month of May.

The dew-wet grass all through they pass,
 The orchard they compass round ;
Save words like sighs and swimming eyes
 No utterance they found.

Upon his chest she leaned her breast,
 And nestled her small, small head,
And cast a look so sad, that shook
 Him all with the meaning said :
Oh hushed was the song the trees among,
 As over there sailed a gled,
On a Whit-sunday morn in the month of May.

Then forth with a faltering voice there came,
 "Ah would Lord Thomas for thee
That I were come of a lineage high,
 And not of a low degree."
Lord Thomas her lips with his fingers touched,
 And stilled her all with his ee' :
" Dear Ella ! Dear Ella !" he said,
 " Beyond all my ancestry
Is this dower of thine—that precious thing,
 Dear Ella, thy purity.
Thee will I wed—lift up thy head—
 All I have I give to thee—
Yes—all that is mine is also thine—
 My lands and my ancestry."
The little birds sang and the orchard rang
 With a heavenly melody,
On a Whit-sunday morn in the month of May.

Modern Giants.

YES ! there are Giants on the earth in these days ; but it is their
great bulk, and the nearness of our view, which prevents us from
perceiving their grandeur. This is how it is that the glory of the
present is lost upon the contemporaries of the greatest men ; and,
perhaps this was Swift's meaning, when he said that Gulliver could
not discover exactly what it was that strode among the corn-ridges
in the Brobdignagian field : thus, we lose the brightness of things
of our own time in consequence of their proximity.

It is of the development of our individual perceptions, and the
application thereof to a good use, that the writer humbly endeavours
to treat. We will for this purpose take as an example, that which
may be held to indicate the civilization of a period more than any
thing else ; namely, the popular perceptions of the essentials of

Poetry; and endeavour to show that while the beauties of 'old writers are acknowledged, (tho' not in proportion to the attention of each individual in his works to nature alone) the modern school is contemned and unconsidered; and also that much of the active poetry of modern life is neglected by the majority of the writers themselves.

There seems to be an opinion gaining ground fast, in spite of all the shaking of conventional heads, that the Poets of the present day are equal to all others, excepting one : however this may be, it is certain we are not fair judges, because of the natural reason stated before ; and there is decidedly one great fault in the moderns, that not only do they study models with which they can never become intimately acquainted, but that they neglect, or rather reject as worthless, that which they alone can carry on with perfect success : I mean the knowledge of themselves, and the characteristics of their own actual living. Thus, if a modern Poet or Artist (the latter much more culpably errs) seeks a subject exemplifying charity, he rambles into ancient Greece or Rome, awakening not one half the sympathy in the spectator, as do such incidents as may be seen in the streets every day. For instance ; walking with a friend the other day, we met an old woman, exceedingly dirty, restlessly pattering along the kerb of a crowded thoroughfare, trying to cross : her eyes were always wandering here and there, and her mouth was never still ; her object was evident, but for my own part, I must needs be fastidious and prefer to allow her to take the risk of being run over, to overcoming my own disgust. Not so my friend ; he marched up manfully, and putting his arm over the old woman's shoulder, led her across as carefully as though she were a princess. Of course, I was ashamed : ashamed ! I was frightened ; I expected to see the old woman change into a tall angel and take him off to heaven, leaving me her original shape to repent in. On recovering my thoughts, I was inclined to take up my friend and carry him home in triumph, I felt so strong. Why should not this thing be as poetical as any in the life of Saint Elizabeth of Hungary or any one else? for, so we look at it with a pure thought, we shall see about it the same light the Areopagite saw at Jerusalem surround the Holy Virgin, and the same angels attending and guarding it.

And there is something else we miss ; there is the poetry of the things about us ; our railways, factories, mines, roaring cities, steam vessels, and the endless novelties and wonders produced every day ; which if they were found only in the Thousand and One Nights, or in any poem classical or romantic, would be gloried over without end ; for as the majority of us know not a bit more about them,

but merely their names, we keep up the same mystery, the main thing required for the surprise of the imagination.

Next to Poetry, Painting and Music have most power over the mind; and how do you apply this influence? In what direction is it forced? Why, for the last, you sit in your drawing-rooms, and listen to a quantity of tinkling of brazen marches of going to war; but you never see before your very eyes, the palpable victory of leading nature by her own power, to a conquest of blessings; and when the music is over, you turn to each other, and enthusiastically whisper, " How fine !"—You point out to others, (as if they had no eyes) the senti- ment of a flowing river with the moon on it, as an emblem of the after-peace, but you see not this in the long white cloud of steam, the locomotive pours forth under the same moon, rushing on; the perfect type of the same, with the presentment of the struggle beforehand. The strong engine is never before you, sighing all night, with the white cloud above the chimney-shaft, escaping like the spirits Solomon put his seal upon, in the Arabian Tales; these mightier spirits are bound in a faster vessel; and then let forth, as of little worth, when their work is done.

The Earth shakes under you, from the footfall of the Genii man has made, and you groan about the noise. Vast roads draw together the Earth, and you say how they spoil the prospect, which you never cared a farthing about before.

You revel in Geology: but in chemistry, the modern science, possessing thousands of powers as great as any used yet, you see no glory :—the only thought is so many Acids and Alkalies. You require a metaphor for treachery, and of course you think of our puny old friend the Viper; but the Alkaline, more searching and more unknown, that may destroy you and your race, you have never heard of,—and yet this possesses more of the very quality required, namely, mystery, than any other that is in your hands.

The only ancient character you have retained in its proper force is Love; but you seem never to see any light about the results of long labour of mind, the most intense Love. Devotedness, mag- nanimity, generosity, you seem to think have left the Earth since the Crusades. In fact, you never go out into Life : living only in the past world, you go on repeating in new combinations the same elements for the same effect. You have taught an enlightened Public, that the province of Poetry is to reproduce the Ancients; not as Keats did, with the living heart of our own Life; but so as to cause the impression that you are not aware that they had wives and families like yourselves, and laboured and rested like us all.

The greatest, perhaps, of modern poets seeming to take refuge

from this, has looked into the heart of man, and shown you its pulsations, fears, self-doubts, hates, goodness, devotedness, and noble world-love; this is not done under pretty flowers of metaphor in the lispings of a pet parson, or in the strong but uncertain fashion of the American school; still less in the dry operose quackery of professed doctors of psychology, mere chaff not studied from nature, and therefore worthless, never felt, and therefore useless; but with the firm knowing hand of the anatomist, demonstrating and making clear to others, that the knowledge may be applied to purpose. All this difficult task is achieved so that you may read till your own soul is before you, and you know it; but the enervated public complains that the work is obscure forsooth: so we are always looking for green grass—verdant meads, tall pines, vineyards, etc., as the essentials of poetry; these are all very pretty and very delicate, the dust blows not in your eyes, but Chaucer has told us all this, and while it was new, far better than any one else; why are we not to have something besides? Let us see a little of the poetry of man's own works,—

" Visibly in his garden walketh God."

The great portion of the public take a morbid delight in such works as Frankenstein, that " Poor, impossible monster abhorred," who would be disgusting if he were not so extremely ludicrous: and all this search after impossible mystery, such trumpery! growing into the popular taste, is fed with garbage; doing more harm than all the preachings and poundings of optimistic Reviews will be able to remedy in an hundred years.

The study of such matters as these does other harm than merely poisoning the mind in one direction; it renders us sceptical of virtue in others, and we lose the power of pure perception. So—reading the glorious tale of Griselda and looking about you, you say there never was such a woman; your wise men say she was a fool; are there no such fools round about you? pray look close :—so the result of this is, you see no lesson in such things, or at least cannot apply it, and therefore the powers of the author are thrown away. Do you think God made Boccaccio and Chaucer to amuse you in your idle hours, only that you might sit listening like crowned idiots, and then debate concerning their faithfulness to truth? You never can imagine but they knew more of nature than any of us, or that they had less reverence for her.

In reference to Painting, the Public are taught to look with delight upon murky old masters, with dismally demoniac trees, and dull

waters of lead, colourless and like ice ; upon rocks that make geolo-
gists wonder, their angles are so impossible, their fractures are so new.
Thousands are given for uncomfortable Dutch sun-lights ; but if you
are shown a transcript of day itself, with the purple shadow upon
the mountains, and across the still lake, you know nothing of it
because your fathers never ' ought such : so you look for nothing in
it ; nay, let me set you in the actual place, let the water damp
your feet, stand in the chill of the shadow itself, and you will
never tell me the colour on the hill, or where the last of the
crows caught the sinking sunlight. Letting observation sleep,
what can you know of nature ? and you *are* a judge of landscape
indeed. So it is that the world is taught to think of nature, as seen
through other men's eyes, without any reference to its own original
powers of perception, and much natural beauty is lost.

To the Castle Ramparts.

The Castle is erect on the hill's top,
To moulder there all day and night : it stands
With the long shadow lying at its foot.
That is a weary height which you must climb
Before you reach it ; and a dizziness
Turns in your eyes when you look down from it,
So standing clearly up into the sky.

I rose one day, having a mind to see it.
'Twas on a clear Spring morning, and a blackbird
Awoke me with his warbling near my window :
My dream had fashioned this into a song
That some one with grey eyes was singing me,
And which had drawn me so into myself
That all the other shapes of sleep were gone :
And then, at last, it woke me, as I said.
The sun shone fully in on me ; and brisk
Cool airs, that had been cold but for his warmth,
Blew thro' the open casement, and sweet smells
Of flowers with the dew yet fresh upon them,—
Rose-buds, and showery lilacs, and what stayed
Of April wallflowers.

I set early forth,
Wishing to reach the Castle when the heat
Should weigh upon it, vertical at noon.
My path lay thro' green open fields at first,
With now and then trees rising statelily
Out of the grass ; and afterwards came lanes
Closed in by hedges smelling of the may,
And overshadowed by the meeting trees.
So I walked on with none but pleasant thoughts ;
The Spring was in me, not alone around me,
And smiles came rippling o'er my lips for nothing.
I reached at length,—issuing from a lane
Which wound so that it seemed about to end
Always, yet ended not for a long while,—
A space of ground thick grassed and level to
The overhanging sky and the strong sun :
Before me the brown sultry hill stood out,
Peaked by its rooted Castle, like a part
Of its own self. I laid me in the grass,
Turning from it, and looking on the sky,
And listening to the humming in the air
That hums when no sound is ; because I chose
To gaze on that which I had left, not that
Which I had yet to see. As one who strives
After some knowledge known not till he sought,
Whose soul acquaints him that his step by step
Has led him to a few steps next the end,
Which he foresees already, waits a little
Before he passes onward, gathering
Together in his thoughts what he has done.

Rising after a while, the ascent began.
Broken and bare the soil was ; and thin grass,
Dry and scarce green, was scattered here and there
In tufts : and, toiling up, my knees almost
Reaching my chin, one hand upon my knee,
Or grasping sometimes at the earth, I went,
With eyes fixed on the next step to be taken,
Not glancing right or left ; till, at the end,
I stood straight up, and the tower stood straight up
Before my face. One tower, and nothing more ;
For all the rest has gone this way and that,
And is not anywhere, saving a few

Fragments that lie about, some on the top,
Some fallen half down on either side the hill,
Uncared for, well nigh grown into the ground.
The tower is grey, and brown, and black, with green
Patches of mildew and of ivy woven
Over the sightless loopholes and the sides :
And from the ivy deaf-coiled spiders dangle,
Or scurry to catch food ; and their fine webs
Touch at your face wherever you may pass.
The sun's light scorched upon it ; and a fry
Of insects in one spot quivered for ever,
Out and in, in and out, with glancing wings
That caught the light, and buzzings here and there ;
That little life which swarms about large death ;
No one too many or too few, but each
Ordained, and being each in its own place.
The ancient door, cut deep into the wall,
And cramped with iron rusty now and rotten,
Was open half : and, when I strove to move it
That I might have free passage inwards, stood
Unmoved and creaking with old uselessness :
So, pushing it, I entered, while the dust
Was shaken down upon me from all sides.
The narrow stairs, lighted by scanty streaks
That poured in thro' the loopholes pierced high up,
Wound with the winding tower, until I gained,
Delivered from the closeness and the damp
And the dim air, the outer battlements.

There opposite, the tower's black turret-girth
Suppressed the multiplied steep chasm of fathoms,
So that immediately the fields far down
Lay to their heaving distance for the eyes,
Satisfied with one gaze unconsciously,
To pass to glory of heaven, and to know light.
Here was no need of thinking :—merely sense
Was found sufficient : the wind made me free,
Breathed, and returned by me in a hard breath :
And what at first seemed silence, being roused
By callings of the cuckoo from far off,
Resolved itself into a sound of trees
That swayed, and into chirps reciprocal
On each side, and revolving drone of flies.

Then, stepping to the brink, and looking sheer
To where the slope ceased in the level stretch
Of country, I sat down to lay my head
Backwards into a single ivy-bush
Complex of leaf. I lay there till the wind
Blew to me, from a church seen miles away,
Half the hour's chimes.

 Great clouds were arched abroad
Like angels' wings ; returning beneath which,
I lingered homewards. All their forms had merged
And loosened when my walk was ended ; and,
While yet I saw the sun a perfect disc,
There was the moon beginning in the sky.

Pax Vobis.

'Tis of the Father Hilary.
 He strove, but could not pray : so took
 The darkened stair, where his feet shook
A sad blind echo. He kept up
 Slowly. 'Twas a chill sway of air
 That autumn noon within the stair,
Sick, dizzy, like a turning cup.
 His brain perplexed him, void and thin :
 He shut his eyes and felt it spin ;
 The obscure deafness hemmed him in.
He said : "the air is calm outside."

He leaned unto the gallery
 Where the chime keeps the night and day :
 It hurt his brain,—he could not pray.
He had his face upon the stone :
 Deep 'twixt the narrow shafts, his eye
 Passed all the roofs unto the sky
Whose greyness the wind swept alone.
 Close by his feet he saw it shake
 With wind in pools that the rains make :
 The ripple set his eyes to ache.
He said, " Calm hath its peace outside."

He stood within the mystery
 Girding God's blessed Eucharist:
 The organ and the chaunt had ceased:
A few words paused against his ear,
 Said from the altar: drawn round him,
 The silence was at rest and dim.
He could not pray. The bell shook clear
 And ceased. All was great awe,—the breath
 Of God in man, that warranteth
 Wholly the inner things of Faith.
He said: " There is the world outside."

Ghent : Church of St. Bavon.

A Modern Idyl.

" PRIDE clings to age, for few and withered powers,
 Which fall on youth in pleasures manifold,
Like some bright dancer with a crowd of flowers
 And scented presents more than she can hold :

" Or as it were a child beneath a tree,
 Who in his healthy joy holds hand and cap
Beneath the shaken boughs, and eagerly
 Expects the fruit to fall into his lap."

So thought I while my cousin sat alone,
Moving with many leaves in under tone,
And, sheened as snow lit by a pale moonlight,
Her childish dress struck clearly on the sight :
That, as the lilies growing by her side
Casting their silver radiance forth with pride,
She seemed to dart an arrowy halo round,
Brightening the spring time trees, brightening the ground ;
And beauty, like keen lustre from a star,
Glorified all the garden near and far.
The sunlight smote the grey and mossy wall
Where, 'mid the leaves, the peaches one and all,
Most like twin cherubim entranced above,
Leaned their soft cheeks together, pressed in love.

As the child sat, the tendrils shook round her ;
And, blended tenderly in middle air,
Gleamed the long orchard through the ivied gate :
And slanting sunbeams made the heart elate,
Startling it into gladness like the sound,—
Which echo childlike mimicks faintly round
Blending it with the lull of some far flood, —
Of one long shout heard in a quiet wood.
A gurgling laugh far off the fountain sent,
As if the mermaid shape that in it bent
 poke with subdued and faintest melody :
And birds sang their whole hearts spontaneously.

When from your books released, pass here your hours,
Dear child, the sweet companion of these flowers,
These poplars, scented shrubs, and blossomed boughs
Of fruit-trees, where the noisy sparrows house,
Shaking from off the leaves the beaded dew.
Now while the air is warm, the heavens blue,
Give full abandonment to all your gay
Swift childlike impulses in rompish play ;—
The while your sisters in shrill laughter shout,
Whirling above the leaves and round about,—
Until at length it drops behind the wall,—
With awkward jerks, the particoloured ball :
Winning a smile even from the stooping age
Of that old matron leaning on her page,
Who in the orchard takes a stroll or two,
Watching you closely yet unseen by you.

Then, tired of gambols, turn into the dark
Fir-skirted margins of your father's park ;
And watch the moving shadows, as you pass,
Trace their dim network on the tufted grass,
And how on birch-trunks smooth and branches old,
The velvet moss bursts out in green and gold,
Like the rich lustre full and manifold
On breasts of birds that star the curtained gloom
From their glass cases in the drawing room.
Mark the spring leafage bend its tender spray
Gracefully on the sky's aërial grey ;
And listen how the birds so voluble
Sing joyful pæans winding to a swell,

And how the wind, fitful and mournful, grieves
In gusty whirls among the dry red leaves ;
And watch the minnows in the water cool,
And floating insects wrinkling all the pool.

So in your ramblings bend your earnest eyes.
 High thoughts and feelings will come unto you,—
 Gladness will fall upon your heart like dew,—
Because you love the earth and love the skies.

Fair pearl, the pride of all our family :
 Girt with the plenitude of joys so strong,
 Fashion and custom dull can do no wrong :
Nestling your young face thus on Nature's knee.

"Jesus Wept."

MARY rose up, as one in sleep might rise,
 And went to meet her brother's Friend : and they
 Who tarried with her said : " she goes to pray
And weep where her dead brother's body lies."
So, with their wringing of hands and with sighs,
 They stood before Him in the public way.
 " Had'st Thou been with him, Lord, upon that day,
He had not died," she said, drooping her eyes.
Mary and Martha with bowed faces kept
 Holding His garments, one on each side.—" Where
 Have ye laid him ?" He asked. " Lord, come and see."—
 The sound of grieving voices heavily
 And universally was round Him there,
A sound that smote His spirit. Jesus wept.

Sonnets for Pictures.

1.

A Virgin and Child, by Hans Memmeling; in the Academy of Bruges.

Mystery : God, Man's Life, born into man
 Of woman. There abideth on her brow
 The ended pang of knowledge, the which now
Is calm assured. Since first her task began,
She hath known all. What more of anguish than
 Endurance oft hath lived through, the whole space
 Through night till night, passed weak upon her face
While like a heavy flood the darkness ran?
All hath been told her touching her dear Son,
 And all shall be accomplished. Where he sits
 Even now, a babe, he holds the symbol fruit
Perfect and chosen. Until God permits,
 His soul's elect still have the absolute
Harsh nether darkness, and make painful moan.

2.

A Marriage of St. Katharine, by the same; in the Hospital of St. John
at Bruges.

Mystery : Katharine, the bride of Christ.
 She kneels, and on her hand the holy Child
 Setteth the ring. Her life is sad and mild,
Laid in God's knowledge—ever unenticed
From Him, and in the end thus fitly priced.
 Awe, and the music that is near her, wrought
 Of Angels, hath possessed her eyes in thought :
Her utter joy is her's, and hath sufficed.
There is a pause while Mary Virgin turns
 The leaf, and reads. With eyes on the spread book,
 That damsel at her knees reads after her.
 John whom He loved and John His harbinger
 Listen and watch. Whereon soe'er thou look,
The light is starred in gems, and the gold burns.

3.

A Dance of Nymphs, by Andrea Mantegna; in the Louvre.

(*,* It is necessary to mention, that this picture would appear to have been in the artist's mind an allegory, which the modern spectator may seek vainly to interpret.)

Scarcely, I think; yet it indeed *may* be
 The meaning reached him, when this music rang
 Sharp through his brain, a distinct rapid pang,
And he beheld these rocks and that ridg'd sea.
But I believe he just leaned passively,
 And felt their hair carried across his face
 As each nymph passed him; nor gave ear to trace
How many feet; nor bent assuredly
His eyes from the blind fixedness of thought
 To see the dancers. It is bitter glad
 Even unto tears. Its meaning filleth it,
 A portion of most secret life: to wit:—
Each human pulse shall keep the sense it had
With all, though the mind's labour run to nought.

4.

A Venetian Pastoral, by Giorgione; in the Louvre.

(*ₓ* In this picture, two cavaliers and an undraped woman are seated in the grass, with musical instruments, while another woman dips a vase into a well hard by, for water.)

Water, for anguish of the solstice,—yea,
 Over the vessel's mouth still widening
 Listlessly dipt to let the water in
With slow vague gurgle. Blue, and deep away,
The heat lies silent at the brink of day.
 Now the hand trails upon the viol-string
 That sobs; and the brown faces cease to sing,
Mournful with complete pleasure. Her eyes stray
In distance; through her lips the pipe doth creep
 And leaves them pouting; the green shadowed grass
 Is cool against her naked flesh. Let be:
Do not now speak unto her lest she weep,—
 Nor name this ever. Be it as it was:—
 Silence of heat, and solemn poetry.

5.

" Angelica rescued from the Sea-monster," by Ingres; in the
Luxembourg.

A remote sky, prolonged to the sea's brim :
 One rock-point standing buffetted alone,
 Vexed at its base with a foul beast unknown,
Hell-spurge of geomaunt and teraphim :
A knight, and a winged creature bearing him,
 Reared at the rock : a woman fettered there,
 Leaning into the hollow with loose hair
And throat let back and heartsick trail of limb.
The sky is harsh, and the sea shrewd and salt.
 Under his lord, the griffin-horse ramps blind
 With rigid wings and tail. The spear's lithe stem
 Thrills in the roaring of those jaws : behind,
The evil length of body chafes at fault.
 She doth not hear nor see—she knows of them.

6.

The same.

Clench thine eyes now,—'tis the last instant, girl :
 Draw in thy senses, set thy knees, and take
 One breath for all : thy life is keen awake,—
Thou may'st not swoon. Was that the scattered whirl
Of its foam drenched thee ?—or the waves that curl
 And split, bleak spray wherein thy temples ache ?—
 Or was it his the champion's blood to flake
Thy flesh ?—Or thine own blood's anointing, girl ?
. . . . Now, silence ; for the sea's is such a sound
 As irks not silence ; and except the sea,
 All is now still. Now the dead thing doth cease
 To writhe, and drifts. He turns to her : and she
Cast from the jaws of Death, remains there, bound,
 Again a woman in her nakedness.

Papers of "The M. S. Society."

No. IV.

Smoke.

I'm king of the *Cadaverals,*
 I'm *Spectral* President ;
 And, all from east to occident,
There's not a man whose dermal walls
Contain so narrow intervals,
 So lank a resident.

Look at me and you shall see
The ghastliest of the ghastly ;
The eyes that have watched a thousand years,
The forehead lined with a thousand cares,
The seaweed-character of hairs !—
You shall see and you shall see,
Or you may hear, as I can feel,
When the winds batter, how these *parchments* clatter,
And the beautiful tenor that's ever ringing
When thro' the *Seaweed* the breeze is singing :
And you should know, I know a great deal,
 When the *bacchi arcanum* I clutch and gripe,
I know a great deal of wind and weather
By hearing my own cheeks slap together
 A-pulling up a pipe.

I believe—and I conceive
 I'm an authority
 In all things ghastly,
First for tenuity,
For stringiness secondly,
 And sallowness lastly—
I say I believe a cadaverous man
Who would live as *long* and as *lean* as he can
 Should live entirely on bacchi—
On the bacchic ambrosia entirely feed him ;
 When living thus, so little lack I,
So easy am I, I'll never heed him
Who anything seeketh beyond the *Leaf :*
 For, what with mumbling pipe-ends freely,
 And snuffing the ashes now and then,
I give it as my firm belief
 One might go living on genteelly
 To the age of an antediluvian.

T.G. R

This from the king to each spectral *Grim*—
 Mind, we address no *bibbing smoker*!
Tell not us 'tis as broad as it's long,
We've no breadth more than a leathern thong
 Tanned—or a tarnished poker:
Ye are also lank and slim?—
 Your king he comes of an ancient *line*
 Which " length without breadth " the Gods define,
And look ye follow him !
 Lanky lieges ! the Gods one day
 Will cut off this *line*, as geometers say,
 Equal to any given line :—

PI PE PI,—PE—their hands divine
 Do more than we can see :
 They cut off every length of clay
 Really in a most extraordinary way—
 Then fill your bowls up—Dutch C'naster,
 Shag, York River—fill 'em faster,
 Fill 'em faster up, I say.
 What Turkey, Oronoko, Cavendish !
 There's the fuel to make a chafing dish,
 A chafing dish to peel the petty
 Paint that girls and boys call pretty—
 Peel it off from lip and cheek :
 We've none such here ; yet, if ye seek
 An infallible test for a raw beginner,
 Mundungus will always discover a sinner.

Now ye are charged, we give the word
Light ! and pour it thro' your noses,
 And let it hover and lodge in your hair
 Bird-like, bird-like—You're aware
Anacreon had a bird—
 A bird ! and filled *his* bowl with roses.
 Ha ha ! ye laugh in ghastlywise,
 And the smoke comes through your eyes,
 And you're looking very grim,
 And the air is very dim,
 And the casual paper flare
 Taketh still a redder glare.

Now thou pretty little fellow,
Now thine eyes are turning yellow,
 Thou shalt be our page to-night !
Come and sit thee next to us,

And as we may want a light
See that thou be dexterous.

Now bring forth your tractates musty,
Dry, cadaverous, and dusty,
One, on the sound of mammoths' bones
In motion ; one, on Druid-stones :
Show designs for pipes most ghastly,
And devils and ogres grinning nastily !
Show, show the limnings ye brought back,
Since round and round the zodiac
Ye galloped goblin horses which
Were light as smoke and black as pitch ;
And those ye made in the mouldy moon,
And Uranus, Saturn, and Neptune,
And in the planet Mercury,
Where all things living and dead have an eye
Which sometimes opening suddenly
Stareth and startleth strangëly.

But now the night is growing better,
And every jet of smoke grows *jetter*,
While yet there blinks sufficient light,
Bring in those skeletons that fright
Most men into fits, but that
We relish for their want of fat.
Bring them in, the Cimabues
With all or each that horribly true is,
Francias, Giottos, Masaccios,
That tread on the tops of their bony toes,
And every one with a long sharp arrow
Cleverly shot through his spinal marrow,
With plenty of gridirons, spikes, and fires
And fiddling angels in sheets and quires.

Hold ! 'tis dark ! 'tis lack of light,
Or something wrong in this royal sight,
Or else our musty, dusty, and right
Well-beloved lieges all
Are standing in rank against the wall,
And ever thin and thinner, and tall
And taller grow and *cadaveral !*
Subjects, ye are sharp and spare,
Every nose is blue and frosty,
And your back-bone's growing bare,

And your king can count your *costæ*,
And your bones are clattering,
And your teeth are chattering,
And ye spit out bits of pipe,
Which, shorter grown, ye faster gripe
 In jaws; and weave a cloudy cloak
That wraps up all except your bones
 Whose every joint is oozing smoke:
And there's a creaky music drones
Whenas your lungs distend your ribs,
A sound, that's like the grating nibs
Of pens on paper late at night;
Your shanks are yellow more than white
And very like what Holbein drew!
Avaunt! ye are a ghastly crew
Too like the Campo Santo—down!
We are your monarch, but we own
That were we not, we very well
Might take ye to be imps of hell:
But ye are glorious ghastly sprites,
What ho! our page! Sir knave—lights, lights,
The final pipes are to be lit:
Sit, gentlemen, we charge ye sit
Until the cock affrays the night
And heralds in the limping morn,
 And makes the owl and raven flit;
 Until the jolly moon is white,
And till the stars and moon are gone.

No. V.

Rain.

THE chamber is lonely and light;
Outside there is nothing but night—
And wind and a creeping rain.
And the rain clings to the pane:
And heavy and drear's
The night; and the tears
Of heaven are dropt in pain.

And the tears of heaven are dropt in pain;
And man pains heaven and shuts the rain
Outside, and sleeps: and winds are sighing;
And turning worlds sing mass for the dying.

Reviews.

Christmas Eve and Easter Day: by Robert Browning.—Chapman and Hall. 1850.

THERE are occasions when the office of the critic becomes almost simply that of an expositor; when his duty is not to assert, but to interpret. It is his privilege to have been the first to study a subject, and become familiar with it; what remains is to state facts, and to suggest considerations; not to lay down dogmas. That which he speaks of is to him itself a dogma; he starts from conviction: his it is to convince others, and, as far as may be, by the same means as satisfied himself; to incite to the same study, doing his poor best, meanwhile, to supply the present want of it.

Thus much, indeed, is the critic's duty always; but he generally feels the right, and has it, of speaking with authority. He condemns, or gives praise; and his judgment, though merely individual and subject to revision, is judgment. Before the certainty of genius and deathless power, in the contemplation of consummate art, his position changes: and well for him if he knows, and is contented it should be so. Here he must follow, happy if he only follows and serves; and while even here he will not shelve his doubts, or blindly refuse to exercise a candid discrimination, his demur at unquestioning assent, far from betraying any arrogance, will be discreetly advanced, and on clearly stated grounds.

Of all poets, there is none more than Robert Browning, in approaching whom diffidence is necessary. The mere extent of his information cannot pass unobserved, either as a fact, or as a title to respect. No one who has read the body of his works will deny that they are replete with mental and speculative subtlety, with vivid and most diversified conception of character, with dramatic incident and feeling; with that intimate knowledge of outward nature which makes every sentence of description a living truth; replete with a most human tenderness and pathos. Common as is the accusation of "extravagance," and unhesitatingly as it is applied, in a general off-hand style, to the entire character of Browning's poems, it would require some jesuitism of self-persuasion to induce any one to affirm his belief in the existence of such extravagance in the conception of the poems, or in the sentiments expressed; of any want of concentration in thought, of national or historical keeping. Far from this, indeed, a deliberate unity of purpose is strikingly apparent. Without referring for the present

to what are assumed to be perverse faults of execution—a question the principles and bearings of which will shortly be considered—assuredly the mention of the names of a few among Browning's poems—of " Paracelsus," " Pippa Passes," " Luria," the " Soul's Tragedy," " King Victor and King Charles," even of the less perfect achievement, " Strafford "; or, passing to the smaller poems, of " The Soliloquy of the Spanish Cloister," " The Laboratory," and " The Bishop orders his Tomb at St. Praxed's ";—will at once realize to the memory of all readers an abstruse ideal never lost sight of, and treated to the extreme of elaboration. As regards this point, we address all in any manner acquainted with the poet's works, certain of receiving an affirmative answer even from those who " *can't* read Sordello, or understand the object of writing in that style."

If so many exceptions to Browning's "system of extravagance" be admitted,—and we again refer for confirmation or refutation to all who have sincerely read him, and who, valuing written criticism at its worth, value also at *its* worth the criticism of individual conviction,—wherein are we to seek this extravagance ? The groundwork exempted, the imputation attaches, if anywhere, to the framework ; to the body, if not to the soul. And we are thus left to consider the style, or mode of expression.

Style is not stationary, or, *in the concrete*, matter of principle : style is, firstly, national ; next, chronological ; and lastly, individual. To try the oriental system by the European, and pronounce either wrong by so much as it exceeds or falls short, would imply so entire a want of comprehensive appreciation as can scarcely fail to induce the conviction, that the two are distinct and independent, each to be tested on its own merits. Again, were the Elizabethan dramatists right, or are those of our own day ? Neither absolutely, as by comparison alone ; his period speaks in each ; and each must be judged by this : not whether he is true to any given type, but whether his own type be a true one for himself. And this, which holds good between nations and ages, holds good also between individuals. Very different from Shelley's are Wordsworth's nature in description, his sentiment, his love ; Burns's and Keats's different from these and from each other : yet are all these, nature, and sentiment, and love.

But here it will be urged : by this process any and every style is pronounced good, so that it but find a measure of recognition in its own age and country; nay, even the author's self-approval will be sufficient. And, as a corollary, each age must and ought to reject its predecessor ; and Voltaire was no less than right in dubbing

Shakspere barbarian. That it is not so, however, will appear when the last element of truth in style, that with which all others combine, which includes and implies consistency with the author's self, with his age and his country, is taken into account. Appropriateness of treatment to subject it is which lies at the root of all controversy on style : this is the last and the whole test. And the fact that none other is requisite, or, more strictly, that all others are but aspects of this one, will very easily be allowed when it is reflected that the subject, to be of an earnest and sincere ideal, must be an emanation of the poet's most secret soul ; and that the soul receives teaching from circumstance, which is the time when and place where.

This premised, it must next be borne in mind that the poet's conception of his subject is not identical with, and, in the majority of cases, will be unlike, his reader's. And, the question of style (manner) being necessarily subordinate to that of subject (matter), it is not for the reader to dispute with the author on his mode of rendering, provided that should be accepted as embodying (within the bounds of grammatical logic) the intention preconceived. The object of the poet in writing, why he attempts to describe an event as resulting from this cause or this, or why he assumes such as the effect ; all these considerations the reader is competent to entertain : any two men may deduce from the same premises, and may probably arrive at different conclusions : but, these conclusions reached, what remains is a question of resemblance, which each must determine for himself, as best conscious of his own intention. To take an instance. Shakspere's conception of Macbeth as a man capable of uttering a pompous conceit—

("Here lay Duncan,
His silver skin laced with his golden blood—")

in a moment, to him, and to all present, of startling purport, may be a correct or an impressive conception, or it may be the reverse. That the rendering of the momentary intention is adequate here there is no reason to doubt. If so, in what respect is the reader called upon to investigate a matter of style? He must simply return to the question of whether this point of character be consistent with others imagined of the same person ; this, answered affirmatively, is an approval,—negatively, a condemnation, of *intention ;* the merit of *style*, in either case, being mere competence, and that admitted irrespectively of the reader's liking or disliking of the passage *per se*, or as part of a context. Why, in this same tragedy of Macbeth, is a drunken porter introduced between a murder and its discovery ? Did Shakspere really intend him to be a sharp-witted

man? These questions are pertinent and necessary. There is no room for disputing that this scene is purposely a comic scene : and, if this is certain, the style of the speech is appropriate to the scene, and of the scene, to the conception of the drama? Is *that conception* admirable?

We have entered thus at length on the investigation of adequacy and appropriateness of style, and of the mode by which entire classes of disputable points, usually judged under that name, may be reduced to the more essential element of conception ; because it will be almost invariably found, that a mere arbitrary standard of irresponsible private predilection is then resorted to. Nor can this be well guarded against. The concrete, *style*, being assumed as always constituting an entity auxiliary to, but not of necessity modified by, and representing subject,—as something substantially pre-existing in the author's mind or practice, and belonging to him individually ; the reader will, not without show of reason, betake himself to the trial of personality by personality, another's by his own ; and will thus pronounce on poems or passages of poems not as elevated, or vigorous, or well-sustained, or the opposite, in idea, but, according to certain notions of his own, as attractive, original, or conventional writing.

Thus far as regards those parts of execution which concern human* embodiment—the metaphysical and dramatic or epic faculties. Of style in description the reader is more nearly as competent a judge as the writer. In the one case, the poet is bound to realize an idea, which is his own, and the justness of which, and therefore of the form of its expression, can be decided only by reasoning and analogy ; in the other, having for his type material phænomena, he must reproduce the things as cognizable by all, though not hereby in any way exempt from adhering absolutely to his proper perception of them. Here, even as to ideal description or simile, the reader can assert its truth or falsehood of purpose, its sufficiency or insufficiency of means : but here again he must beware of exceeding his rights, and of substituting himself to his author. He must not dictate under what aspect nature is to be considered, stigmatizing the one chosen, because his own bent is rather towards some other. In the exercise of censure, he cannot fairly allow any personal *peculiarities* of view to influence him ; but will have to decide from common grounds of perception, unless clearly conscious of

* In employing the word "human," we would have our intention understood to include organic spiritualism—the superhuman treated, from a human *pou sto*, as ideal mind, form, power, action, &c.

short-coming, or of the extreme of any corresponding peculiarity on the author's part.

In speaking of the adaptation of style to conception, we advanced that, details of character and of action being a portion of the latter, the real point to determine in reference to the former is, whether such details are completely rendered in relation to the general purpose. And here, to return to Robert Browning, we would enforce on the attention of those among his readers who assume that he spoils fine thoughts by a vicious, extravagant, and involved style, a few analytic questions, to be answered unbiassed by hearsay evidence. Concerning the dramatic works : Is the leading idea conspicuously brought forward throughout each work ? Is the language of the several speakers such as does not create any impression other than that warranted by the subject matter of each ? If so, does it create the impression apparently intended ? Is the character of speech varied according to that of the speaker ? Are the passages of description and abstract reflection so introduced as to add to poetic, without detracting from dramatic, excellence ? About the narrative poems, and those of a more occasional and personal quality the same questions may be asked with some obvious adaptation ; and this about all :—Are the versification strong, the sound sharp or soft, monotonous, hurried, in proportion to the requirements of sense; the illustrative thoughts apt and new ; the humour quaint and relishing ? Finally, is not in many cases that which is spoken of as something extraneous, dragged in aforethought, for the purpose of singularity, the result more truly of a most earnest and single-minded labor after the utmost rendering of idiomatic conversational truth ; the rejection of all stop-gap words; about the most literal transcript of fact compatible with the ends of poetry and true feeling for Art ? This a point worthy note, and not capable of contradiction.*

These questions answered categorically will, we believe, be found to establish the assurance that Browning's style is copious, and certainly not other than appropriate,—instance contrasted with instance—as the form of expression bestowed on the several phases of a certain ever-present form of thought. We have already endeavored to show that, where style is not inadequate, its object as a means being attained, the mind must revert to its decision as to relative and collective value of intention : and we will again leave

* We may instance several scenes of " Pippa Passes,"—the concluding one especially, where Pippa reviews her day ; the whole of the "Soul's Tragedy,"— the poetic as well as the prose portion ; " The Flight of the Duchess ;" " Waring," &c. ; and passages continually recurring in "Sordello," and in " Colombe's Birthday."

Browning's manifestations of intellectual purpose, as such, for the verdict of his readers.

To those who yet insist : " Why cannot I read Sordello?" we can only answer :—Admitted a leading idea, not only metaphysical but subtle and complicated to the highest degree; how work out this idea, unless through the finest intricacy of shades of mental development? Admitted a philosophic comprehensiveness of historical estimate and a minuteness of familiarity with details, with the added assumption, besides, of speaking with the very voice of the times ; how present this position, unless by standing at an eminent point, and addressing thence a not unprepared audience? Admitted an intense aching concentration of thought; how be self-consistent, unless uttering words condensed to the limits of language ?—And let us at last say : Read Sordello again. Why hold firm that you ought to be able at once to know Browning's stops, and to pluck out the heart of his mystery ? Surely, if you do not understand him, the fact tells two ways. But, if you *will* understand him, you shall.

We have been desirous to explain and justify the state of feeling in which we enter on the consideration of a new poem by Robert Browning. Those who already feel with us will scarcely be disposed to forgive the prolixity which, for the present, has put it out of our power to come at the work itself : but, if earnestness of intention will plead our excuse, we need seek for no other.

The Evil under the Sun.

How long, oh Lord ?—The voice is sounding still,
　　Not only heard beneath the altar stone,
　　Not heard of John Evangelist alone
In Patmos. It doth cry aloud and will
Between the earth's end and earth's end, until
　　The day of the great reckoning, bone for bone,
　　And blood for righteous blood, and groan for groan :
Then shall it cease on the air with a sudden thrill ;
Not slowly growing fainter if the rod
　　Strikes one or two amid the evil throng,
　　Or one oppressor's hand is stayed and numbs,—
　　Not till the vengeance that is coming comes :
For shall all hear the voice excepting God ?
　　Or God not listen, hearing ?—Lord, how long ?

Published Monthly.—Price One Shilling.

Art and Poetry,

Being Thoughts towards Nature.

Conducted principally by Artists.

Of the little worthy the name of writing that has ever been written upon the principles of Art, (of course excepting that on the mere mechanism), a very small portion is by Artists themselves; and that is so scattered, that one scarcely knows where to find the ideas of an Artist except in his pictures.

With a view to obtain the thoughts of Artists, upon Nature as evolved in Art, in another language besides their *own proper* one, this Periodical has been established. Thus, then, it is not open to the conflicting opinions of all who handle the brush and palette, nor is it restricted to actual practitioners; but is intended to enunciate the principles of those who, in the true spirit of Art, enforce a rigid adherence to the simplicity of Nature either in Art or Poetry, and consequently regardless whether emanating from practical Artists, or from those who have studied nature in the Artist's School.

Hence this work will contain such original Tales (in prose or verse), Poems, Essays, and the like, as may seem conceived in the spirit, or with the intent, of exhibiting a pure and unaffected style, to which purpose analytical Reviews of current Literature—especially Poetry—will be introduced; as also illustrative Etchings, one of which latter, executed with the utmost care and completeness, will appear in each number.